the **WORK** *of* **PLAY**

Colin Lankshear and Michele Knobel
General Editors

Vol. 48

The New Literacies and Digital Epistemologies series
is part of the Peter Lang Education list.
Every volume is peer reviewed and meets
the highest quality standards for content and production.

PETER LANG
New York • Washington, D.C./Baltimore • Bern
Frankfurt • Berlin • Brussels • Vienna • Oxford

Aaron Chia Yuan Hung

the **WORK** of **PLAY**

Meaning-Making in Videogames

PETER LANG
New York • Washington, D.C./Baltimore • Bern
Frankfurt • Berlin • Brussels • Vienna • Oxford

Library of Congress Cataloging-in-Publication Data
Hung, Aaron Chia Yuan.
The work of play: meaning-making in videogames /
Aaron Chia Yuan Hung.
p. cm. — (New literacies and digital epistemologies; v. 48)
Includes bibliographical references and index.
1. Video games—Social aspects. 2. Play—Social aspects. I. Title.
GV1469.34.S52H86 794.8—dc22 2011009626
ISBN 978-1-4331-0906-5 (hardcover)
ISBN 978-1-4331-0905-8 (paperback)
ISSN 1523-9543

Bibliographic information published by **Die Deutsche Nationalbibliothek**.
Die Deutsche Nationalbibliothek lists this publication in the "Deutsche
Nationalbibliografie"; detailed bibliographic data is available
on the Internet at http://dnb.d-nb.de/.

Cover design by Hans Kirkendoll and Benjamin Posch

The paper in this book meets the guidelines for permanence and durability
of the Committee on Production Guidelines for Book Longevity
of the Council of Library Resources.

© 2011 Peter Lang Publishing, Inc., New York
29 Broadway, 18th floor, New York, NY 10006
www.peterlang.com

All rights reserved.
Reprint or reproduction, even partially, in all forms such as microfilm,
xerography, microfiche, microcard, and offset strictly prohibited.

Printed in the United States of America

Contents

Foreword vii
Acknowledgments xi

CHAPTER ONE
Introduction 1

CHAPTER TWO
Serious Games and Education 10

CHAPTER THREE
Situated Orders: Ethnomethodology and Conversation Analysis 31

CHAPTER FOUR
Videogames as Embodied Interactions 59

CHAPTER FIVE
Situated Play: Instruction and Learning in Fighting Games 89

CHAPTER SIX
Forms of Play: Training and Dueling 131

CHAPTER SEVEN
Construction of an Opponent 177

CHAPTER EIGHT
Meaning-Making in Videogames 197

Notes 207
Bibliography 209
Index 222

Foreword

Aaron Chia Yuan Hung offers us here a very serious book about a very serious human activity: playing!

Many, like him, seek to learn about humanity by looking at people playing. But most conduct their search from a very closed sense of what play is, who plays, and what part of the player's humanity playing might transform. Typically, psychologists hypothesize what part of development playing might help or hinder. Sociologists investigate what playing with, for example, Barbie dolls might do to gender equality. Others keep discussing the meaning of, for example, choosing to play with dolls of the "wrong" color. School people wonder how playing might impact performance on various tests. And every generation worries, in its popular media and in family conversations, that "our children are spending too much time playing [the most recent popular game]."

Few, by contrast, do what Hung does here as he deliberately looks at people playing together to figure out how they do play, in the ongoing interactional details of the activity. The book is a distinguished addition to an emerging and influential body of investigation that asks us to start from scratch, leaving aside easy preconceptions about what playing is all about. Hung and his peers start with the evidence that playing is something that all human beings do, and it is something that they do, like everything else, mostly with each other, in smaller or larger groups, often in face to face interaction (as in playing chess), or in enormous crowds that now can span the globe (as during soccer world cups). Human beings sometimes do play by themselves but even there the long histories that make it possible, for example, to play "Solitaire" on a computer soon takes us back to the kind of interactional questions that Hung investigates.

As a cultural anthropologist, I have been fascinated by play for the same reasons that have kept me fascinated by a discipline dedicated to understanding humanity from the ground up, in village plazas and streets (and in video arcades) using whatever methods or approaches make sense. Anthropology started as a multi-discipline and it remains one. More than a century ago, it was clear to Boas and others that biology, history, linguistics, folklore or politics were not sufficient to understand what one could see human beings do. Human beings are bodies that speak, symbolize, organize themselves with each other and thereby produce a history that keeps transforming what they can do—and what they cannot. One cannot understand them by favoring one aspect over others. Hung works in this systematically eclectic tradition. To understand playing, he follows his people wherever they are taking him so that eventually, he borrows from linguistics, conversational analysis, ethnomethodology, gender studies, etc., to document the complexity of an activity some might consider altogether vulgar, if not offensive. And so I claim Hung for anthropology.

Following anthropology, however, leads directly to a major dilemma that Hung faces squarely. On the basis of their experience following human beings all around the world, doing all sorts of more or less specialized tasks, anthropologists keep making two apparently contradictory claims: that all human beings are fundamentally alike, and that they make for themselves conditions, "cultures," that can be so different as to make their everyday experiences incommensurable. And so it is the case that all human beings play, that they often play the "same" games, and that they also make each epoch in the playing of a game somehow different from what it was like playing the game in another epoch. Anthropology is both, and at the same time, broadly universalistic and profoundly particularistic. Hung's work fully belongs to this tradition, as he makes the same daring analytic moves Margaret Mead once made when she challenged many of Euro-American most cherished generalizations about human development on the basis of her observations of some young girls on an island far removed from all centers of power or influence. Similarly, Hung tells us probably more than we thought we would need to know about three adolescent boys and one adolescent girl playing together for a few hours one type of videogame. But his purpose is not simply to tell us about them in their

particularity. Hung is not content to tell us "what it means to them." He goes much further as he tells us about what all human beings can do because these four did do it. He tells us about the kind of steps people might have to take in order to proceed with any game, with their broader social relationships, while having fun and, most interestingly perhaps, finding new ways to have fun.

So, this is a book about playing and all that playing entails. Like the best anthropology, it is a book that tells us what to look for any time we see human beings playing anywhere, and not only in the United States, at the turn of the 21st century. Current classificatory schemes make the players in this book "recent immigrants from Asia" but the import of the book is not to any so-called "population." Hung, of course, does not present the four as typical of any type of human beings. Rather he shows they are interesting because they contribute a particular case of human work figuring out available resources, dealing with them, and also, in various ways, transforming them, if only for the duration of the game, or of their relationship.

In other words, the four protagonists play. And they "make play" in their conditions. I mean "play" here in the sense we use when we talk about the gaps in the fitting of parts of machine. For engineers and mechanics, play between parts of gears is both a problem and a necessity. Too little play and the machine might freeze; too much play and it might break apart. Most relevant perhaps is the fact that, as the machine is used, and time passes, play increases. For machines this is often a sign that the end is near. For human beings, it may just be a sign that new possibilities are being opened in the transmission of apparently deterministic forces. This "making play" in the social machineries may even lead to what might later be seen as "new" cultural forms. This is why I am particularly fascinated, in Hung's book with two sets of sequences. First is the time when the two most expert players develop a new game with possibilities they have discovered in the game software—even though the designers had not planned for the game to be played this way. Second, and most significant, is the complex interplay between the girl and the boys as they construct special relationships. One boy ends instructing her on how to play the game. Another will soon ask her on a date. Everyone is playing here, at life as well as at a videogame. We get a sense that what Hung observed is but a sequence within a much

larger game that is altogether serious and probably "deep" in the sense Geertz developed from Bentham. While playing, the whole status of the relationship between the participants is, indeed, "at play."

And so, Hung's work is to be taken most seriously, and also enjoyed for the play he produces in our usual analytic moves. Videogaming, like all playing (in the usual sense), is much more than a possible training for life. It is much more than a virtual life aside from real life. Videogaming is an occasion for the production of life—with its dangers, and with its glories.

—Hervé Varenne
Professor of Anthropology and Education
Teachers College, Columbia University

Acknowledgments

This book could not have existed without the help and support I got from my colleagues, friends and family.

First, I want to thank the editors at Peter Lang—in particular Colin Lankshear and Michele Knobel for showing interest in the topic. I also wish to thank the people at Peter Lang, especially managing director Christopher Myers, and design and production supervisor Sophie Appel for always being there to answer my questions and making everything easy, and Hans Kirkendoll and Benjamin Posch for your amazing cover design.

A special thanks to: JoAnne Kleifgen, Hervé Varenne, Robbie McClintock, Eva Roca, Joyce Kim, Jennifer Fennema-Bloom, Payal Arora, Charisse Gulosino, and Jonathan deHaan.

I am grateful to those who took the time to talk to me and/or read early drafts of the book: Clifford Hill, Eric Larsen, Matthew Curinga, and Katalin Kabát. Your insights have been tremendously helpful. I also need to thank Louise Huang for all the help you've given me.

Thanks also to the great colleagues and professors at Teachers College who have been supportive of my work, including Charles Kinzer, Lalitha Vasudevan, Dan Hoffman, Seunguh Paek, Antonius Savaranos, Leah Mason, Bahar Otcu, Gillian Andrews, Sarah Wessler, Lance Vikaros, Marie Keem, Maureen Matarese, Jin Kuwata, Mark Owen, and the Sadnytzky family.

Finally, I would like to express endless gratitude to my friends and family, especially my parents for asking me every week whether I am done with the book and/or working on a new one; Grandma, for your inspiration; CW and CK, for being my brothers; Christine, for your honesty; Jodie and Adrian, for your beauty; Shawn, for your love; Richter, for the conversations; Tom, for your politics; Wayne, for your support; Chai Ping, for your memories; and Plato, for your patience.

For my parents and grandparents

• CHAPTER ONE •

Introduction

All play means something.
—Johan Huizinga (1950, p. 1)

We live in strange times. On the one hand, politicians and pundits like to voice their concern that children and adolescents are spending too much time watching television or playing videogames, and are falling behind in their reading and critical thinking skills. On the other hand, literacy scholars argue that traditional schooling is fast becoming irrelevant because it fails to teach much needed "21st century skills" for the new economy (Lankshear & Knobel, 2006).

Part of the confusion might be that researchers are always playing catch-up. By the time it takes us to understand a new media phenomenon, write a grant, conduct the study, interpret the data, publish the report, and spread the word, the social experience might have already evolved to another phase. Many of the new media phenomena that are shaping our social experience today—*Wikipedia* (2001), *Second Life* (2003), *Myspace* (2003), *Facebook* (2004), *Youtube* (2005), *Twitter* (2006), *Groupon* (2008), *Foursquare* (2009), *Farmville* (2009)—are barely ten years old, and may or may not still exist ten years from now. Clearly, the time it takes for us to understand the impact of new media through research is slower than the time it takes for the social experience and the media to evolve. Furthermore, much of our understanding of new media comes from statistical research, such as the ones conducted by *Nielsen, Pew Internet and American Life, Google Analytics* or other large-scale quantitative studies. These reports provide us with a continuous stream of data on a monthly, weekly, even daily basis, informing us about shifting trends in the media landscape. The speed and relative ease in which these quantitative data can be gathered makes them a popular source of data, but there is still a lot we do not understand about how

these media are used in specific contexts. For example, how are these new spaces used in local contexts and how do these uses connect with broader trends? What do people use these technologies for and how do they adapt the technology to fit their needs, and vice versa? If the history of technology has taught us anything, it is that we are innovative creatures who constantly find new ways of using things in ways they were not designed for. This is what makes new media so interesting yet so challenging to study and theorize about.

Conventional Wisdoms

> It is the peculiar and perpetual error of the human understanding to be more moved and excited by affirmatives and negatives.
> —Francis Bacon

In the age of "kinderpolitics," children and adolescents have increasingly become the foci of ideological debates. This extends not only to what they do in school but also what they do in their leisure. Attempts to blend the two areas often leads to outcry and aggravation. Emerging media—film, comic books, rock and roll, television, videogames, the Internet—have always aroused suspicion, particularly from people who do not use or understand them. The very fact that people—usually younger people—gravitate toward emerging media leads many to assume that there has to be something inherently decadent and corrupting in their conception and use, the reasoning being that, anything *that* entertaining cannot possibly be good for you.

Not surprisingly, entertainment has been the driving force for technological advancement, particularly in the case of video and computer games. As game designers continue to push for more complex designs, better graphics and sound, console and computer makers have to increasingly add storage and processing power to their systems. The notion of game-based learning has been around for decades and is enjoying resurgence among educators, thanks in part to a series of innovations that have swept through media technologies in recent years. These include: expansion of high-speed Internet and wireless networks, switch from analog to digital signals in television, adoption of high-definition displays, increase in capacity of storage media, widespread use of touch interface and motion control, falling costs of microprocessors, evolution of videogame consoles into media hubs, improved

portability and power of mobile devices, growing trend towards ubiquitous computing, increasing participation and collaboration in online communities, development of open source software, evolving attitudes towards proprietary rights, copyright and privacy, and improvement in graphic cards and processors. A result of these and other developments is that people are able to interact with media in ways that have not been possible in the recent past.

The full impact of these developments is still not fully known because these developments are still ongoing. But now, traditional schooling practices are looking increasingly archaic in comparison to the social experience that goes on outside the classroom. New technologies have always been an ill fit with schools. Those that do make it through the school gates tend to be slight variations preexisting of technologies that educators are already comfortable with: photocopiers instead of mimeographs, computers instead of typewriters, PowerPoint instead of overhead projectors, SMARTBoards instead of blackboards; technologies that are more disruptive of traditional practices, such as individual laptops and mobile devices, have a harder time getting through because they require a whole new set of practices and a whole new definition of education (Collins & Halverson, 2009; Kleifgen & Kinzer, 2009).

Among game researchers, the conventional wisdom is that videogames are good for you—either because they represent the new forms of skills valued by a new economy or because they inherently embody good learning principles. These beliefs are at the forefront of the push to use videogames or game-based learning in traditional school. However, not all of these conventional beliefs hold up well to in-depth criticism. Here are a few examples of that come to mind:

- *Schools (in America in particular) should embrace game-based learning in order to compete with students around the world.* According to a recent report from the Program for International Student Assessment, students in America have been falling behind in international rankings in areas such as reading, science and math. Reports like this have often been cited as a reason to use new forms of learning—such as game-based learning—in schools (Duke, 1974; Shaffer, 2007). The argument that this unfavorable ranking is why schools need to embrace game-based learning is specious at best, as it overlooks the fact that the top-ranked countries—China, Hong Kong, Singapore,

South Korea—tend to have very traditional forms of learning that build on rote memorization and repetition. The reason why students in these countries do better has less to do with how they teach and more to do with their societal attitudes toward teachers and schooling in general.

- *Players continue to play videogames because they have good design and learning principles.* It's clear that game designers know a lot about learning and it's clear that videogames have been immensely popular. What is less clear is the extent to which this success is the result of self-selection. Players choose to play videogames because the medium works for them, but that does not tell us how much the success is due to the players' intrinsic interest and how much is due to well-designed learning principles. Not everyone enjoys videogames and not every player successfully learns how to play. Every system—including traditional schooling—has its success stories, but no one is likely to point to the most extreme cases of success and use that as evidence of why a system works. To find out whether videogames are *more* successful, researchers need to compare not just avid players but players of all kinds, including non-players. Would these good learning principles still work as well if we ask a non-player to try out a game, or will the non-player feel disoriented and confused?

- *Players have a positive experience learning from videogames.* Pleasure is sometimes mentioned as the reason why videogames are successful. The thinking is that, not only do players learn but they also enjoy themselves while learning. But again, it is unclear how much of the positive experience is due to a self-selection bias. If we study only those who continue to play and not those who fail to enjoy videogames, then we would always get a biased result. Furthermore, not all videogames are successful, and even the most well-designed games are likely to turn off some players. The notion that learning, in general, works better in a positive environment is also not fully supported by research. Gundaker (2007), for example, has documented learning among African Americans during slavery, and found out that "hidden education" was not uncommon even in those oppressive and violent environments. As educational theorist Jacques Rancière (1991) points out, people learn if they have the *will*

to learn, and pleasure has little to do with the outcome. Newly-coined terms such as "rage quit" (when a player, usually in an online game, exits the game in anger) demonstrate that frustration is a common part of gaming, but this frustration seldom keeps players away permanently. Perhaps we need more complicated notions than "pleasure" or "positive experience" to describe the complex mix that players derive from videogames.

- *Players support one another through collaboration in online communities of practice.* One oft-cited benefit of videogames is that it encourages collaboration, distributed knowledge and other forms of supportive learning. One example is that certain players go out of their way to collaborate on walkthroughs, which are detailed documentations of games that are shared with the rest of the Internet. This is certainly true. It is also comparatively rare as most players do not participate in this type of collaboration. Furthermore, any activity that generates interest is likely to encourage collaborative work, and it is not clear whether videogames encourage online support any more than any other situation when people have an interest in a shared activity. In other words, online collaboration exists because of the popularity and accessibility of the Internet, and videogames are only one of *many* activities that generates these types of online communities.
- *Players (selectively) internalize the content of the videogame.* Players are often portrayed as unique sponges who soak up either the pro-social or violent content but seldom both, and conveniently, what players soak up depends on what the researcher's position is. There is ample evidence to suggest that violent games *do not cause* players to become violent, but we have no reason to believe that they become more pro-social either. Presumably, players are aware of whether the game they are playing is violent or not—we wouldn't expect anyone who plays *Grand Theft Auto IV* to argue that it is a peaceful game—but what is unclear is whether this awareness leads to a change in behavior. As Squire's (2002) argues, there is insufficient evidence to suggest that players transfer their learning across contexts.

These criticisms don't mean that these beliefs are wrong, but that they are based on incomplete and/or selective evidence. It shouldn't be surprising that, if all we ever studied were players who enjoy videogames and focus only on success stories, we would get a distorted

view of how effective videogames really are as educational tools. As game researchers, we can do better than that. Our expectations for the potential of videogames or game-based learning should not be distorted by our personal expectations of games in general. To the extent that we believe videogames are *useful*, we need to move beyond simply asserting this belief and supply the empirical evidence and detailed observations that support this belief.

Plan of the Book

The title of the book—*The Work of Play*—builds on the notion that all social interaction requires organizational work of some sort. This work is what constitutes the interaction as meaningful and orderly to other social actors. Even something as mundane and simple as everyday conversation requires its participants to have a set of shared understandings and orientations in order for interaction to unfold smoothly. Play—an activity commonly associated with leisure and triviality—cannot occur without this organization work. Ethnomethodologists and conversation analysts have focused on this work in their studies, and this present book builds on these studies and applies it to the case of videogame play.

We know relatively little about what players do when they play videogames. Most studies have depended on post hoc analyses (e.g.,, interviews, questionnaires, surveys) on gaming behavior. As many anthropologists and sociologists would argue, a post hoc recollection is a reconstructed event that is different from the original event itself. In other words, we cannot rely on the participant's recollection as a reliable portrait of the activity. This book attempts to describe gameplay— including learning, organizing, instructing, turn-taking, arguing, cheating, accusing, training—as an *in situ* event, thus capturing the action closer to its original form.

Chapter Two provides a broad overview of research on videogames and learning. In addition to studies by literacy scholars and educators such as Gee (2003, 2004), Prensky (2006), Shaffer (2006), Squire (2003, 2006), and Steinkuehler (2004, 2007), I draw on game studies from the 1960s and 1970s, in particular those of Abt (1970) and Duke (1974). Many present-day game researchers seem to be unaware of this earlier period of game studies, since they rarely refer to them in literature reviews. Yet,

despite technological advances that videogames have made over the past few decades, the arguments that scholars make today about the potential of games for furthering learning remain largely the same as those made in the 1970s. The trajectory of this earlier movement may provide insights into some of the current problems of using games for learning, such as the lack of empirical studies and the practical difficulties of using games in the classroom.

Chapter Three gives an introduction to ethnomethodology and conversation analysis. It starts by pointing out that ethnomethodology and game studies both emerged during a period when game theory and models were gaining influence in the social sciences. Recent publications by Garfinkel (2008), who founded the ethnomethodology approach, has revealed that he was both influenced by and critical of game theory. In particular, he was interested in how information is communicated as a system, and how people react to their perception of the system. The iterative nature of game theory models led him to consider how people perceive the system at any given moment. Conversation analysis came out of ethnomethodology, and is used as a way to articulate the moment-by-moment unfolding of interaction. Researchers such as Mehan (1979), Suchman (1984, 2006) and Goodwin (2006) have applied conversation analysis to longer stretches of interaction that occur in contexts as diverse as classrooms, photocopiers, and playgrounds. Their studies have been important in showing the contextual and contingent properties of interactions.

Chapter Four introduces the genre of fighting games in general, comparing them to other videogame genres. Most videogames involve combat, but fighting games are unique in that they tend not to contain any narrative and are designed solely for competition. I also describe videogames as embodied experiences (Dourish, 2001) that require players to perform their actions through controllers. These controllers are complicated devices, often containing nearly two dozen buttons that represent a variety of actions. In order to become competent, players need to first master the controller and understand its relationship to the actions in the game.

Chapter Five describes an instructional episode that unfolds between a novice and three expert players. This episode is particularly interesting because it reveals the novice's meaning-making practice as she makes

sense of the game, one that happens to be "mistaken" in relation to the official rules of the game. I argue that, when players have different competencies, they might encounter misunderstanding between the differing interpretations of the event. It also shows that players can continue to make sense within the context of their interaction even when their interpretations of the game diverge from the game designers' intentions. This is because social actors have to share a common interpretation of their activity system in order to render it meaningful to one another. The finding suggests that "situated learning" or "just-in-time" instruction alone is not enough for instruction to be understood. Although the experts in the game provided instructions when they noticed her make a mistake, they did not create the proper context for her to understand what their instructions meant. Thus, giving proper instructions requires having an understanding of how the learner is interpreting the game and when he/she needs extra support to navigate the complex game environments and controllers.

Chapter Six looks at the different forms of play that players engage in. Surprisingly, players are not always "playing" when they are in fighting games. Sometimes, they are "training," and sometimes they are "dueling." Each of these different frames implies a different set of rules and expectations, many of which are independent of the game's rules. For example, during training, the objective is to try out new moves or new characters, and players are not allowed to attack one another without permission. During dueling, the objective is to win, but in a way that all parties (usually two players) deem "fair," where fairness refers to a criterion that has to be negotiated over time. These frames of play are analogous to the way everyday talk is modified with varying degrees of formality to render them into new kinds of social interaction, such as debates, interviews, and so on (Sacks, Schegloff & Jefferson, 1974). I argue that, like everyday conversation, "regular play" is the least formal version of play (at least in fighting games), whereupon all the other variations of play are built. These forms of play, however, need to be negotiated between the players, and are often not determined by the game design alone. This expanded understanding of framing may provide insights for educators and game designers on how to structure and design different frames of play (e.g., instruction, training, and play) within educational games.

Chapter Seven looks at how players positions themselves in relation to the other players, particularly how they distinguish their status by including some players and excluding others (Goodwin, 2006). It compares two groups of players in two similar games: in the first group, the players consistently put down one another while boasting of their own expertise; in the second group, the players consistently put down themselves while complimenting one another. This comparison provides an interesting insight into how social relationships are often more salient in organizing videogame play than the game design, thus suggesting that the role of videogames in influencing either pro-social or anti-social behavior might be overplayed. The chapter also describes how players talk about their own behavior in the game, particularly in relation to the type of player they are. These constructions of identity influence how they perceive and project themselves as players and social actors.

Chapter Eight uses the discussion from previous chapters to show how the micro-level analysis can shed light on broader themes and trends in videogames and education. The focus on context, time, and space allows studies such as this to reveal how new literacies are developed and advanced in a transnational context. It looks at how players identify themselves as different types of players, and how they (re)construct the game (and genre) according to the activity. It emphasizes the importance of studying videogames in context, as it reveals that players shift and reposition themselves in a fluid manner, where much of their behavior is improvised according to the flow of the interaction around them.

• CHAPTER TWO •

Serious Games and Education

> If this flood of materials and literature is any indication, the Age of Games is surely upon us.
>
> —Michael P. McCarthy (1973, p. 62)

The past decade has seen growing interest in games for learning, and scholars from many disciplines have converged in gaming conferences around the world to consider the potential of videogames as educational tools. Certainly, people have been interested in play and learning for a long time; scholars such as Johan Huizinga, Roger Caillois, George H. Mead, Jean Piaget, and Gregory Bateson have all argued that "play" is central to human societies and communication. While there were some studies of videogames in the 1980s (cf. Loftus & Loftus, 1983), the focus on games for education is often thought of as a relatively recent phenomenon. Espen Aarseth (2001) refers to 2001 as "year one" of videogame research, since it was the first time that institutions of higher education granted degrees for game studies. In 2002, Ben Sawyer co-founded the Serious Games Initiative to draw attention to games for teaching about social issues such as politics, health, civics, and peace and, in 2004, organized the Serious Game Summit for the annual Games Developers Conference.

This present interest in videogames echoes the sentiments of an earlier movement in the 1960s and 1970s, right around the time videogames were first entering our living rooms. Many of the scholars associated with this early movement of "serious games" came with ideas that closely resemble the ones made today. McCarthy (1973) refers to this movement as the "Age of Games," noting that games represent an "imaginative and pedagogically sound" (p. 62) way of teaching history. Charles and Stadsklev (1973) profiled 70 games for use in K–12 classes

for teaching social studies, including games for teaching history, geography, urban studies, race relations, and decision making. Unfortunately, many, if not most, of the games they reviewed are now out-of-print. Many of these games resemble present-day videogames, not only in name but also in spirit. *Simpolis*, for example, is a simulator based on New York City, where players take the role of mayoral candidates who have to address problems relating to education, pollution, housing, crime, and civil rights, much like in the games in the *SimCity* series, where the player controls the zoning, transportation, education, and overall development of the city. Certainly, the technology has changed in the decades between *Simpolis* and *SimCity*, but the arguments for using games for education have remained relatively familiar.

Research on games today rarely acknowledges this earlier movement. One reason might be that these earlier studies have been out of print or otherwise unavailable. Another possibility might be that these works have been deemed obsolete, since current videogames have little in common with their 1960s counterparts. Moreover, many of these earlier scholars were not talking specifically about *videogames*, but rather games in general. They were more interested in the games as a "state-of-mind" than as a technical medium (Woods, 2004). Finally, it is also likely that scholars in different disciplines do not communicate with one another very often, and do not realize that they share many ideas in common.

Part of this chapter is devoted to describing some of these earlier game studies and connecting them to today's research. Many of these studies are back in print and are worth (re)examining. As researchers, we might want to revisit these works in order to find out why this earlier movement in using games for education had fizzled out, and whether the more recent push for serious games is fundamentally similar or different. Schools haven't changed a whole lot. Was it because games failed to deliver what they promised? Or was it because there was too much talk about what games could do and too little evidence?

Early Game Studies

The field of simulations and games for education has been around as early as the 1950s. Much of the early work was inspired by the blossoming field of game theory, which was having growing influence in

political science, economics, communication, sociology, and other disciplines. Avedon and Sutton-Smith (1971) summarize two phases in early game research. During the first phase (late 1950s-1960s), most scholars were interested in using computerized models to simulate international relations, pointing out that much of the research during this period was "largely impressionistic and subjective" (Avedon & Sutton-Smith, 1971, p. 321). During the second phase (1960s-1970s), researchers tried to be more objective, focusing on studying how games can stimulate interest, help students improve retention of information, interest, foster critical thinking, and encourage the development of decision making skills. These studies showed that students were indeed more interested in learning when playing games, and some researchers went on to provide elaborate theories of learning through games. Many also discussed ways that games could be implemented in specific classroom subjects (Carlson, 1971; Coleman, 1971; Kraft, 1971; McCarthy, 1973; Oxford & Crookall, 1990a, 1990b).

Here, I focus on two scholars in particular—Richard Duke and Clark C. Abt—because their work has been most influential in this early period of simulation and games.

The Future's Language

In 1974, Richard Duke published *Gaming: The Future's Language*, in which he argues that games should be thought of as a type of communication mode that, like language, graphics, and sound, are each able to reach different types of audiences and carry messages of varying degrees of complexity. "Future's language" does not mean "language of the future"; instead, Duke means that a game orients its users toward a future point in time—or a future's perspective because, in order to communicate through a future's language, users have to anticipate different possible moves that they and others might make, and plan their own moves accordingly.

Games and simulations are not the only types of future's language. Other examples are maps, flow charts, and concept maps. For example, when you look for directions on a map, you have a starting point and the point you wish to reach—this is your future's orientation. Knowing how to use maps, flow charts, and concept maps requires that you know where you wish to end up at some future point in time. Games and

simulations orient you in the same manner. Whether you are playing chess or *Tetris* or *SimCity*, you are thinking of future moves and countermoves, possibilities and consequences.

Many of Duke's arguments parallel the arguments game scholars make today. For example, Duke argues that, as our societies become increasingly complex, our conventional methods of communication become less adequate in conveying information to diverse populations. He categorizes human communication into a continuum going from "primitive" to "advanced" to "integrated." Primitive modes are ubiquitous forms of communication such as hand gestures, road signs, and flag-waving (like the flags used by airport ground crews). These modes are relatively easy to understand but tend to be restricted to simple messages. Advanced modes include everyday conversations, graphics, books, mathematical and musical notations, lectures, and so on. These modes are able to communicate more complex messages, but tend to require more specialization. For example, a conversation requires that participants have some degree of competency in a common language, and mathematical notations and formulas only make sense to someone who recognizes the symbols and equations. Finally, integrated modes include multimedia, such as film and television, as well as flow charts, maps, architectural blueprints, and simulation/games. This includes what some today refer to as "multimodality"—that is, texts that integrate different semiotic modes, such as video, graphics, audio, and language. Integrated messages tend to be more elaborate, but are able to convey complex information.

That Duke has been influenced by gestalt psychology is evident in his terminology and his emphasis on games as a mode that can communicate holistic, "big picture" messages in which the whole is more than the sum of its parts. Gestalt approaches have somewhat fallen out of favor, but many of these ideas relate to studies in communication, perception and phenomenology. Much of the interest in gestalt psychology has to do with how the mind puts meaning together, and how our perception can trick us into interpreting the same picture in several different ways.

Even though present-day technologies have made it considerably easier to produce and distribute multimedia messages, Duke's model continues to be a useful framework for analyzing modes of

communication. The different modes of communication, each with its unique affordances, are ideal for different messages and participants. For example, two mathematicians would probably find it easier to communicate their ideas through mathematical notions and equations than through conversation alone. When deciding which mode(s) to use, it is important to be aware of what the message is, what context it is communicated in, and who the participants are.

Duke (citing Moore and Anderson, 1969) describes four learning principles that can be found in games and simulations:

1. Perspectives principle: games allow players to participate from multiple perspectives.
2. Autotelic principle: games provide a safe environment that allows players to try out risky moves without danger to their personal well-being.
3. Productive principle: games are well-structured problems that encourage active participation, critical thinking, problem solving.
4. Personalization principle: games adapt to players' styles of learning, often letting them pose the questions they want to ask, and then allowing them to seek the answers.

In addition to these principles, Duke points out that games are often designed to reflect real-world contexts, and thus allow players to learn in a contextualized manner. Moreover, games represent problem-specific domains, each with a unique jargon that is understandable only within a gaming situation. (Phrases like "to castle" or "backward pawn" or "en passant" would not make much sense in a conversation that doesn't involve chess.)

Duke also suggests that learning occurs in a "spiral" in which players are exposed to increasing degrees of complexity and gradually get to learn the total system. The spiral concept of learning reminds us that different modes of communication take different lengths of time to communicate their messages. Games, for example, require more time to communicate their meaning than other modes of communication. For games to be used in a structured environment such as a classroom, these time constraints need to be taken into account. Duke also emphasizes the need to consider what modes are best suited for what ends. He also points out that, while games are able to communicate complex systems

and orient users to a future's perspective, they are difficult to design and time-consuming to learn.

In his preface, Duke mentions that the growing interest in games is a worldwide phenomenon that is spreading throughout institutions of higher education. He notes that there has been an abrupt increase in the supply of games, and that this rising popularity signals that games are a successful and engaging medium. Furthermore, despite writing before the Internet age, he points out that society is becoming increasingly interconnected, and consequently, that its problems can no longer be approached in a piecemeal fashion. His interest in gestalts stems from his belief that society needs to be understood in a holistic manner, and that having a better understanding of its complexities will allow us to have a better grasp of potential solutions.

Serious Games

> My own quite impressionistic view is that a game is a particular way of looking at something, anything. (Abt, 1970, pp. 5-6)

Abt, an engineer and game designer from MIT, discusses the potential of using games to improve education in his book *Serious Games* (1970). Like Duke, Abt feels that educational methods need to adapt to societies' needs as they become increasingly technologically sophisticated.

Abt echoes the arguments made by many play theorists, such as Huizinga (1955), who point out that many human activities—business, warfare, politics—have a game-like quality that involves moves, tactics, strategies, planning, and so on. Abt argues that the benefit of games is that they combine thought with action, so that students do not have to learn through abstractions. He defines serious games as games that "have an explicit and carefully thought-out educational purpose and are not intended to be played primarily for amusement. This does not mean that serious games are not, or should not be, entertaining" (Abt, 1970, pp. 9-10). Instead of learning in an abstract environment, games allow students to consider alternate possibilities and consequences to their actions. Games create a dramatic environment that puts students in control by requiring them to develop strategies, solve problems, and make decisions, thus making them more invested in their learning. Like Duke, Abt points out that "with games one can evaluate students' performances without risking the costs of having errors made in 'real-

world' tryouts and without some of the distortions inherent in direct examination" (Abt, 1970, p. 13).

Abt believes that, in addition to playing games, students can learn by designing games, as it allows them to consider the factors that are important to any given decision making process. For example, students can imagine their problems in terms of games and think of alternative moves they might make and the consequences of each move. It also makes them consider the key actors that might be relevant to their problem and what concerns each might have.

Abt points out that there are critical gaps between what is taught in schools and what is useful in life. More specifically, he argues that the methods of teaching are becoming increasingly ineffective in handling the complex knowledge of a rapidly changing society. He also notes that schools, and especially tests, privilege students with good English-language skills. He further observes:

> [S]ociety is becoming more and more complex as it becomes more highly technological and that education for life roles is becoming increasingly important are truisms today. The chasm between the "educated" and the "uneducated" is growing wider, and the numbers of both groups are increasing. Yet fewer jobs for uneducated or unskilled workers exist now than in the past, leaving a higher percentage of poor people out of work. (Abt, 1970, p. 119)

Abt mentions several advantages to using games. He believes that games fulfill Dewey's promise of creating an active learner. He notes that adolescents often fail to see the relevance of the abstract concepts they learn in classrooms to the real world. He also believes that games provide an efficient way for students to receive useful feedback. In a traditional classroom, it is often difficult for the teacher to give one-on-one attention to a student; however, in a game, players can relate to a game based on their own backgrounds and experiences, and thus, receive more individualized feedback. To use a present-day example, a massively multiplayer online game (MMOG) can involve hundreds, even thousands, of players at the same time, each of whom progresses through the game at their own pace and explores within their own comfort zones; it takes less effort for them to learn from the game because they control their own pace.

Abt also notes that traditional schools tend to marginalize disadvantaged and minority groups, who often see schools as "foreign institutions" irrelevant to their lives. He observes that many high school

dropouts are able to participate and be motivated by games because it engages them in a unique way, especially by providing a comfortable, risk-free zone in which they can experiment with ideas and possibilities. Finally, making a point that will be reiterated by game researchers today, Abt notes that employers would learn more about potential employees if they observed them interact in a multiplayer game, than from having them take a paper-and-pencil test.

While Abt is enthusiastic about serious games, he cautions that games are not going to solve all the problems facing education. He also warns against the "Hawthorne effect" when studying the effectiveness of games; this is when participants in an experiment respond positively to a situation due to the fact that they are being studied, and not because of the experiment itself. In other words, Abt points out that researchers should be careful when deciding whether games are truly effective for learning. Games are, after all, more fun than regular school subjects, and students could very well be responding to a change in their environment, and not to the game itself.

Interlude

Contrary to Aarseth's suggestion, 2001 was not "year one" of games studies. The first meeting of the North American Simulation and Gaming Association (NASAGA) was held at the University of Michigan in 1970; the same university also started a certification program in gaming and simulations in 1981, allowing students to take graduate-level courses in the field (Duke, 2000). In 2000, *Simulation & Gaming: An International Journal of Theory, Design, and Research* celebrated its 30th anniversary. Since the inception of this journal, it has published numerous articles on using games for language learning, business, sociology, international development, and many other subjects (Crookall, 2000). But somehow, this serious game movement made so little impact on education that many aren't even aware it existed. Perhaps, as Crookall suggests, universities were too conservative to embrace the interdisciplinary field of gaming and simulation.

It is also possible that the serious game movement was affected by the political climate of education. In 1983, the National Commission on Excellence in Education published the report *A Nation at Risk*, which described how education in the United States was in decline. In response,

politicians (and many educators) began to push for back-to-basics programs and high-stakes standardized testing (Hillocks, 2002; Janesick, 2001; Kifer, 2001), approaches that left no room for innovations like educational games. It was also in 1983 that the videogame industry suffered a near collapse (Kent, 2001a, 2001b). After an era of growth through the 1970s and early-1980s, the industry had become oversaturated by gaming consoles and third-party game developers, who were releasing poorly designed games.

The industry remained in decline for the rest of the 1980s, until console-makers were able to improve data storage and graphic capabilities. As CDs, and eventually DVDs and Blu-Rays, were able to store more data, videogames became larger in size and more sophisticated in design. Since 2000, the videogame industry has expanded dramatically, becoming one of the most profitable entertainment industries in the world. At the same time, broadband connections were also spreading, making it possible for players from around the world to play in ways that few could have imagined back in the 1980s. By 2000, the first generation of gamers (and still the largest group) was reaching their mid-30's, and the appeal of videogames had cut across all sections of society. The economy was on the rise, and more people were able to afford computers, videogame consoles, high-definition televisions, high-speed Internet access, and peripherals.

Eventually, talk about serious games resurfaced.

Current Approaches to Games Studies

In some ways, the serious game movement has returned to pre-1960 excitement, when scholars provided largely selective, anecdotal, and subjective perspectives on games and education. Many of the more recent contributions recycle familiar arguments: societies are becoming more complex, schools still use outdated methods of teaching, students do not find subject matter relevant to the real world, schools help reproduce societal inequalities, students (in the United States) are losing their competitive edge against students from other countries, and games and simulations allow students to think in terms of systems and design and are fun, motivating, and immersive. The fact that these arguments get recycled does not necessarily make them irrelevant or dismissible. If nothing else, they point out the inherent challenge of changing an entire

educational system that includes people with so many different and sometimes opposing interests at stake.

The line of thinking is logical enough: since videogames are popular, and since players have to learn how to play them, videogames must be doing something right as they simultaneously teach and entertain players. Moreover, players tend not to like games that are too easy; they want to be challenged. What if we could harness this motivation and passion for learning and make it a part of schooling?

Games as Discourse

James Paul Gee has been an influential voice among educational researchers who support using videogames for education. Gee (1996, 2004) has a background in linguistics and critical discourse analysis, and his support of using videogames stems from his earlier research in social literacies, discourse analysis, and the relationship between schools and "fast" capitalist societies.

Gee's work can be situated within the broader movement in literacy research called New Literacy Studies (NLS). In the 1970s and 1980s, this movement developed out of pioneering work by such scholars as Heath (1983), Scribner and Cole (1981), Scollon and Scollon (1981), and Street (1984). Heath (1983) conducted an ethnographic study of families from different ethnic and socioeconomic backgrounds. In comparing the home- and school-based literacy practices of these different families, she argues that children growing up in different families are taught different sets of values, some of which have a better fit with the classroom. For example, literacy practices such as bedtime reading evoke certain kinds of talk sequences (e.g., initiation-response-evaluation) that match classroom practices. Scribner and Cole (1981) studied the effects of literacy on the Vai people in Liberia, focusing on whether there were cognitive differences (with respect to memory, logic, ability to reason, etc.) between literate and non-literate Vai. Their study shows that people use different literacies to accomplish different tasks. Arabic literacy was tied to religious practices, while English was a largely school-based practice. Contrary to earlier studies, literacy itself did not yield any cognitive benefits. Scollon and Scollon (1981) studied the literacy practices of the Athabaskans and English speakers in Alaska, and argued that the different practices created different orientations, or

consciousness, towards the world. As with Scribner and Cole's study, Scollon and Scollon suggest that mainstream (Anglo) English-speaking culture privileges a discourse pattern that focuses on relationships between abstract concepts and ideas rather than relationships between people.

Street (1984) argues that literacies are embedded in structures of power. Unlike earlier literacy traditions that posit literacy as a neutral set of skills (what he calls the "autonomous model"), Street suggests an "ideological model" that draws attention to the political entities that shape, legitimate, and reproduce social relationships through literacy practices. Street defines NLS as:

> ...the recognition of multiple literacies, varying according to time and space, but also contested in relations of power. NLS, then, takes nothing for granted with respect to literacy and the social practices with which it becomes associated, problematizing what counts as literacy at any time and place and asking "whose literacies" are dominant and whose are marginalized or resistant. (Street, 2003, p. 77)

He goes on to caution against imposing one set of literacy practices onto different groups without regard for their cultures. Street's definition reminds us that all literacy practices (including videogames) are embedded within relations of power. As such, videogame researchers, particularly those interested in education, should consider whether their research takes account of what students play on their own.

Gee builds much of his argument around his distinction between "small-d discourse" and "Big-D Discourse." He defines "Big-D Discourse" as "ways of behaving, interacting, valuing, thinking, believing, speaking, reading and writing that are accepted as instantiations of a particular role" (Gee, 1996, p. viii). These Discourses shape how people are expected to behave, and those who are not familiar with them may be marginalized. Schools, for example, tend to represent values that privilege white, middle-class literacy conventions, and consequently, students without this background often have a more challenging time engaging with school literacies. If Big-D Discourse represents the umbrella of literacy practices overhanging our everyday interactions, then small-d discourse represents the actual use of language in any given situation—or how "discourse" manifests itself in our everyday lives. This manifestation occurs not only in conversation, but in any use of language (broadly defined). Gee's method of discourse

analysis draws out these themes and helps us to identify the underlying structures and relations of power that seep into everyday interactions (Gee, 1999).

Gee was also part of the New London Group (1996), a group of literacy researchers who developed a model of "multiliteracies" that encompasses five main modes of communication: Linguistic, Audio, Gestural, Spatial, and Multimodal. They argue that "new multimedia and hypermedia channels can and sometimes do provide members of subcultures with the opportunity to find their own voices" (New London Group, 1996, pp. 70-71). They also argue that educators need to move away from a mono-literacy view that privileges one form of meaning-making (typically the Linguistic) at the expense of the other modes.

From his study of discourse, Gee argues that traditional schooling tends to reflect "old capitalist" forms of learning, where knowledge is decontextualized and pre-packaged and all students are expected to receive the same kinds of information, regardless of their backgrounds and learning styles. This is reminiscent of the assembly-line production of old capitalism. Presently, the advanced technological societies have moved towards "new" (or "fast") capitalism, where change is the norm and workers are expected to learn, collaborate, and share knowledge. Gee, Hull, and Lankshear (1996) refer to this movement as the "new work order," in which there is a growing gap between the managerial class that controls the means of production, and the workers on the factory floor.

These authors note that new capitalism does not represent a complete disconnect from the values of old capitalism; new capitalism merely represents a more accelerated version of old capitalism. This is an important point to consider because we are often so caught up with "new" concepts—"new" literacies, "new" media, "new" technologies, Web 2.0—that it is easy to think of them as isolated artifacts with no history. Gee et al. (1996) point out that new capitalism is rooted in neo-colonial histories, which is caught up in the larger machinery of globalization. The expansion of communication networks technologies speeds up the rate of change and the spread of information, thus making it more difficult for schools and educators to respond in meaningful ways.

Although many of Gee's arguments on using videogames for learning echo what Duke, Abt, and others pointed out decades before, he supports his arguments with research in the learning sciences (Bransford, Brown, & Cocking, 2000), multiple intelligences (Gardner, 1991, 1999), and situated learning in communities of practice (Lave & Wenger, 1991; Wenger, 1998). Building on these studies, Gee (2003) outlines a series of learning principles characteristic of videogames that are often lacking in traditional classrooms. Effective learning allows students to play the role of experts who have to deal with the subject matter, for example, scientists, engineers, mathematicians, historians, and so on. Since videogames require players to "play" a role, games become a good demonstration of how learning can occur in a contextualized, meaningful setting where people learn by doing and knowledge is not isolated into discrete facts but is connected to action.

The learning principles found in videogames seem to fit well with new capitalist values, such as providing "just-in-time" or "on demand" instruction, which caters to what the user needs within a meaningful context. Skills and knowledge are never learned in isolation, but are taught as part of the ongoing action. In addition, Gee (2004) argues that the literacy practices that form around gamer communities—fan fiction (Black, 2008), online forums (Steinkuehler, 2007), etc.—prepare them for activities in the networked world, where ideas are shared, expert knowledge is distributed among different groups, and learning is collaborative.

Games as Metaphor

One of the challenges of building on the games-as-discourse platform is that "games" and "play" are very fertile metaphors that permeate many (if not most) of our activities (Huizinga, 1955). At the same time, the success of "games" as a metaphor can also potentially befuddle the way we apply them to "non-game" situations by hiding aspects of reality that are not covered by the metaphor.

In their seminal work *Metaphors We Live By*, Lakoff and Johnson (1980/2003) argue that metaphors structure our *entire* experience of the world through our use of language. They define metaphor as "understanding and experiencing one thing in terms of another" (p. 5). One example they provide is "Argument is war," in which arguments

are conceptualized using such war-like notions as winning and losing, having a good defense, going on the attack, finding a weak point, and so on. These metaphors are not simply individual shortcuts that we use, but are systematic in nature. In other words, we can point to many different aspects of the concepts "argument" and "war" and find that the metaphor continues to work. We can find a weak point in someone's defense, target that spot, and demolish their defenses; alternately, we can fortify our argument with a solid foundation and find allies to back us up.

Lakoff and Johnson argue that metaphors are "experiential gestalts" (p. 77) that construct and limit our relationship to the world around us by making our experience into "structured wholes." They emphasize that our understanding of the world is based on our concrete experiences of the world. As we experience our world in terms of space and time, our relationship to the world is also structured by these experiences, and this is particularly evident in the words we use to describe the world. For example, we tend to view objects in terms of their spatial properties—*top* of the mountain, *side* of the road, *edge* of the cliff—and spatial orientation—*behind* schedule, *over*seas, *up*coming events. Lakoff and Johnson argue that these are not mere coincidences, but that these (and other) conceptual metaphors actually help us make sense of our everyday lives.

Their theory of metaphors problematizes the rationality of the Western philosophical tradition, specifically in its belief that we can have access to an objective truth. To the extent that our experiences are *completely* shaped by metaphor, how can we argue that we have direct access to "reality"? The only way would be if we were able to step *outside* the metaphor.

We can tie this back to NLS and the emphasis on studying social interactions in context, and think of Lakoff and Johnson's notion of metaphor as a rough equivalent of Gee's notion of big-D discourse, in that we are not able to make a meaningful interpretation of an action, word, or idea in complete abstraction. Just as scholars in the NLS tradition have challenged the autonomous definitions of literacy, Lakoff and Johnson argue that we cannot divorce our concrete experiences of the world from our interpretations of meanings. Consequently, two people from two different cultures might have difficulty understanding

one another, but mutual understanding can be achieved through negotiation of meaning. We can also examine our own understanding in terms of the metaphors we use and compare it to those used by people from a different background.

The idea of "games as metaphor" equips us with a double-edged sword: on the one hand, a careful use of games in educational contexts can help us achieve a gestalt experience of a concept that we might not otherwise be able to achieve through other communication modes; on the other hand, a reckless use of games runs the risk of oversimplifying our understanding of how a system works.

Games as Epistemology

Epistemology—the philosophy of knowledge—is often contrasted with *ontology*—the philosophical study of the nature of being and the categories of existence. These terms have been at the foundation of Western philosophy for millennia, and we will return to them in the next chapter. For now, we will consider them in terms of their relation to educational games.

Shaffer (2007) argues that computers, especially through videogames and simulations, are able to create sophisticated worlds that adequately encompass aspects of our complex world and present them in a way that allows learners to access them in an authentic manner. For him, "epistemic games" are "games that are fundamentally about learning to think in innovative ways" (p. 10). They allow students to think about the domain-specific rules, or epistemologies, that govern any particular environment. Building on Dewey, Shaffer argues that our present way of dividing school curriculum into separate subjects gives students a distorted view of the world.

Shaffer focuses not simply on the pleasurable aspects of games, but also on the subordination of the player to the rules and roles of the game. For example, in a game of debate, students should evaluate evidence based on whether it holds up under the rules of a debate, and not on whether they personally agree with the position the evidence is designed to support. Game rules are domain-specific in that the rules we use in one domain (e.g., science) may not apply in another domain (e.g., everyday life).

Shaffer adds that epistemic games can improve education in the United States and make it more competitive with other countries. While I agree with Shaffer's overall position that schooling can benefit from the use of epistemic games, this approach needs to be used with caution. Lakoff and Johnson (1980/2003) have pointed to the benefit of using computerized models:

> [T]he study of computation models might nevertheless tell us a great deal about human intellectual capacities, especially in areas where people reason and function partly in terms of objectivist models. Morover, current formal techniques in computer science show promise of providing representations of *inconsistent* sets of metaphors. This could conceivably lead to insights about the way that people reason and function in terms of coherent, but inconsistent, metaphorical concepts. (Lakoff & Johnson, 1980/2003, pp. 22, original emphasis)

However, they also caution that metaphors might be comforting to use because they provide our experience with a sense of coherence. Furthermore, they point out that metaphors hide aspects of reality that are not covered by the metaphor and prevent us from seeing the whole picture. Their caution echoes the recent Nassim Nicholas Taleb book *The Black Swan*, which warns us against the epistemic arrogance of models and forecasting. He defines *epistemic arrogance* as "our hubris concerning the limits of our knowledge" (Taleb, 2007). His central thesis is that we always underestimate the effect of uncertainty in our everyday affairs. He argues that, as our knowledge of the world grows, so does our confidence in our knowledge of it but as history tells us, every time we are confident about how the world works, we soon find out that our knowledge needs correction or has become obsolete. Unfortunately, this does not stop us from believing that we can create meaningful models of the world, and leading experts from continuing to make failed forecasts that misestimate the impact of policies concerning war, politics, education, economics, and so on.

Between epistemic games and epistemic arrogance, there is still some room for using games in a manner that can educate players about the epistemological aspects of a specific domain. Just as we can step outside the constraints of a metaphor by negotiating meaning, we might be able to circumvent the dangers of epistemic arrogance by stepping beyond the rules and questioning the nature of the rules themselves. To do so, we can think of games as ideological worlds that are created by designers who communicate their worldview through the system of the game.

Games as Designed Experience

Squire (2006) refers to games as "designed experiences" that embody the ideological positions that game designers incorporate into the game's structure. Videogames, in particular, can express these worldviews through the increasingly photorealistic representations of the environment. The game *Grand Theft Auto*, for example, showcases the turbulent lifestyle of a gangster as seen through the eyes of an African American gang member. Players confront the game designers' ideologies through their interaction with the game's rules—specifically in terms of the choices that players have available and the representations of the characters in the game.

Squire notes that players do not passively experience these ideological worlds, but actively impose their own perspectives on what these worlds mean (Squire, 2008). Based on discussions with some players of *Grand Theft Auto III*, he notes that players with different backgrounds have different readings of what the game means. A group of African American, working-class high school students found the game's representation of poor blacks working their way out of a gang life and moving into the suburbs to be unrealistic. They also found it unlikely that players can learn about real-life violence simply by playing the game, especially since these students have to confront violence in their real lives everyday. In contrast, a group of white working-class high school students were more interested in demonstrating their encyclopedic knowledge of the game—its plot, characters, mission—and voiced concern over racial stereotypes. Clearly, these two groups of players were experiencing different aspects of the game, and interpreting its representations in contrasting ways, even though they were all playing the same game. Squire refers to these different groups as "interpretative communities."

Squire (2006) also distinguishes between two types of games—exogenous and endogenous. In *exogenous games* content is extrinsic to game play. In trivia games, for example, content is interchangeable. We can design a trivia game that tests either one's knowledge of Shakespeare or one's knowledge of geography or English grammar. This kind of game often offers its content as isolated bits of knowledge or skills that are not related to any context. In contrast, in *endogenous games* content and context are interrelated and intrinsic to the game. These games tend to

model complex worlds where players can experiment with their prior knowledge and expectations, and where skills are used to solve problems within a context meaningful to the game.

This distinction between exogenous and endogenous games emphasizes the challenge of not only implementing games in classrooms, but implementing the *right* games. While most teachers have probably used games in their classrooms, it is likely that many of these were exogenous, trivia-like games because they fit into the school's structure of interaction. If the worldwide popularity of game shows and competitions on television is any sign, these exogenous games tend to generate a great deal of excitement among players. Exogenous games are easy for teachers to implement and are reusable for different topics throughout the year. They are also efficient, because students won't have to relearn the rules for each new game. Most of us know the general concept of *Jeopardy!*, and we can probably set up a similar game in a relative short period of time. But, setting up a well-thought-out history game that teaches players about the complex relationships between the social, political, and economic factors that contributed to World War II is an altogether more challenging undertaking. In addition, exogenous games are a better fit in most of today's schools because they are easy to assemble and dismantle. In an already tightly packed curriculum where time is precious, endogenous games are difficult to implement, especially when the best way to learn is often through failure, or losing the game. The feedback in exogenous games tends to be quick, almost immediate: your answer is either right or wrong. As Duke (1974) points out, it can take a lot longer to figure out the complex relationships in an endogenous game, and each iteration of the game can take hours, if not days, to complete.

Leander (2007) notes that it is often difficult to implement new technologies into classrooms because they entail a different spatial and temporal configuration that runs counter to the structure of traditional schools. As an example, Leander argues that teachers who are used to having control over the distribution of knowledge and the interactional order of a traditional classroom (i.e., where the teacher facilitates the conversation) might resist technologies that redistribute their control. This echoes the difficulties that Scollon and Scollon (2004) documented in their description of the early use of the Internet in a university setting.

Exogenous games leave teachers in control, because they can choose when to start and finish the game, what content to use, and which players participate. Endogenous games—especially videogames—tend not to be easily customizable; those that are tend to be time-consuming and require a relatively high level of technical (or programming) knowledge. As Leander points out, teachers and administrators tend to expect technologies to fit into their structure, instead of working around the new possibilities opened up by the reconfigured social organization.

That is not to say that future games cannot be designed to allow for easier configuration. Some games allow customization (e.g., *Neverwinter Nights*, *Civilization* series), but these customizations are still relatively complicated and time-consuming for a novice to use. It would be useful for game designers to understand the realities that teachers face in the classroom, and for teachers to understand the distinction between endogenous and exogenous games, and why it might be worthwhile to implement more endogenous games into their lessons.

The Future of Educational Gaming

Even though videogames today are considerably more complex, there is no reason to dismiss the earlier studies on games, especially since their perspectives on games and learning overlap significantly with the arguments made by scholars today. If educational gaming is to advance, researchers need to go beyond the rhetoric of simply asserting that games are good for learning and back up their beliefs with empirical evidence.

As a fan of videogames myself, I am often torn between wanting to share my enjoyment of games with everyone around me and accepting that perhaps not everyone enjoys videogames. In other words, to state the obvious, videogames, just like any other medium (e.g., books, radio, television, film), will never have universal appeal. Just as some students do not respond well to language-centered texts, some students will not respond to games and simulations.

Even gamers themselves do not enjoy all genres of videogames. Some enjoy fighting games, and will never sit through a role-playing game; some prefer MMOGs, and will never bother with a strategy game. Game researchers get into the bad habit of making blanket statements that lead people to think that all videogames (or, at least, all well-

designed videogames) will appeal to everyone, when that is hardly the case. Gamers are among the most outspoken critics of videogames; in spite of the considerable technological advances over the decades, videogames still make use of certain stale conventions and narrative clichés, which gamers do not hesitate to point out (do an Internet search for "videogame clichés" for a sampling). Videogames are products that need to sell in the market, and it is in the interest of game designers to listen to gamers' feedback and try to incorporate their suggestions.

Many of the most prolific researchers come from a game design perspective, and hence, many studies of educational gaming have focused on design (Stevens, Satwicz, & McCarthy, 2008). While design is certainly important, overemphasizing design risks putting the cart before the horse, especially since there is still a lot we do not understand about how players learn to play and how they interact with one another. As Squire (2008) notes, there is still a lack of ethnographic research that focuses on player interaction. Furthermore, relatively little attention has been paid to address the impact of socioeconomic status on players and gameplay behavior (Andrews, 2008; Hung, 2010). Such qualitative research might allow us to improve on design in the future.

In addition, there are many videogame genres, including the most popular ones, which remain underrepresented in research literature. According to a recent poll conducted by the Pew Internet and American Life Project (Lenhart, Kahne, et al., 2008), only 10 percent of the teens interviewed said they visit virtual worlds (e.g., *Second Life, Gaia*) and only 21 percent said they play MMOGs (e.g., *World of Warcraft*); instead, most of them (65 percent) said they play games with players who are in the room with them (as opposed to playing over the Internet). Many other popular genres, such as racing games (74 percent), puzzle games (72 percent), sports games (68 percent), action games (67 percent), adventure games (66 percent), and fighting games (49 percent), get comparatively little representation in research, especially from educational researchers. In a follow-up study with adult gamers, only 2 percent reported visiting virtual worlds, and 9 percent report playing MMOGs (Lenhart, Jones, & Macgill, 2008). Perhaps researchers believe that MMOGs and virtual worlds have greater potential in demonstrating collaborative learning and social interaction, or perhaps researchers gravitate toward genres they are familiar with.

Discussion

I share Lemke's (2006) position that we need to understand the "meaning-making practices people employ in these complex virtual environments" (p. 11). Lemke proposes that researchers should address issues such as the following: how players communicate with one another in-game and in real-life, how meanings accumulate across multiple gaming sessions, how players integrate artifacts and features of the place to make sense of the game, and how meaning-making in real time differs from meaning-making through a static text. In addition, researchers should also look at how players communicate and collaborate with other players during the game, how players integrate in-game meanings and activities with their out-of-game identities, and how gaming activity and meaning-making practices differ according to a player's gender, cultural background, social class, etc.[1] In this book, I have taken these suggestions seriously and tried to shed some light on how players interact with the game as well as with one another *through* the game; I have also looked at their behavior across gaming sessions and across different games (within the same genre). This book focuses on fighting games, a genre that I personally do not gravitate toward in my free time. (I prefer real-time and turn-based strategy games, role-playing games, first-person shooters, action games, adventure games, survival horror, and simulations.) Consequently, I believe that my unfamiliarity with the genre enabled me to approach fighting games with fewer preconceived notions of what behavior during these games ought to look like.

• CHAPTER THREE •

Situated Orders
Ethnomethodology and Conversation Analysis

You can observe a lot by watching.

—Yogi Berra

The underlying question this book tries to answer is: What are the methods of meaning-making that players use to make sense of videogames? Here, methods refer not only to data collection methods, but the methods that people use in their everyday lives to understand their world, including the direct and indirect interactions they have with people, artifacts, machines, and the physical world in general.

This chapter introduces the reader to the theoretical approach used for this study—ethnomethodology—as well as its related analytic tool—conversation analysis. Ethnomethodology can be difficult to grasp, both for its commonsense and practical approach and its contrast with traditional social scientific methods. As a way of explaining ethnomethodology, this chapter provides the broad theoretical context from which ethnomethodology emerged and went on to influence other disciplines of study.

Theory and Practice

Ideally, social theories are used as lenses through which to see and interpret the world. These theories should not only tell us how the world works, but also what we can do to effect change in areas of inequity. In sociology, theories are used to explain macro-level influences, sometimes

referred to as social structure, social system, and so on. These theories are meant to explain why societies work the way they do and answer questions such as: How do societies exist? How do they perpetuate themselves? What causes inequalities? Why do people tolerate these inequalities, and so on.

However, overrelying on social theories to tell us how the world works creates a few problems. First, it often assumes that individuals, particularly those who are perceived as "victims" of the system, are unaware of their circumstances, and that the role of the researcher is to point out these circumstances to them. Second, it runs the risk of selective evidence, in which researchers collect the evidence that fits the theory and disregards those that don't. This creates a problem of circular reasoning, in which the theory can never be disproved. Finally, it leads to a chicken-and-egg problem: Does the social structure determine micro-level, everyday action, or do everyday interactions shape macro-level phenomena?

Ethnomethodology was formulated by Harold Garfinkel as way of addressing some of these issues. It is usually considered somewhat of a black sheep within sociology, as it does not follow the traditional methods of study and analysis. The main premise of ethnomethodology is that social order is not an invisible force acting as puppet masters to members of society; instead, it is something that manifests in everyday, mundane interactions, and are *observable-and-reportable*, not only to the researcher, but to all members of society. It assumes that social order is what people construct through their interactions with one another. As such, the role of the ethnomethodologist is to study how people perceive order and meaning in their lives and to describe these empirically observable methods.

The Nature of Reality

As mentioned in Chapter One, *epistemology* (the study of reality) and *ontology* (the nature of reality) are concepts that have preoccupied Western intellectual history, in some form or other, for over two millennia, and continues to resurface in studies in philosophies of science and theories of knowledge. In more layperson terms, epistemology has to do with finding ways to explain the natural world in terms of natural laws, a concern that was asked by the pre-Socratic philosophers

(Wheelwright, 1966). Thus, instead of explaining phenomenon by pointing to supernatural forces, these early philosophers sought to find universal laws that could explain causality in nature. Ontological questions have to do with the nature of categories and ideas; in other words, that there are "real" objects in nature that can be meaningfully studied and explained. These include objects such as atoms, molecules, cells, gravitational pull, electromagnetism, strong and weak nuclear forces and more familiar concepts such as culture, identity, motivation, attitude, social forces, and so on. These categories are important for researchers because they shape what researchers are able to study and, more crucially, what they are able to meaningfully discuss. In our everyday lives, most of us take these categories for granted and assume that they exist in "reality." To use an example, the notion of "species" remains a debated concept among biologists (Wilkins, 2009). This does not necessarily mean that the concept of "species" does not exist in reality, but that there is disagreement among biologists about certain aspects of the classification system. At the same time, this does not stop them (and us) from making perfectly meaningful statements about particular animal species, their habitats, breeding habits, behaviors, and so on. Whether species is a "thing" that exists in reality is an ontological question, one that scientists continue to grapple with today. Up until relatively recently, not all scientists assumed that their study had direct correspondence with reality. Early scientists (or natural philosophers, as they were known at the time) were typically more interested in practical applications of their ideas, and did not insist that their models of the physical world represented actual reality.

However, there continues to be a fine line between using categories as a convenient way of referring to a set of ideas and reifying it (i.e., making it real) as an aspect of reality. Although scientists do their best to ensure that this distinction is clear, it is not always easy, especially when studying aspects of reality that are invisible or otherwise inaccessible to our senses. In some cases, we can access these aspects of reality using instruments, such as telescopes, microscopes, particle accelerators, CAT scans, and the like. But even in these cases, scientists are often still concerned about whether biases have been built into the machines themselves, and are telling us aspects of reality that are, in fact, not real.

The relationship between the natural sciences (i.e., physics, biology, chemistry) and the social sciences (i.e., sociology, anthropology, psychology) is an uneasy one, much like neighbors who usually respect one another but nonetheless don't like the other to trespass on their lawns. However, the fact that they share a common root (the "science" part of their discipline) means that these trespasses are inevitable. Occasionally, a concept developed in the natural sciences becomes an analogy for a concept in the social sciences, such as the influence of the principles of thermodynamics on Freud's theory of the unconscious, or Darwin's notion of the survival of the fittest on Marx's theory of class struggle. The social sciences have often been criticized for being too subjective and ideological, and many attempts have been made to make the disciplines more objective. Within sociology, one of the major efforts in restructuring the field came from Talcott Parsons.

Theories of Society and Social Action

The Social System

Talcott Parsons was a major influence in American sociology from the 1930s to the 1970s. His key contribution was an elaborate and ambitious attempt to describe a coherent and encompassing theory of society, ranging from the macro, institutional level (e.g., economy, government, schools) all the way down to the level of individual mental processes (Parsons, 1937, 1951, 1961). His theory is generally put under the *structural-functionalism* school of thought, which envisions a society as a system, with separate interdependent subsystems. A key part of these systems is that they are self-regulating and tend toward equilibrium; that is, if an external force throws the system out of balance, the system will eventually correct itself and return to a state of equilibrium over time.

Parsons believes that social order is maintained by the internalization of the society's values through institutions such as families, schools and governments. As such, behaviors that disrupt the balance are seen as momentary deviations from the norm that would be corrected by systemic mechanisms. Just as mechanical laws can be used to describe the universe, Parsons believes that social laws can be used to describe societies. This means that he was seldom interested in what actions individuals followed in particular circumstances or how they interpreted

their circumstances (Heritage, 1984). His primary concern was the function that individuals fulfilled within the larger societal structure.

Parsons argues that the role of a science is to create theoretical frameworks from raw data (Parsons, 1937). Just as physicists are not studying how *specific* objects interact with one another but how laws can explain all motion throughout the universe, Parsons was interested in empirical observations insofar as they helped build his theory of the social system.

His overarching theory was criticized on several fronts. One criticism was the Western bias in his theory of an ideal modern society, which often used the United States as an ideal model. His decline in popularity might also be attributed to the reaction against grand theories of society in the 1970s in favor of more local, microsociological approaches to social interaction. Another criticism, and one more relevant to our discussion here, is his treatment of individuals' actions in subjugation to the larger social system. Heritage (1984) points out that this treatment puts the researcher in the position of an ideal observer that is always right. That is, when individuals act according to the norms of society, they are functioning to maintain the social order; when individuals do not act according to the norms of society, they are either being irrational or they were poorly socialized; thus, either way, the model can never be disproved by real-world data. Such treatment of individuals means that any theory of society is right because we only focus on positive (affirming) evidence when people cohere with our expectations of the social structure.

Social Theory and Videogames

Before moving onto Garfinkel's response to Parsons's social system, I want to address a possible question some readers might have: What does social theory have anything to do with videogames? I see at least two connections.

First, there is something orderly about the grand theories of society that makes them particularly easy to program into a game's design. For example, Parsons's social system with interdependent subsystems applies to many historical strategy games such as the *Age of Empires* series, *Dawn of Discovery* (a.k.a. *Anno 1404* outside of the United States), the *Civilization* series, and the recent, less successful incarnation of the

SimCity series, known as *SimCity Societies*. In *Dawn of Discovery*, for example, players have to balance the development of social, economic, political and military structures and the accumulation of natural and financial resources. Inhabitants require food and housing, and as they upgrade from peasants to citizens to patricians, their maintenance needs and demand for goods change. The production of different goods have their own supply chains—for example, the production of books requires the availability of printing house, indigo farm (for ink), paper mill, and lumberjack's hut. Each part of the supply chain has its own supply chain, resulting in a complex economic system that needs to be carefully adjusted, particularly in response to external forces, such as the depletion of raw materials or war. *SimCity Societies* resembles Parsons even more in that the goal is to balance between different "societal values"—such as productivity, creativity, spirituality, and so on—each represented by different types of buildings. Thus, a well-balanced city is one that has the right number of buildings functioning to fulfill a part of the larger structure. Finally, games like the *Age of Empire* series or the *Civilization* series follow a linear historical progression much like the one outlined by Parsons (1971) in *The System of Modern Societies*, in which he describes the progression of ages, from the pre-modern age (with the development of law and division of labor), to the age of revolutions (industrial and democratic), to the "new lead society," with the United States as the prime example. Games like *Age of Empires*, as the title suggests, quite literally puts the player through different ages of civilization, and reifies the linear progression of history from primitive to the modern era. In *Age of Empires II*, for example, players can advance through four historical ages—Dark Age, Feudal Age, Castle Age, and Imperial Age—each having its own unique set of units and technologies. Likewise, in *Civilization V*, players can advance through seven eras—ancient, classical, medieval, renaissance, industrial, modern, and future—once they achieve the right technological advances.

Second, game researchers themselves have used Parsons-like notions to describe player behavior, particularly in online games. Most notable is Richard Bartle's (1996) description of the four types of online players—achievers, socializers, explorers, and killers—each of whom have their own priorities during play. Achievers are helpful players who try to help others accomplish their tasks; socializers are more keen on talking and

discussing issues that may or may not be pertinent to the game; explorers are interested in finding out the details of the game and how the system works, and killers are prone to antisocial, destructive behavior towards other players. Bartle suggests that "A stable MUD is one in which the four principal styles of player are in equilibrium" (n.p.). As new players arrive, each with the own interests, the equilibrium shifts. Bartle argues that, in order to put the system back into balance, designers of virtual worlds can insert facilities that add new functions to the game. For example, adding more communication functions to appeal to socializers, or expanding the size of the world to appeal to explorers, and so on.

It remains uncertain whether we can draw a direct and deterministic relationship between a game's design and its players; or, in other words, to assume that players' behaviors can be shaped simply by altering the game's design alone. This view would be analogous to deterministic grand theories of society, in which a society's values and structures are reproduced through various mechanisms and institutions, regardless of what individual social actors do. In this sense, the game's design and rules are similar to a society's structure. Grand theories of societies have been challenged by social scientists, who argue that individuals do have agency and are able to resist oppression and react against structure in unpredictable ways. Likewise, game designers acknowledge that players often interact with the design in unexpected ways (Rouse, 2005). In fact, this unpredictability is often what makes videogames so dynamic and interesting for different players, who are able to approach the games from various backgrounds and come away with their individual interpretations.

The Ethnomethodological Response

Garfinkel was studying under Parsons during a time when sociology was relying heavily on quantitative methods to generate theoretical models of society (Rawls, 2002). Although Garfinkel's dissertation and subsequent research program diverged from Parsons's conception of society, there were many overlapping points. For Garfinkel, social order existed not as internalized norms and roles, but as everyday, mundane practices. In other words, while Parsons found concrete instances of individual behavior uninteresting, Garfinkel found it highly significant in informing us on how social order is constituted on a moment-by-moment basis. (In

an oft-cited analogy, Garfinkel suggests that the approach that traditional sociologists use is akin to studying what holds up the roof of a house by ignoring the very walls that hold them up.)

Garfinkel and ethnomethodology can be a bit of an acquired taste (Lynch, 1993). Although Garfinkel has been academically active, up until relatively recently, a considerable part of his work remained unpublished and was only circulated among his students and followers. His writing style is also a bit unconventional, often containing paragraph-long sentences and complex concepts, making them hard to follow. But his key point is simple: To understand why people do what they do, we should observe and follow their methods.

The term "ethnomethodology" is borrowed from the social anthropology's notion of "ethnosciences," or the study of local ordering and classification method (Lynch, 1993). For example, "ethnobotany" is the study of how different cultures study and classify plants according to local practices, customs, and practices, which lead to taxonomies different from those used by botanists. Consequently, ethnomethodology refers to "member's methods," or the methods that people use to maintain order and coherence for themselves and for others interacting with them. As such, ethnomethodology flips Parsonian social order on its head by studying how people come to see their environment as "orderly." (Dourish & Button, 1998).

At this point, it might help to lay out some basic concepts in ethnomethodology: order, accountability, indexicality and contingency.

Order

Garfinkel conceives of order as the underlying pattern that organizes the way we perceive any given situation. To start with a simple example, consider these numbers: 2, 4, 6, 8, 10, 12. If asked to predict the next two numbers, some might suggest "14, 16" to be the logical progression, using the "rule of even numbers" as the underlying pattern to these numbers. However, the rule could just as easily be "any number under 100" or "any positive number." In fact, there are an infinite number of rules that can apply to these numbers, even though most people are likely to consider "even numbers" to be the underlying pattern.

Likewise, Garfinkel believes that people look for evidence of pattern, using what he terms the "documentary method of interpretation." That is, we look for positive evidence that supports an underlying pattern and

ignoring negative evidence that do not fit in with the pattern. Garfinkel (1967/2008) devised a series of breaching experiments, which are experiments designed to disrupt the underlying order and reveal the assumptions people bring to the situation. In one of his experiments, participants were asked to pose questions yes/no questions to a counselor and, after receiving the response, participants were asked to articulate what they thought of the responses. Unbeknownst to the participants, the counselor was given a predetermined ordered list of "yes" and "no" responses to be used regardless of the question posed. Interestingly, all the participants were able to interpret the responses they received as adequate, meaningful responses to their questions, even when the responses contradicted with one another. Some of the methods they used to explain contradictions were to say that perhaps the counselors gained new insight over the course of their exchange, and so the contradiction wasn't so much a contradiction as it was a correction in light of new information. In other words, the response was always treated meaningfully as "an answer to a question," even though no such intention existed.

Accountability

If any given situation is open to endless interpretations, how do we avoid being crippled by incoherence and misunderstanding? Garfinkel posits that individuals have to assume and ensure that the people are "on the same page" as they are. Most of the time, if we are interacting with another competent member, we can proceed with the interaction with little trouble. Here, "competent member" refers to someone who knows how to interpret the situation in a way similar to you. This notion of competence approximates what Gee terms as "Discourse," or "way of knowing." For example, two professional mathematicians will be able to understand one another relatively easily since they understand the rules of their discipline, whereas laypersons would have a much harder time understanding the mathematical arguments.

Garfinkel demonstrates that our assumption that another competent member shares our point of view is so ingrained that any disruption can lead to rapid breakdown in communication. As Garfinkel (1967/2008) writes: "Persons require these properties of discourse as conditions under which they are themselves entitled and entitle others to claim that they know what they are talking about, and that what they are saying is

understandable and ought to be understood" (pp. 41-42). The orderliness of everyday action has to be accountable in a way that is "observable-and-reportable" to any competent member (Lynch, 1993) and not something that only occur in people's heads. In other words, this order is not simply part of an invisible "social structure" that only an ideal observer can see. As Koschmann, Stahl and Zemel (2002) point out, "it is not acceptable to offer descriptions that depend on analyst-imposed categories as accounts for what participants do or don't do" (p. 138). Thus, the role of the researcher is not to explain members' actions according to *a priori* (predetermined) concepts, but to describe how members account for their actions and achieve coherence through their interactions. Moreover, this means that when the assumed order is disrupted, there are observable attempts made to restore understanding and coherence.

Significant insight into the accountability of order comes from instructed actions, which has been a focus in Garfinkel's studies (Garfinkel, 2002; Koschmann, Stahl, & Zemel, 2007). Instructed actions are instances when members make accountable to one another the underlying assumptions of order and meaning. As Garfinkel and Sacks (1970) describe, "The interests of ethnomethodological research are directed to provide through detailed analyses, that account-able phenomena are through and through practical accomplishments. We shall speak of 'the work' of that accomplishment in order to gain the emphasis for it of an ongoing course of action" (p. 342). The fact that underlying order can be described and accounted through instructed action sets ethnomethodology apart from the Parsonian move that subordinates individuals' perception of their circumstances and treats individuals as "judgmental dopes" whose only roles are to fulfill a function of society (Garfinkel, 1967/2008).

Indexicality
In linguistic terms, indexicality, or indexical expressions, refer to words that have to be understood within the context they were uttered (Heritage, 1984). The clearest examples of indexical expressions are deictic markers such as "I," "you," "this," "that," "here," and "there." For example, the phrase "I like that" is meaningful only if we know what "that" points to or who "I" is. However, Garfinkel points out that even nondeictic markers are indexical and cannot be fully "objective." In the

example, we do not know for sure what "like" means, whether it is meant ironically or in some other way. Indexicality extends to nonverbal actions as well. We cannot fully understand whether the meaning of a gesture—such as a punch on the shoulder—is meant as an act of aggression or playfulness or simply an accident. As such, all communication is indexical in some form and requires that we have the competence and context to understand its relevant meanings.

The issue of indexicality of language means that no statement can fully elaborate all possible meanings available. Suchman (2002) suggests that "deictic expressions, time and place adverbs, and pronouns are just particularly clear illustrations of the general fact that all language, including the most abstract or eternal, stands in an essentially indexical relationship to the embedding world" (p. 79). The way we communicate with one another, whether it is directly through conversation or through an interface like a computer, our interactions are embodied in a real, empirical world to which we are oriented.

Contingency

Closely related to order and indexicality is the notion of contingency. If any given situation is open to interpretation, we must have to continually proceed on the basis of imperfect or incomplete information, and constantly repair our understanding along the way, much like the participants in the counselor advice breaching experiment. Koschmann et al. (2007) write that "actors are faced with what others are doing and must select which fragments of the other's conduct and its context to consider in inferring the sense of the actions under consideration. The only requirement that actors themselves place on their sense making is that it be adequate for the purposes at hand" (p. 137). When we interact with another person, we don't know for sure that they understand us *exactly* the way we want them to, but we have to assume that they are, and, over time, gradually adjust and repair one another's understanding. This means that *context* is something that has to be maintained and renewed on a moment-by-moment basis (Heritage, 1984; Schegloff, 1996b).

The notion of contingency challenges the idea that people rely exclusively on preformed cognitive plans to solve problems or resolve conflicts. As Suchman (2002) suggests, while these plans serve as resources, due to the indexicality of the language of description, they are

always too vague to fully account or aid us in solving the immediate problem at hand. Lynch (1993) and Suchman (2002) compare this with Turnbull's (1993) study of Gothic cathedral builders, who were able to construct magnificent structures with precision and without the benefit of architectural blueprints. Instead of relying plans, the builders resolved their issues using techniques such as *bricolage* that helped them with the immediate task at hand.

Here's another example that might be more familiar. Cooking recipes are, essentially, step-by-step instructions that help you create a particular dish. These instructions are written in an "objective" fashion, with steps such as "Add ½ tbs salt" or "Dice onions." However, these steps are never able to fully describe all the possible contingencies that a possible instruction-follower might confront. For any given recipe, some of the contingencies you might face include the type of saucepan (different ones distribute heat differently), the quality of produce, the humidity and air pressure of the setting (water boils at different elevations), the type of stove, the precision and size of the oven, and so on. The recipe can also vary in its level of detail, for example, specifying sea salt instead of table salt. Thus, many recipes often require that the cook have the competency to understand various techniques and cooking essentials—for example, that there are many kinds of salts, and that table salt is not as good as sea salt or Kosher salt for cooking. The recipe serves as a resource for the cook to use, but a cook still has to deal with any number of issues that might come up that could change the process and outcome of the dish.

Koschmann et al. (2007) point out that "[the contingency] policy highlights the need for a *sequential analysis* of interaction…that is an analysis of how instruction is produced within an unfolding stream of interaction" (p. 137, original emphasis). This implies that individuals' actions need to be studied *as it occurs in time*, as opposed to through post hoc analysis via interviews or questionnaires. A large body of ethnomethodological studies comes from conversation analysis (which we discuss later), which studies naturally occurring interactions gathered through tape recordings. Such descriptions ought to be "presented in a way that readers can decide for themselves whether or not to believe the ethnographer's account of what it is that a particular group of people is doing at any given time" (McDermott, Gospodinoff, & Aron, 1978, p. 245).

Studies in Ethnomethodology

There's an Internet meme that goes something like this:

1. Formulate a plan.
2. Execute the plan.
3. ??????
4. Profit!

The original aim of the meme pokes fun at dot-com ventures that come up with ill-conceived or questionable ideas and try to gain profit from them without first coming up with a coherent business plan. Over the years, this meme has evolved to refer to anyone who tries to become (in)famous using the Internet as a vessel to distribute their ideas in an attempt to create a viral campaign. While variations of this meme include additional steps, the last two are always the same: *??????* and *Profit!* This meme can be used to describe many studies as well—including many studies of the effects of videogames—that focus exclusively on input and output variables and fail to examine the actual processes at work. Latour (1987, 2005) referred to this as the "black box," which is a phenomenon that we understand only through input- and output-processes. Much of the goal of ethnomethodological studies is to unpack the *??????* and find out how these processes work.

Lynch (1993) puts studies in ethnomethodology into two overlapping categories: workplace studies and conversation analysis (CA). Work, in this context, refers broadly to the practical matters of mundane action that people conduct and manage on an everyday basis. These studies often unfold in workplaces, such as airports (C. Goodwin & Goodwin, 1996), research labs (Latour & Woolgar, 1986), observatories (Garfinkel, Lynch & Livingston, 1981), and factory floors (Kleifgen, 2001). Participant observation is often employed to gather data on how individuals orient themselves to their work. CA is often used in conjunction with participant observation in workplace studies. However, many CA studies have diverged significantly from its roots in ethnomethodology and developed into its own program of study that focused more on the technical description of interaction and not on how these descriptions exhibit orderly accounts of members' competences (Heritage, 1984; Rawls, 2002; Seedhouse, 2004).

The following sections describe three ethnomethodological studies of work: Hugh Mehan's study of classroom interaction, Lucy Suchman's study of human-machine communication, and Marjorie Goodwin's study of playground games. These studies have been selected both for their relevance to the theme of this book as well as for being exemplary studies in their own right.

Learning Lessons

At a time when classroom research was restricted to the analysis of input and output variables, Mehan (1979) used ethnomethodology to describe the social organization of instruction between teachers and students. Most classroom research at the time tend to treat humans merely as variables in the larger educational system, whose individual lived experiences did not factor into researchers' designs. Mehan's goal was to study the lived processes of education and describe the routine, everyday events of classrooms and lessons.

Time plays a crucial role in the overall structure of a lesson. Lessons are sequentially and hierarchically organized. Lessons have a setup, an opening, a series of activities and a closing. In each of these segments, teachers and students are managed in slightly different ways. For example, openings and closings are typically similar, with a teacher providing a monologue that either summarizes the lesson to follow or wraps up the preceding lesson. In between these two segments, students and teachers engage in various forms of interactions, during which teachers make an elicitation and students provide some kind of response, such as agreement/disagreement (choice elicitations), an answer (product elicitations), an opinion or interpretation (process elicitations) or line of reasoning (metaprocess elicitations).

Interaction sequences are bound by the Initiation-Response-Evaluation (IRE) format. That is, the teacher initiates a question, the students respond, and the teacher evaluates the response. Note that the evaluation does not necessarily have to be an actual "Good job" response. If the teacher moves on to ask a new question, then an affirmation of the previous question is assumed; if the teacher repeats the question to another student, then an incorrect response is assumed.

What is fascinating about these different structures of organization is not simply that they exist, but that all participants in the interaction are

aware of the structure and take time to amend it if an expected interactional sequence does not occur. Mehan refers to the organization of classroom interaction as a turn-allocation machinery, in which the participants know who should be talking at any given time. Not only do teachers allocate these turns, but students themselves know when they should or should not be talking and take the time to make note of that when a sequences goes off its expected routine. The order of the classroom is bound by tacit rules of interaction. These rules do not have to be explicitly mentioned, but are adhered to over the course of the interaction. Mehan notes that these rules manifest implicitly through statements by the teacher, such as "Raise your hands if you know..." or "Can someone tell me...?" These statements serve to communicate to students when a turn-allocation is about to change and how the students are expected to respond. In other words, the rules *are* the order, and this order represents the underlying organizational pattern of the classroom.

Understanding the social organization of a classroom is part of having the competence of being a member in that classroom. This is particularly important when working with individuals from a different cultural background, who might not necessarily understand the IRE format in an instructional context. Mehan writes that "treating culture as human productive practices makes competence interactional in two senses of the term. One, it is the competence necessary for effective interaction. Two, it is the competence that is available in the interaction between the participants" (p. 130). This is related to how context is seen as both renewing and shaping the interaction on a moment-by-moment basis (Heritage, 1984). These interactional rules create the context that makes an interaction into a classroom interaction, as opposed to a regular conversation with a friend.

Human-Machine Communication

Suchman's (1987, 2002) study of human-machine interaction created new possibilities for ethnomethodology and workplace studies. In her research, participants were organized into pairs and given a set of tasks to finish at a photocopier (e.g., make copies, collate, staple, etc.), and the participants had to rely on the instructions provided by the photocopier in order to complete these tasks. Suchman treats the machine instruction as part of the conversation sequence and locates the source of

communication breakdowns between people and machines at the point where these is a mismatch between what the machine doing and what the people think it is doing. Her work notes the importance of the indexicality of language in human-machine configurations. She writes that "because the significance of an expression always exceeds the meaning of what actually gets said, the interpretation of an expression turns not only on its conventional or definitional meaning nor on some body of presuppositions, but on the unspoken situation of its use" (2002, p. 79). While two people in communication can ensure the mutual intelligibility of their interaction through constant repairs and clarifications, it is a lot harder to check on mutual intelligibility with a machine. In the design of her study, she displayed the resources available to both the users and the photocopier (i.e., the machine instructions, the users' actions), the resources available only to the users (i.e., their conversation with one another), and the resources available only to the machine (i.e., the design rationale, or the plan that guides the machine's actions).

Suchman notes that the photocopier's designers "tacitly relies on certain conventions of human conversation. Most generally, designer and user share the expectation that the relevance of each utterance is conditional on the last; that given an action by one party that calls for a response, for example, the other's next action *will be* a response" (p. 145, original emphasis). From the user's point of view, the system's response usually tells her whether the last action was done correctly and what the next action ought to be. If the machine provides the next instruction, the assumption is that the last action was completed successfully; if the machine provides no instruction (where one is expected), then the assumption is that the last action was not completed correctly. However, if the machine repeats an instruction, it becomes unclear whether the machine is telling user to (a) repeat the last step; (b) restart the procedure (i.e., an error has occurred that causes the machine to return to its original state); or (c) that the previous step was improperly carried out and needs to be remedied. Since (b) is rare in human interaction, Suchman argues that most users try to fix the situation by assuming (a) or (c). The only time (b) might occur between humans is when there is some kind of interference (e.g., telephone static), where one party thinks that the other did not hear a greeting or question and repeats it.

•CHAPTER THREE—SITUATED ORDERS• 47

Suchman's study critiques cognitive studies and artificial intelligence (AI) theories. She uses the example of ELIZA, the famous AI program that was built to provide therapy advice to people. Building on Garfinkel's breaching experiment, Suchman points out that people use the documentary method of interpretation to make sense of what the machine is trying to communicate. Essentially, just like the counselor giving predetermined yes/no responses in Garfinkel's experiment, such programs rely on people's tendency to look for the "evidence of order" in finding sense in ELIZA's responses. In a later edition of her book, she extends this study to other AI interactions and argues that humans make meaning in the locally produced contingencies that AI programmers cannot anticipate ahead of time. Suchman (2002) also criticizes cognitive science's planning model of action. Plans are much like architectural blueprints for problem solving, with the assumption that people have cognitive plans in their heads that they follow in order to resolve a problem. She argues that:

> Our imagined projects and our retrospective reconstructions are the principal means by which we catch hold of situated action and reason about it, whereas situated action itself, in contrast, is essentially transparent to use as actors. The planning model, however, takes over our commonsense preoccupation with the anticipation of action and the review of its outcomes and attempts to systematicize that reasoning as a model for action while ignoring the actual stuff, the situated action, which is the reasoning's object. (pp. 60-61).

In other words, the planning model of cognition tries to create abstract models of action by ignoring the contingencies of particular contexts. Instead of ignoring these contingencies, Suchman suggests that we study *how people deal with the contingencies* and use them as part of the problem solving methods.

As with many ethnomethodological studies, Suchman's work looked at occasions of "trouble," in this case, communication breakdowns. Such instances serve as moments when the underlying pattern that people assume to exist become more transparent to the researcher (and to the people in the interaction) and allow us to see how and why this order was assumed. She describes two basic forms of communication breakdowns. With *false alarms*, the user finds evidence of error where none exists. She describes two people trying to make five double-sided copies. What they should have done was to make five single-sided copies, then feed it back into the machine to make the next side (the

original study was conducted in the early 1980s, when photocopiers were not as sophisticated as they are today). Instead, the users had made one copy, and thought they had made a mistake, even though they did not. From the point of view of the photocopier, no mistake was made and so no instructions were given to fix the problem, leaving the users stuck to figure out what to do next. The communication breakdown occurred, in this case, because of a confusion regarding the ultimate goal of the action. The humans understood the end goal to be five double-sided copies but this information is not available to the machine.

With *garden paths*, the user misconceives the action and actually does make an error but does not realize it and continues to read the following instructions as part of the procedure. In her example, the users were supposed to make four single-sided copies of an unbound document using the part of the photocopier called the "Recirculating Document Handler" (RDH). The instruction on the photocopier's display was to "Place all originals on the RDH"; the users were to put all the pages onto the RDH but instead they only put one page and, in return, got four pages of the first page. In this case, the communication breakdown occurred when the machine believed that the users only wanted to make four copies, and when the copies were made, it assumed that the task was complete and gave no further instructions. The users, however, still had other copies to make and expected the machine to produce the "next turn" in the interaction sequence. As such, both user and machine expected the other to produce the next turn and they get stuck in the confusion.

Suchman makes a point that can be related to videogame research. Gee (2003) suggests that players often skip or skim over instruction manuals because they don't make a whole lot of sense if you do not know the game. He suggests that this is why videogames are good at providing "situated learning" because instruction makes more sense when it is given in a meaningful context. Suchman (2002), also points out that many people don't read instruction booklets when using many other machines or software programs. She writes that "We can infer from the users' failure to consult the instructions…that they have a preconception about what to do, based on past experience. Such preconceptions probably account in large part for the common complaint from designers that people 'ignore' instructions; they ignore them because they believe

that they already know how to proceed" (p. 165). Ignoring these instructions, of course, leads to possible communication breakdowns between users and machines, who often have different interpretations of what is going on, whether an action needs to be fixed, and if so, how.

Rules of Play

Goodwin (2006) studied middle-school girls playing playground games such as hopscotch and jump rope. Her study focused on, among other things, how roles were negotiated with respect to rules that guide appropriate behavior, what constituted violations of those rules and what remedies should be followed. Goodwin notes a prior lack of attention on girls' games, especially because early researchers such as Piaget often saw them as being less strategic or complex than boys' games. She also points out that much of the social scientific research on gender and socialization in the 1980s and 1990s were based on participants from White, middle-class backgrounds, mostly relying on focus groups or interviews for data collection. Her participants came from a more diverse background, including Hispanics, Asians, African Americans, working class, English as a Second Language (ESL) and bilingual girls. Goodwin helps clarify common myths about girls' social lives, for example, the misconception that girls are more prosocial and less competitive than boys when, in fact, they can be just as hierarchical and exclusionary as boys. She notes that previous scholars often oversimplify issues of gender and class and fail to look at the broader, socialization context witnessed in the lived, everyday experiences of these girls.

Previous literature on rules in games posits that rules are identical throughout the game and that they provide "mechanical jurisprudence" for the activity. However, Goodwin points out that the girls were often testing the boundaries of the rules to see how far they can extend them to their advantage before being caught. Throughout much of her research, girls constantly monitored one another's behavior to ensure that everyone was acting in expectation to the group's norms. As such, they also understood conflict to be a part of play that has to be resolved over the course of the interaction. Moreover, the rules themselves were not decided ahead of time, but were articulated in the midst of play. Some rules governed turn-taking allocation; others governed who gets to start and what roles each players take up. Like conversation, Goodwin notes

that game order is not decided in advance but administered turn-by-turn. Understanding rules in games becomes a practical accomplishment, whether it is played on the playground or anywhere else. It is practical in the sense that players have to be able to point to or demonstrate instances of violations. It is not simply that there are rules of play and that players follow them. Rules are not so black-and-white that it was always clear what went on, especially as players were trying to avoid being caught cheating. Consequently, a significant part of the play is the negotiation and deliberation of rules and fairness.

Goodwin also describes the girls' interaction with other members who share the school playground. Her focus participants were a group of fourth-grade girls who often had conflicts, either with the fourth- to eighth-grade boys (who dominated the field) or the sixth-grade girls who bullied them. As such, they were positioned at a somewhat lower part of the school's overall hierarchy. These asymmetrical relationships became part of their daily and moment-to-moment interactions, during which they had to constantly resolve problems, such has having fair access to the field, being fairly treated by students of other grades, and so on. Goodwin notes that girls were not shy of demonstrating their control and expertise against boys, particularly in games where the girls were the experts. In controlling access to their games, girls might be less direct, but are nonetheless able to prevent others from joining.

Goodwin's study demonstrates the complexity in seemingly simple games and show how rules governing the game are negotiated over the course of the game. It is an example of the ethnomethodological principle that the context is constituted by the observable and reportable details of the action, which are accountable to all competent members involved in the activity. It also shows that rules are merely resources that guide members that are often contested and re-examined over time.

Conversation Analysis

The moment-by-moment construction of context has been a dominant part of conversation analysis (CA), which has its roots in ethnomethodology (C. Goodwin & Heritage, 1990; Heritage, 1984). The studies by Mehan, Suchman and Goodwin incorporated CA in different ways, as does the study described in his book. CA was developed by Harvey Sacks, a colleague of Harold Garfinkel. Since ethnomethodology and CA

emerged in the 1960s, they have taken slightly divergent paths in terms of their areas of interest. While ethnomethodology has kept a small group of followers, CA has grown into a tradition in its own right, being used not only in sociology, but also in linguistics, anthropology, communication and other disciplinary fields. Many ethnomethodologists have regretted the divergence and have encouraged CA studies to pay attention to its philosophical roots (Lynch, 1993; Rawls, 2002). Consequently, not all ethnomethodological studies use CA (many of Garfinkel's breaching experiments did not) and many CA studies are not ethnomethodological in nature.

For the uninitiated, CA studies can seem tedious, particularly with regards to its transcription conventions that try to capture the minute details of interaction, such as when and how people interrupt one another, when people gaze at the other person, how long they pause in the conversation, when they do an intake or outtake of breath, and so on. Not all CA requires this level of detail and the details are there to help readers re-capture how the conversation transpired over time, particularly with respect to order, indexicality, accountability, and contingency. Unlike most other forms of data collection, the details of CA transcripts are meant to provide the reader with the same data that the researcher used for his/her analysis and to let the reader decide what the observable features of the interactions were and whether the researcher had made the proper analysis.

The key goals of CA are summarized in the article *A Simplest Systematics for the Organization of Turn-taking for Conversation* by Sacks, Schegloff and Jefferson (1974), a seminal article in CA studies. Sacks et al. note that conversation, like most interaction (e.g., navigating through traffic, walking along the sidewalk, going through the door, standing in a queue, playing a game, and so on) revolves around the organization of turn-taking. Different activities differ in the ways turns are allocated. In Mehan's (1979) study, turns were allocated following the IRE convention, while in Goodwin's (2006) study, the turns in games were allocated during the course of play.

Among the topics that CA studies investigate are the local distribution and organization of order, in this case, the allocation of turns in conversation. Sacks et al. define a "speech-exchange system" as any kind of communication system that involves turn-taking; everyday conversation is

considered the least formal type because conversational turns are not pre-allocated, but distributed locally over the course of the conversation. Examples of more formal speech-exchange systems are interviews, debates, jokes, lectures, hearings, depositions, and so on, in which turns are pre-allocated and in which other kinds of conversational conventions are modified. As such, everyday conversation is on one extreme end of a continuum of speech-exchange systems, being the least formal of all. Consequently, having a good understanding of how everyday conversations work helps us understand how other kinds of speech-exchanges work as well because they are based on variations on a similar set of rules.

Some Basic Rules of Conversation

Sacks et al. summarize that *everyday conversations* consist of the following conventions (pp. 700-701):

1. Speakers take turns during the conversation (i.e., one person doesn't take up the entire turn; if they do, they are probably in a more formal kind of speech-exchange system).
2. One speaker usually speaks at a time.
3. When more than one person speaks, it is usually for a brief moment (e.g., when one person interrupts).
4. Most turn transitions occur without a gap. One person starts speaking usually right before or just when the current turn ends.
5. The order of speakers is not fixed ahead of time.
6. The length of the turn is not fixed ahead of time.
7. The length of the entire conversation is not fixed ahead of time.
8. The topic of conversation is usually not specified in advance.
9. The relative order of turns is not fixed ahead of time.
10. The number of people who can take part in the conversation varies.
11. Conversations can be continuous or discontinuous (i.e., it can be discontinuous when another speaker fails to pick up the conversation during a turn-transition).
12. Turn-allocation techniques are used to help select who the next speaker is.
13. Turns vary in length; they can be one-word or sentence-long responses.

14. Repair mechanisms exist when errors or violations in turn-taking occur.

The rules that govern turn-allocation are (p. 704):

1. At the point when a turn-transition is expected:
 a. *Current speaker selects next*: The current speaker selects the next speaker (e.g., by asking a particular person a question), and the other person is obliged to take the next turn.
 b. *Self-selection*: If no next-speaker is specified, then any other speaker make take the next turn.
 c. If no next-speaker is specified *and* no new speaker takes up the next turn, the current speaker may (but not necessarily) continue with the turn.
2. If the current speaker continues with turn, then the rule-set restarts.

Note that this turn-allocation rule-set is hierarchical, with 1(a) taking priority over 1(b), which takes priority over 1(c) and so on. In other words, turn-allocation proceeds in an *orderly* fashion, and all speakers typically understand and follow this rule-set during conversation.

Adjacency pairs are features of conversation that help control turn-allocation among speakers. For example, a question-answer is an adjacency pair made up of a *first-pair part* (the question) and a *second-pair part* (the answer). Other adjacency pairs are greeting-return greeting, summons-answers, and so on. As Suchman (2002) points out in her study, just as conversation involves turn-taking, as does interaction with a machine or program. The expectation of the users of the machine to produce a second-pair part to an instruction became the source of a communication breakdown. In addition, the second-pair part produces a constraint in the conversation in that it creates expectations among the speakers on who should take the next turn. This means, for example, that silence in conversation means different things, depending on where it occurs during the conversation. If it occurs after a first-pair part (e.g., someone asks a question), then the silence is treated as a lack of response. In addition, there are certain types of adjacency pairs where silence is not treated neutrally. With accusations (e.g., "Did you eat my cookie?"), silence is typically treated as an implicit admission of guilt. With invitations (e.g., "Do you want to come to my party?"), silence is treated as a decline (C. Goodwin, 1981; Heritage, 1984).

As with ethnomethodology, these conversational rules are not "laws" that govern behavior without exception. Instead, they should be understood as *constraints* that shape social interaction. When these rules are broken, effort is typically taken either to repair the errors or to address why conventions were not followed (e.g., when someone says "Sorry to interrupt but…" as a way of addressing why he/she disrupted the turn-allocation system). In that sense, conversation is self-repairing the same way larger ecological systems are seen to self-repair, except that this occurs at the local level.

These are but a small sample of the areas that CA researchers have studied. More will be discussed over the course of this book. For now, readers should familiarize themselves with some of the basic transcription conventions used in CA studies.

Transcription Conventions

As mentioned before, CA studies vary in the level of detail used on their transcriptions. These details give readers the same resources that the participants and researchers have for the analysis, which is particularly important in staying focused on (and only on) the observable and reported features of the interaction.

The following transcription symbols are adapted from Sacks et al. (1974) and Suchman (2002):

[Overlapping talk, with bracket marking the point of overlap
:	Lengthened syllable, indicated by number of colons
–	Cut off utterance
?	Rising intonation
=	No interval between end of prior sentence and beginning of next
.hh	Audible breathing intake
hh	Audible breathing out
()	Uncertainty over verbatim transcription
(())	Action or other non-linguistic feature
(1.0)	Number of seconds of silence

Since some of the transcription is in Mandarin or Cantonese, it will also include three layers of transcription, as follows:

	Li	you	biancheng	ling	original[1]
		again	turned into	zero	gloss

(My score turned into zero again.) *translation*

Here's an example that appears later in the book. (M) refers to an utterance in Mandarin and (C) refers to an utterance in Cantonese:

1 Li(M) *jiao wo zhenme wan la::::::: !*
 teach me how to play exclamation
 (Teach me how to play!)
2 Andrew [()
3 Li(M) [*hao jian a nimen laoshi*
 [very mean exclamation you always
 [(You're all so mean to always kill me.)
4 *sha wo=*
 kill me=
5 Kevin(C) =*gam (nego) gam laa wai=*
 =press (this) press exclamation=
 =(Hey, press that button.)=
6 Andrew(M) =*ni bie yong zhege la*
 =you don't use this exclamation
 (=Don't use this character, use Pikachu.)
7 *yong* Pikachu
 use Pikachu

In this example, Li, a novice player, is blaming the other players for ganging up on her and not teaching her how to play. Andrew makes the attempt by teaching her what character to pick (line 6), while Kevin is trying to move the game along by asking the other players to "Press that button" in order to move pass the intermediary screens (line 5). In lines 1, the ::::::: indicates an elongated stretching of the "ah" sound. At lines 2 and 3, Andrew and Li are talking simultaneously, although Andrew's words are not audible. Likewise, in line 5, the phrase (*nego*) in brackets indicates that the recording was not clear but it is inferred that this is what was said in that gap. Finally, in lines 5 and 6, the = notations indicate that these turns began immediately after the prior turn ended.

CA researchers vary in how the present their transcripts, particularly in the case of non-English transcriptions. Some of them omit the gloss. The gloss has been included here for the reader to give a better grasp of how I arrived at the translation. Further, most CA studies tend focus on

short excerpts of conversation, such as conversational openings and closings, greetings and assessments. With videogames, it can be a bit difficult to present communicative work in short, decontextualized segments without distorting what had unfolded over a longer stretch of time. Here, I have opted to present the data in manageable segments while also paying attention to the longer sequence that typically unfolds over hours of interaction. When possible, I have also tried to preserve or indicate the chronological order of the excerpted segments, as this is important to keep in mind, particularly when trying to understand the process of learning as it unfolds over time.

Implications

Ethnomethodology and conversation analysis have broad implications and applicability in many domains. Here, I have summarized ideas that are most germane to this book. The findings presented here attempts to peek inside the "black box" of play and to discover how players perceive order in the game—how they understand the rules of the game and how they interact with the game and with one another during the game. One of the things that ethnomethodology emphasizes is the notion of "first time through." More specifically, ethnomethodologists argue that the post hoc analysis of a situation is different from the situated event as it unfolds in real time. If we want to study how learning occurs in games, we should study and describe this learning *when they encounter it for the first time*. This is because a recollected event loses the messiness of the original, ongoing engagement during the game. In other words, after players become familiar with the game, the way they talk about their learning differs from how they actually approached it for the first time.

Order, accountability, indexicality, contingency, and other ethnomethodological concepts play a significant role in videogame interaction. In videogames, *order* represents the design of the game—that is, the rules that the designers put in place that constrain what players are able to do. In particular, I am interested in how players ascribed meaning to the design of the game and how they understood the actions in the game to be part of the design. Videogames are, after all, imperfect. Sometimes there are bugs and glitches, sometimes systems crash, and sometimes game designers create events that make players think that a glitch has

occurred. Competent players usually have to find a way of telling apart what is "orderly" in the game (i.e., part of the design) and what is not.

Accountability comes up when players have to decide what it means to be "playing." As the subsequent chapters show, "play" is a form of interaction that needs to be made mutually intelligible. Players are not always playing when they are holding their controllers. Sometimes they are "training," sometimes they are "dueling," and sometimes they are "playing." All of these forms of play have their own rules that are determined not by the game designers but by the players. In this case, interaction in videogames resembles the different rules that govern speech-exchange systems, each with slight variations on organizational features such as turn-turning and turn-allocation.

Indexicality and *contingency* manifest in the instructed actions that players give to one another. The action in videogames occurs on several levels—there is the action on the screen, the action between players off the screen, the action in the room, the action on the controllers, and so on. Game controllers themselves are complicated devices with scores of buttons, triggers and joysticks, and many more combination possibilities that are contingent on which game you are playing. Instructions such as "Press that button" is an indexical expression that only makes sense within the context of the gaming situation. When it doesn't make sense to a player, additional effort needs to be exerted to further furnish the contextual meaning of the instruction.

Ethnomethodology posits that people have methods of making sense of their environments, and even if these methods are under the radar, they are still observable and reportable, especially when trouble occurs that disrupt the orderly routine of the ongoing action. This method of finding order is even more salient during videogame play, because videogames are designed to be orderly on some level. A non-player watching an action-packed screen would have great difficulty discerning what is going on, while an expert would have no problem navigating complex displays, screens, buttons and symbols. Whether the players ultimately figure out the same order that the designers had in mind is what interests me as a researcher. To me, it is particularly interesting if the players see order where none exists. The tendency for people to look for evidence of an underlying pattern is, arguably, what makes videogames fun. First, our individual ethno-methods installs a "layer of meaning" over the programmed design

so that, for example, players can attribute "intelligence" to game-controlled characters, much the same way people do when they encounter AI programs such as ELIZA. Suchman (2002) notes that:

> ...[T]he project of building interactive machines has more to gain by understanding the differences between human interaction and machine operation than by simply assuming their similarity. My argument has been that as long as machine interactions are determined by stipulated conditions, machine interaction with the world, and with people in particular, will be limited to the intention of designers and their ability to anticipate and constrain the user's actions (p. 186).

To the extent that videogames are types of interactive machines that had been designed according to specific plans (or good design rules), their successful operation poses challenges similar to ones that Suchman's participants encountered.

Second, the possibility that different players might have different ways of perceiving order makes videogames a much more varied and unique experience for each player. Instead of each player having exactly the same experience and coming away with identical skills and knowledge, different players can get different experiences from their gaming, much the way Squire (2008) describes when interviewing youths playing *Grand Theft Auto III: San Andreas*. Ethnomethodology has the potential to reveal the "black box"(i.e., the ?????? of social interaction) of videogame interaction and to uncover what unfolds as players engage with one another through videogames.

Dourish and Button (1998) note that many readers have misunderstood Suchman's notion of "plan" in thinking that plans are irrelevant and that all actions are situated. In fact, Suchman's point was that plans serve as *resources* that guide users through the action, but since plans are inherently vague, designers cannot fully account for the specific, contingent circumstances that unfold on a moment-by-moment basis. Likewise, the findings in this book suggest that game designs serve as plans that guide the players' actions, but are, in and of themselves, not enough to fully account for the players' actions in specific situations.

In the chapters that follow, I treat videogames—specifically fighting games—as embodied interactions; that is, as interactions that are situated in particular contexts and that involve particular players, who have to deal with practical issues, including the action in the game, the controller, bodily configurations, and fellow players.

• CHAPTER FOUR •

Videogames as Embodied Interactions

> Everything is in everything. The power of the tautology is that of equality, the power that searches for the finger of intelligence in every human work.
> — Jacques Ranciére (1991, p. 41)

In film and literature, *genre* can refer to one of two things: *content* (e.g., fantasy, drama, science-fiction, romance, comedy) and *form* (e.g., short film/story, documentary, nonfiction, biography). In videogames, genre refers more specifically to the format of the game and how it is played. There are no formally established definitions for genre, but they serve as loose classification systems that allow players to know what kind of gameplay a particular game contains. Much as there is a relationship in language between form and meaning, there is a similar relationship in games as well. Some videogame genres are better suited to represent certain content. For example, most strategy games tend to be about making historically strategic decisions (troop placements, city locations, resource use) while most first-person shooters tend to be about conducting war and/or espionage.

The first part of this chapter analyzes some distinguishing features of a variety of videogame genres. Here, I suggest that the structure of a videogame genre is analogous to the "plan" that Suchman (2002) describes in her study of instructional designs of photocopiers, or the "underlying pattern" that Garfinkel (1967/2008, 2002) describes in his documentary method of interpretation. In other words, the essential features and conventions of a genre serve as resources to help players make meaning in a game. The second part of this chapter describes videogames as "embodied actions." That is, players do not simply play the game but interact with it through input devices, such as controllers,

and have a physical, bodily relationship to the game. These physical relations can affect gameplay, especially if players are interacting with others in the same room. This part builds largely on Paul Dourish's book *Where the Action Is: The Foundations of Embodied Interaction*, in which he brings together studies in ethnomethodology, human-computer interface (HCI), phenomenology, and interactive systems design. Like Suchman, Dourish regards HCI not as mental states or processes that are confined to the boundaries of the head, but as situated actions that unfold in real time and real space. Throughout this book, I will argue that the study of videogames need to account for physical embodiment and contingencies because these relationships affect how meanings are made and understood.

The Genre of Videogames

All games—whether for commercial or educational use—are influenced by pre-established conventions of a recognized genre. Despite the considerable advancement in technology, hardware, and graphics, genre conventions have remained relatively stable over the decades. Ito (2009) notes that developers often take a conservative stance in design and are unwilling to stray too far from proven formulas and designs that have worked in the past. Just as in other media forms, innovation in videogames is a balance between creating forms of interaction that have worked before and designing new but untested activities that may or may not be readily accepted by the players. Being recognizable as a genre also makes it easier for developers to market their games. Innovation does occur, but not as rapidly as one would expect from this medium, and the apparent lack of innovation has not stopped the industry from becoming immensely successful.

The existence of genre conventions has both benefits and drawbacks. On the one hand, these conventions allow games to be recognized as members of a genre, so that players who buy, for example, a first-person shooter knows ahead of time what type of interaction and content the game would contain before playing it. On the other hand, once genres stabilize, they can become somewhat resistant to change. The latest and fourth iteration of the *Street Fighter* game, which came out in 2008, still looks remarkably similar to the first *Street Fighter*, which came out in 1987. Some games that have been lauded for their innovative design and

for defying genre clichés and convention (e.g., *Ico, Eternal Darkness: Sanity's Requiem, Killer-7*) do not always translate to the massive sales seen in games with more recognizable conventions. Game developers have to face the challenge of creating new rules that still fit within an established genre or risk alienating potential fans of the genre. Consequently, it is more common to see innovation in the form of better graphics and sound effects than in gameplay.

While game researchers often refer to "videogames" as a shortcut, there are significant differences between the many genres of videogames that make gameplay unique for each. Genres evolve as technologies change, some falling out of favor (e.g., arcade games) and others growing in popularity. Some genres, such as sidescrollers, even manage to make a small comeback. Games are difficult to categorize because they incorporate aspects of multiple genres and form hybrid genres. Educational games also seem to follow commercial game genres, perhaps because it is easier to design and market a game using a well-proven template. Sticking close to genre conventions means that players won't have to learn additional rules, and can jump right into the essence of the game.

The Conventions of Videogame Genres

Videogame genres have been relatively under-theorized in academic research (Vorhees, 2009). In his description of videogame genres, Wolf (2001) lists over 40 categories, some of which overlaps with other categories. He uses *interactivity* as the key characteristic in differentiating the genres, specifically in terms of the player's goals. Kürklick (2001, 2007) categorizes game genres along three dimensions: interactivity, indeterminacy (openness) and narrativity. Myers (2003) conducts a semiotic analysis of genres and focuses specifically on symbolic forms and interactivity. Ito (2009) uses genres as a way of discussing the social, cultural, and technological networks embodied in different videogame (she uses the term "children's software") designs. She distinguishes between "media genres," which refer to the *affordance* of the medium, and "participation genres," which refer to how the content of the activity is structured to be recognizable as part of a larger constellation of practice. My definition of genre is looser and aims simply to describe the features that help differentiate one genre from another. It asks the

question: How does a player tell the difference between one genre and another? This analysis builds on concepts developed by other scholars to construct a comprehensive taxonomy to describe videogame genres. Specifically, I focus on the following conventions: turn structure, timescale, player configuration, affordance, and procedural literacy.

The genres discussed here include fighting games, strategy games (real-time and turn-based), role-playing games, first-person shooters, and simulations. These genres have been chosen because they are sufficiently distinct from one another that it helps elucidate the properties I want to focus on. For readers who are unfamiliar with videogame genres, I hope this introductory description can provide a basic understanding of how videogames differ structurally from one another. Given the visual and dynamic nature of videogames, some readers might want to search online for gameplay videos to get a better sense of what these games look like. Two good sources for these are *Youtube.com* and *Gamespot.com*.

Turn structure

All games are structured by turns and moves. Goffman (1969), who had written frequently on games, play and strategic interactions can offer us some simple definitions. He defines a *turn* as a point when the player has to make a decision, and a *move* as the action taken during a given turn. The turn structure is the fundamental design that defines and manages interaction in a game. It communicates to the players when they are in control and when someone or something else (e.g., the game) is in control.

Many videogame genres have a modular structure, with an overarching game that is broken down into smaller modules or units—missions, mini-quests, episodes, chapters, budget cycles—depending on the genre. Usually, if a player fails a task at the lower level, he/she is still able to restart or even skip the level without any significant impact on the overarching game. The game's structure affects how it provides feedback to the player about specific strategies. With a short module, players get feedback quickly and can replay and learn from their prior actions faster than in a game with modules that take longer to complete. There are other events that might interrupt the turn structure of a game. Many games have cinematic sequences that advance the overarching narrative. Most of these can be skipped and allow the player to jump right back into the game. However, these narratives often contain clues

that players might need to know in order to advance to the next stage. Other events that break the player out of the turn structure are save points—or moments when the player is allowed to save the game and stop playing.

Another way of conceptualizing turns and moves in games is to picture it as a large project with an end goal (i.e., to win, to attain the highest score, to finish the narrative, etc.) that can be broken down into smaller, interconnected steps. For example, a school curriculum unit is typically broken down into a series of lessons, each of which contain individual objectives, activities, and assessments. At each particular point, a student might be doing something different—listening to a lecture, writing notes, working in a group, taking a quiz, and so on. Games are often structured along the same lines, with longer games having more intermediate steps than simpler, shorter games.

We can try to picture the turn structure of games using a simple notation system. For example, a game of chess, played from start to finish, involves multiple alternating turns by each player. Thus, if we were to describe it as a formula, it would look something like this:

$$[\text{Alternating Turn}]^n \rightarrow \text{checkmate}$$

where each game is made up of n number of turns, and where \rightarrow designates the end state. (Of course, the end states are always player-defined in some ways; in timed chess game, players have to complete their turn within restricted time frames.) In chess, a player's turn is relatively discrete, which means a player gets one move in each turn. Most games that involve simple turn-taking can be described in this manner. In videogames, some genres require players to take alternative turns, much like chess, while others allow all players to move simultaneously.

A few disclaimers. First, this notation system is not meant to capture all possible configurations of any given game; however, it can provide readers a general idea of what the turn structure of a given genre looks like. Second, this notation does not work with multiplayer games where the player is part of a team because, in these cases, while a team's goal is to win the game, a player's role within the team might be defensive or supportive. This notation makes more sense in cases where there can only be one player who wins the game. Finally, the notation assumes an

idealized end state, in which the players are playing the game as it is "meant" to be played. In other words, the turn structure serves as signposts for players to know that they're heading in the right direction. In many cases, games don't really "end" even when the main objectives have been achieved. Many games allow players to continue playing and exploring the environment and developing their characters for as long as they want. This is particular true of "sandbox"-type games, which is a general term used to describe open-ended games without specific goals that players must achieve at any given time.

Fighting games (e.g., *Super Smash Brothers Melee*, *Street Fighter*, and the *Naruto* series) typically have short turn structures that last a few minutes. Usually, fighting games are broken down into "rounds," like a boxing match, in which the player has to win the best of a set number of games (e.g., best of three rounds) in order to win that game. Players can usually alter the length of a unit, but typically a "round" does not last for more than a few minutes. If there are a large number of players, they might be able to enter tournaments, in which different players take turns fighting one another until a champion emerges. A fighting game tournament can be described as:

Tournament [Round]n → become champion

Otherwise, an individual (i.e., non-tournament setup) game would simply be:

[Round]n → become champion

Strategy games come in two forms—turn-based and real-time—and both differ significantly in their turn structures. Most strategy games tend to be related to "empire-building" scenarios, in which the player is put in the position of a leader who has to shape a civilization over the course of history. In turn-based strategy games (e.g., the *Civilization* series, *Colonization*, and *Alpha Centauri*), players can take as much time as they want to complete whatever is permissible within a game's turn. For example, in *Civilization*, building a city improvement (e.g., barracks, city walls) typically takes several turns to complete. Players can initiate the building process during a turn, but the building won't be complete for several more turns. After the player has completed all the moves, other players will take their turns one by one, until they have all had a turn.

With turn-based games, the player can theoretically take as long as he/she wants. The structure for turn-based strategy games resembles chess and would look something like:

[Alternating Turn]n → achieve victory conditions

Real-time strategy games (e.g., the *Age of Empires* series, *Dawn of Discovery*, and *Age of Mythology*) do not have turns per se; actions still take time to unfold but all players take their turns at the same time, and thus decisions have to be made in "real time." Early decisions made in the beginning of both kinds of strategy games have long-term effects over the course of the game. Hence, the player's decision making involves not only what to do in a given turn or moment in the game but what consequences individual decisions might have in the long run. The lengths of strategy games vary, but most take at least several hours to finish. One key difference between turn-based and real-time strategy games is that turn-based games typically unfold on a single map, in which the player plans all of his/her actions. Real-time games can sometimes be played in a number of ways. Most of them have a "campaign mode," which allows the player to follow along a historical narrative. These might be broken into missions, each mission unfolding on a different map. Individual missions can be further broken down into objectives that players have to complete in order to finish the mission successfully. The structure for campaign mode would look a bit more complicated:

Campaign [Mission [Objective]n]n] → complete campaign's narrative

In non-campaign mode, where players have only a single objective (e.g., accumulate a certain amount of gold), real-time strategy games have a simpler structure, such as:

[Objective]n → complete objective

Role-playing games, or RPGs, are probably the most complex in structure, especially because many RPGs are open-ended and allow players to decide how they want to play. As the name suggests, the focus of RPGs is on the character; however, it helps to distinguish between two types of RPGs. One type allows players to control only one character

(e.g., *Dragon Age: Origins*, the *Neverwinter Nights* series, the *Elder Scrolls* series, the *Fable* series, and the *Fallout* series); in these games, players are usually allowed to customize a variety of traits in the character, such as its appearance, physical attributes, relationship with other characters, and so on. The other type of RPG gives players less control over their characters' attributes, but does allow players to control more than one character (e.g., the *Mass Effect* series[1] and the *Final Fantasy* series.) The gaming community does not seem to have a term to distinguish between these two types of RPGs, but for the sake of clarity, I will refer to the former as "single-character RPGs" and the latter as "team RPGs." Note that "team" should not be confused with "multiplayer." Most RPGs have vast environments for players to explore and are typically based on a fantasy- or science-fiction-based world. Most RPGs have a main narrative that players can follow but the more complicated ones have multiple side-quests that might have little or nothing to do with the main story. In addition, the main narrative is usually broken down into smaller units as well, some of which will not be available until players have achieved a certain level. In RPGs, *levels* represent the accumulated experience of the player. This experience can be gathered through killing monsters or completing quests. Depending on the game, advancing a level—called *leveling up*—can bring a variety of benefits. In many cases, the game allows players to pick from a number of traits that they want to improve, so they can decide how and whether certain characters should specialize in certain abilities or skills.

The main structure of an RPG can be described as:

$$\text{Main quests [Levels [Episodes/Chapters]}^n]^n$$
$$(+ \text{ Side quests)]} \rightarrow \text{complete narrative}$$

Side quests are in parentheses because they are optional. Side and main quests take varying lengths of time to complete. Some side quests can be relatively simple, for example, delivering an object to another character; some quests might involve a fight with another character or group of characters, and that might take longer, especially if the player is at a low level in the game; some quests contain puzzles that players have to solve, often involving interacting with the environment in a predetermined fashion, such as going through an obstacle course. The main quest itself is usually divided into smaller chunks. Since narrative is important in

RPGs, the story is usually broken down into episodes. Upon completion of an episode, the player is shown a *cutscene*, or cinematic sequence, that advances the story and guides the player to the next episode. Completing just the main campaign of an RPG can take up to 40 hours of gameplay, and players who enjoy exploring every facet of the vast RPG worlds can take even longer.

As the name suggests, first-person shooters (FPS) put players in the first-person perspective of the character they control. FPS also come in two varieties: in regular FPS (e.g., the *Resistance* series, and the *Call of Duty* series), the player is usually part of a large team whose goal is to get from one location to another without being killed. *Tactical FPS* games (e.g., the *Rainbow Six* series, the *Ghost Recon* series, and the *Far Cry* series) put an additional emphasis on stealth and careful maneuvering, and players are usually acting alone or part of a smaller team. While regular FPS often require players to move along a set path, tactical FPS might give players more control in deciding how to arrive at a particular location. Players in tactical FPS are usually much more fragile whereas players in regular FPS are more resilient to attack. Both types of FPS tend to be related to military, counter-terrorism or espionage scenarios.

Most FPS games are divided into checkpoints, which are points when the game would automatically save the player's progress. This is a key difference that distinguishes FPS from the other genres, as most genres give players control over when to save the game. Having the freedom to save the game's progress allows players to test out decisions and backtrack if they want to alter the decision or make a different one. FPS lock players into their decisions, sometimes with dangerous consequences. The turn structure of FPS looks something like this:

Campaign [Mission [Checkpoints]n]n → complete campaign

Checkpoints are marked by location. Since the main goal in FPS is to outmaneuver your opponents, the checkpoints are usually positioned at locations players can arrive at only after successfully killing the opponents. Since players do not know where the checkpoints are ahead of time, part of the decision making involves knowing what weapons and ammunition the player wants to have at any given moment. Advancing from one checkpoint to another can take up to an hour. If a

player gets killed before reaching a checkpoint, then she has to start all over again from the beginning of the last checkpoint.

Simulations might be an odd one out among these genres because they are technically *not* games in that they do not have a game-imposed win state. Some simulations do set up scenarios with objectives that players have to reach, but most simulations allow players to decide how they want the game to progress. As such, simulations do not "end" in the traditional sense; they end when the player decides to stop playing. Simulations are often thought to have the most potential for education, especially since they often simulate systems and life cycles. The *SimCity* series, for example, puts the player in the role of a mayor, who makes decisions regarding zoning, taxes, infrastructure, crime, and so on; *The Sims* puts players in control one or several characters, and requires the player to make decisions on when to eat, when to bathe, when to use the bathroom, when to socialize, and so on. Since simulations often include managing budget, their structures are usually tied to a budget cycle. We can approximate simulations with:

$$[\text{Budget/Daily Cycle}]^n \rightarrow \text{complete user-defined goal}$$

Players usually have to make their decisions within the constraints of a budget cycle. Thus, a lot of time can be spent on waiting for money to trickle in.

Timescale
Lemke (2000) describes human activities as action nested in various scales of time—or *timescales*—which can range from microseconds to entire lifetimes. Using Mehan's (1979) study as an example, Lemke points out how multiple timescales intersect at the classroom level: individual IRE sequences are nested within class periods, which include openings and closing remarks by the teacher; these are in turn nested within lesson plans, which can cover several periods; lessons are nested within curriculum units, semesters, multiyear curricula, and so on. These timescales affect activities within them in different ways and, consequently, affect how individuals respond at various points and levels in the timescale. Not surprisingly, in videogames, timescales are closely tied to their turn structures.

Fighting games are one of few genres that impose strict time constraints. Like a boxing match, all games within each round counts down from a set number of minutes, with the timer positioned prominently on the screen. Players may alter their strategy as the timer counts down. For example, I have noticed players engaging in more risky, aggressive behavior when they are losing, with the goal to score a few extra points before the end of the game; conversely, players who are winning take more defensive strategies and try to avoid conflict with other players. If the game is set up as a tournament, then these are nested within a larger timescale, which can run from 10 to 20 minutes and up to a few hours, depending on the number of players in the tournament. Many fighting games reward players for extended play, usually by adding new characters that players can control. *Super Smash Brothers Melee*, for example, does not tell players how close they are in unlocking a new character, thus encouraging players to continue playing until they are rewarded.

The decisions that players have to make in a given turn-based strategy game also depends on how far the game has progressed. Early in the game, when the player has fewer decisions to make, a turn might last only a few seconds. As the game progresses, the turns get longer, taking several minutes to complete. When the game becomes more complicated (e.g., if you are at war with an opponent), you have to factor in more decision making time. Some LAN versions of turn-based games have a timer to ensure that a player does not spend too much time on her turn while keeping others waiting. Finishing an entire turn-based strategy game would depend on the size of the map, with larger maps leading to longer games. With real-time strategy games, players have to manage time according to what stage in the game they are at. For example, in *Dawn of Discovery*, one of the missions is to complete the construction of a grand cathedral before your computer opponent.[2] The cathedral is divided into four separate stages. The game gives you 90 minutes to complete each stage. Since each successive stage requires different resources, players have to balance managing the resources with the building of the cathedral with finishing the cathedral before your opponent. If resources run out before the stage is complete, then the construction process is stalled and precious time wasted.

RPGs are the most involving and complex genre. Sometimes, completing the main narrative of a game can still leave the player with substantial parts of the game to finish. Side quests usually take less time to complete. Usually they are mini-games, which can be as trivial as tapping the right button when a symbol flashes on the screen. Treasure hunts are another type of side quest, which involves finding artifacts that designers have scattered throughout the map. RPGs give players some control over how they progress through the game, but require players to be at a relatively advanced level by the end of the game. Thus, players have to spend time leveling up their characters by accumulating experience. In general, players need fewer experience to progress when they are at a lower level, thus both motivating the character with reward while scaffolding the level of difficulty. Some games cater to the player's experience by making the game progressively more difficult for the player as she advances, for example, by posing more difficult enemies to fight. RPGs are also one of few genres that take into account concepts such as day/night cycles. In *The Elder Scrolls IV: Oblivion*, for example, a game set in a fantasy medieval-like setting, shops open during the day and close during the evening. Players who want to do shop at a store (without breaking and entering) will have to wait for daybreak to do so. However, not all RPGs incorporate this aspect of time into their gameplay. They might adjust the day/night setting based on the narrative but they will not have a regular day/night cycle that advances independent of the storyline.

Checkpoints in regular FPS games typically take less (real) time to reach than tactical FPS because the latter requires more time planning and problem solving. Occasionally, the objective of a tactical game is to move from one spot to another without being noticed, so players cannot move at a very fast pace. Furthermore, regular FPS games, which typically involve war scenarios, are meant to immerse the player in chaotic situations. As such, the point is precisely to have the player make decisions on the spot, instead of taking time to ponder over consequences.

Theoretically, simulations can last forever. At some point, the player might end the game if he/she feels that there is nothing left to do. Simulations unfold in real time, but usually let players speed up, slow down, or even pause time as needed, which usually cannot be done in

other genres. (You can obviously pause any game, but you usually cannot change the speed at which time flows. RPGs do allow you to "skip time," usually by having your character(s) go to sleep.)

Player Configuration
Player configuration refers to how players have to organize themselves physically around the game. This organization has significant impact on how, when, and where games can be played. Over the course of my study, I have found Internet cafés to be an important meeting place for students to play after school, particularly for those who do not have their own computers or game consoles or who do not have fast broadband connections at home (Hung, 2010). At these cafés, multitudes of computers are networked and connected to the Internet, making it possible for students to play online and networked games in a shared physical setting.

Player configuration also affects how the game displays action to the player. Fighting games take place on a single screen. In other words, although fighting games can accommodate up to four players in the same room, all the action occurs on the same visual field (as opposed to a split screen.) Thus, it is easier for players to keep track of what other players are doing because they all share the same visual perspective.

Most strategy games today can be played online but some turn-based strategy games have a "hot seat" feature that allow players in the same room to take turns on the same computer. This means that one player would make all her moves, then leave the computer and let the next player make her moves, and so on. Since players start from different parts of the map and the structure of the map and the location of specific game pieces (i.e., cities, armies) are crucial information for each player, the game would also switch map perspectives when it switches player in a hot seat game so that players can continue to hide their strategies from one another. Given its turn structure, real-time strategy games are not able to support this type of play but they do allow players with individual computers to connect via a local area network (LAN) or play over the Internet.

Unlike strategy games or FPS, which tend to include single- and multiplayer modes, RPGs are, for the most part, usually either single-player or multiplayer. Despite these limitations, RPGs tend to be extremely popular, especially the multiplayer versions. Most MMOGs (or

MMORPGs—massively multiplayer online role-playing games) can only be played on computers and not on consoles, which means that players are not confined to their TV but can play them wherever they can carry a laptop and find a high-speed Internet connection. *Neverwinter Nights* is one of the exceptions that allows both single- and multiplayer modes. It also lets players design their own adventures (called "mods") and share them with other players, thus opening up alternate ways of interaction with the game.

FPS games often focus on their online gaming, which can involve multiple kinds of teamwork and objectives. Two common kinds of online FPS games are *deathmatch* (in which the goal is to kill as many players as you can under a time constraint) and *capture the flag* (in which players have to capture a number of enemy "flags" and bring them back to their home base while preventing the other team from stealing their flag). Players in the same room often have to resort to a split screen, in which each player sees only her character's point of view. This means that, in a four-player game, the screen would be split into four smaller screens, each taking up a quarter of the screen space. Unlike fighting games, split screens make it difficult for players to observe all screens simultaneously. A player might be able to glance at another screen and infer where the other player is located, but it would be difficult to spread your attention across all screens at the same time. FPS and real-time strategy games are usually used in LAN tournaments, where large numbers of players gather in spaces filled with hundreds, even thousands, of computers. These large LAN tournaments are serious events that last several days and require teams to be well trained prior to the competition.

While *The Sims* has an online version (*Sims Online*), most simulations are single-player games. There are no hot seats, split screens, or LAN versions of simulations. Some simulations, like *SimCity*, do not require the player's constant attention. That means that it is possible for the player to leave the simulation to run on its own—for example, to accumulate enough resources for later development—while the player is away. As such, the game "plays on its own" even without the player, which is somewhat unique to simulations.

Affordances

Affordances is a concept borrowed from engineering and has since been applied broadly to disciplines as diverse as architecture (Maier, Fadel, &

Battisto, 2009), HCI (Dourish, 2001; Gaver, 1991; Gibson, 1979; McGrenere & Ho, 2000; Norman, 1988), and social theory (Erickson, 2004). The word that often appears with affordance theory is *ecology*—which highlights the importance of the broader environment in which actions take place. In HCI, affordance theory is used to remark on aspects of the system's design that might facilitate or impede usage. Affordances has been defined in a wide variety of ways (McGrenere & Ho, 2000). The concept was first used by Gibson (1979), who drew on perception and gestalt psychology to develop the field of *ecological psychology*, which describes the range of possible actions that users are able to do within any given environment. For Gibson, affordances either exist in the design or they don't. However, people can create new affordances for themselves by altering their environment. Norman (1988) modifies the definition to include perceived affordances that may or may not be intentionally designed. He also accounts for the background of the user, whose culture and experience may affect her awareness of affordances in the design. Affordances depend both on the design of the artifact as well as the background and physical characteristics of the intended user. As a toy, a ball has certain affordances that makes it easy for a human or a dog to play with; these affordances would not be useful for a fish, which does not have the physical components needed to interact with a ball. Likewise, with videogame genres, there are specific affordances that are built into their designs that make certain actions possible and/or easier to perform. For our purposes here, I define affordances as the range of actions that players can perform in any given genre. In videogames, affordances usually have to do with what the player can do to another player and how the player interacts with the game's environment.

In fighting games, players interact within a single frame of reference; there is usually little else beyond the screen that they need to consider. In some fighting games (*Street Fighter*, *Tekken*), the only interaction is the fight between the characters. In these games, there is nothing in the environment to interact with. In other fighting games (*Super Smash Brothers Melee*), the game's environment itself might interact with the players, either by undergoing constant change or by dropping items throughout the screen that players can use. Some of these items can be picked up and thrown at the opponents or used to extend the player's abilities for a brief period of time.

With strategy games, players interact with a larger space that evolves throughout the duration of the game. In other words, there are always things happening off-screen that players need to attend to. In the beginning of most strategy games, players only have information about a limited area of the map. Players have to explore the rest of the map and figure out strategic locations to position units, gather resources, build infrastructure, or defend the empire. Oftentimes, the affordances of the game change over time in a somewhat predetermined fashion. The affordances of strategy games are closely tied to the amount and kind of technologies and/or improvements that players choose to focus on. In *Civilization*, players have to invest in discovering technological advances, each of which allows players to construct new kinds of buildings or create new types of military units. These advances are hierarchical, so that some advances are prerequisites to other advances. *Civilization*, and other similarly designed games, tend to allow players to pursue multiple possible trajectories in the early part of the game, thus allowing each player in the game to have their own set of strengths and weaknesses. In real-time strategy games, buildings and units are often tied together such that a certain building (e.g., a house) can accommodate a certain number of units (e.g., civilians). These buildings can be upgraded at some point to expand the number of units they can accommodate or allow players to create better units.

The affordances in RPGs are usually tied to the player's level in the game. Some RPGs require players to pick a specific trajectory to follow, usually denoted by *class* (fighter, mage, ranger, etc.) and *race* (human, elf, and dwarf). In some cases (e.g., *Fable*, the *Elder Scrolls, Star Wars: Knights of the Old Republic*), players can follow a "good" or "evil" *alignment*, each of which opens new possibilities for the player while closing others. Other affordances are tied to the items that players find throughout the game, such as magic-imbued weapons, potions, and other gadgets. As such, what players can do in an RPG is closely connected to how much of the game they have explored; the more they have explored, the more they can do. In addition, there seems to be differences between single-character and team RPGs with regards to the player's relationship to the environment. In single-character RPGs, players tend to have free movement throughout the environment, allowing them to move to, climb on, jump/fall down from any location on the map. Team RPGs have

stricter limits on what players can do. Many parts of the map are out-of-bounds and exist only for decorative purposes. Free movement maps are a relatively recent innovation, made possible by sufficient hardware processing power that can design and program every surface and feature to permit interaction. As hardware and programming methods improve, players will probably be able to interact with more and more features of the map.

In FPS, affordances are tied to the weapons and equipment that players carry. Some FPS might reveal new weapons to the player over the course of the game; other FPS have the standard arsenal of weapons that any player can pick to use whenever they find one. Individual weapons might also come with their own peripherals that can further extend their range or firepower or ammunition. Given the focus on the perspective of the player, much of the action in the game is about using the environment in a strategic way. Most FPS games require players to duck behind objects to dodge gunfire or avoid detection. Some games even take into account environmental effects such as the sound of crunching glass or footsteps. What players can do in an FPS tends to stay relatively limited over the course of the game, but what does tend to change is the environment. Most FPS take players across a variety of map environments. In *Call of Duty: Modern Warfare 2*, for example, players get to exchange gunfire in an airport terminal, office building, urban streets, snow-covered military base, desert, and airfield, just to name a few. Game developers often create additional maps that players can purchase online as downloadable content (DLC).

The game's environment can be surprisingly static and predictable from genre to genre. RPGs and FPS tend to have many "props" such as tables, boxes, crates, and the like that permit quite restricted forms of interaction. In RPGs, these items act like as stage props and do not serve any particular function other than to fill up the visual space. Players can smash them but that's about it. In FPS, the main purpose of these items is to serve as cover for the player to hide behind. Occasionally, some can be destroyed through gunfire. There are some genres that allow additional forms of interaction; *Resident Evil 5* (an action-adventure genre), for example, allows players to push furniture in front of doors to serve as barricades. However, these affordances have to be specifically programmed into the game. This supports Norman's (1988) point that

there is a visual aspect to an affordance as well as a cultural aspect. A table in a game does not always act as a table; even if it does, it functions as a table of very limited use. Game designers often have to find a way to distinguish the props that players can use from those that are only there for decoration. Usually, the interact-able prop has a different color or glow to it. A player familiar with the genre is expected to understand these visual conventions that are designed to communicate affordance and usability.

Affordances in simulations are harder to summarize because they vary considerably from one game to the other. Since the goal of simulations is to provide open-ended and flexible play, they have the most affordances of the genres discussed here. Ito (2009) refers to this genre as "construction" because these games are essentially authoring tools that allow players to decide what they want the game to look like. Thus, games can look vastly different from player to player. Understood in this manner, the affordances in simulations are the building blocks provided for players to construct their game. A player in *SimCity* can locate a residential zone in the middle of nowhere, but the game will not allow the zone to turn into a building unless it is connected to the electrical grid and road network. Likewise, in *The Sims*, players can choose to leave their Sims in a swimming pool without a ladder to exit (as some players do) but the game will eventually let the Sim die due to starvation or thirst.

In some cases, the game's genre affects whether it can be played on a console or personal computer (PC) or both. Fighting games, RPGs, and FPS can exist on both consoles and PCs. Up until recently, turn-based strategy games were mostly PC games, until the team behind *Civilization* released *Civilization Revolution* specifically designed for consoles. Even then, they had to modify the game to be faster and shorter in format. Real-time strategy games are almost exclusive PC games, as are simulations. The reason why some genres work better on computers and others on consoles is due to what actions players are expected to perform. In some cases, the mouse and keyboard is simply more suited to perform certain actions (e.g., dragging and selecting a large group of items) than a game controller. As game consoles move away from controllers and closer to direct motion-controlled gameplay, new

affordances might be created that would allow new genres and methods of interaction.

Procedural Literacy
Procedural literacy can be loosely described as the set of skills needed to understand how something works. As the name suggests, being procedurally literate requires hands-on experience that often involves trial-and-error and playful manipulation. Bogost (2007) suggests that, in order to acquire procedural literacy about a game, the player must understand how the building blocks of the game are interrelated within the context of the game and how this knowledge can be transferable to other domains. As such, procedural literacy can be seen as the flipside of affordance. In other words, in a well-designed game, players are guided by the affordances to become procedurally literate with the game. While procedural literacy is usually described with regards to a specific game title, I focus here on generalizations that can be made across the genre. Procedural literacy defines the essence of a genre and what players are *likely* to learn from playing games in that genre.

Fighting games involve large casts of characters for players to choose from, each with their unique abilities and weaknesses. Some games also have a variety of stage settings in which the fights occur, each of which can further benefit or penalize any given character. The characters are balanced so that no character is superior over everyone else. Some will be better against certain characters but weaker against others. Fighting games closely resembles the Pokemon characters that Gee (2004) discusses, in which he argues that all children who play these games are able to describe the different Pokemon characters' names, appearances, abilities, and other attributes. Likewise, adept players of fighting games understand which characters are good for different situations because they have learned these attributes through repeated observation and practice.

The procedural literacy in turn-based strategy games is best documented in Kurt Squire's (2004) dissertation based on *Civilization III*. Turn-based strategy games slow down the action in the game and allows players to take their time in planning the next move. With turn-based strategy games, the focus is usually on deciding where to expend your resources. In *Civilization III*, players have to balance between advancing technological research, maintaining cities, building armies, establishing

diplomatic relationships, balancing the budget, and so on. Players usually have to adjust their strategies according to the circumstances: in times of peace, it is possible to focus on developing technology, expanding the empire, and improving cities. However, if another party suddenly declares war, then the player has to shift strategies to prepare for conflict. The game is designed such that players usually cannot pursue all strategies at the same time, thus requiring that they are competent in understanding how and when to adjust strategies. The *Civilization* series has often been compared to historian Jared Diamond's (1990) book *Gun, Germs and Steel* (Bogost, 2005; Squire, 2006), in which Diamond argues that the historical development of individual civilizations depends on local circumstances such as geography and available resources instead of on intellectual or cultural superiority. Games like *Civilization III* allow players to pose "what if" questions and explore alternate historical trajectories in ways that might not easily be done through a textbook. More importantly, it allows players to understand that historical outcomes depend on a large series of interconnected decisions over a long period of time.

The "real-time" nature of real-time strategy games usually means that most games are about managing resources. Oftentimes, real-time strategy games are designed such that X (let's say, a military unit) requires resources A and B, each of which needs to be mined or manufactured and brought to a certain location for processing. When managing a complicated game with multiple units and resources, a player will need a working knowledge of what is happening at all locations. Resources in these games tend to be finite. Failure to pay attention to the resource level can cause devastating production interruptions. When this does happen, the player has to quickly find ways to ease up any bottlenecks to get operations back up and avoid a domino effect that would lead to additional shutdowns in other parts of production. As some have suggested, real-time strategy games have the potential to teach economics and operations management (Schiesel, 2009). To play these games well, players have to know where the production issues are and how to diagnose and solve the problem in a timely fashion. Players also have to create proper buffers in the system that can absorb uncertainties in supply and demand, thus minimizing the effects of unforeseen crises.

Gee (2004) argues that RPGs fit well in the new capitalist economy, as it allows players to understand how to be members of cross-functional teams, in which individuals use their specialized expertise to collaborate with others on different projects. Well-designed RPGs force players to focus on specialized knowledge and abilities. Most RPGs require players to pick between different classes of characters. In fantasy-based RPGs, players usually have to make a choice between characters that are good at long-range attacks, hand-to-hand combat, defense, healing, and stealth. Science-fiction-based RPGs like *Mass Effect* are variations on the same theme. Some games allow players to control one character, who has to pick a specialization and be able to work as a team member in a larger group; other RPGs allow players to control a larger number of characters but limit players to how many characters they can control at any given time. As such, players need to understand which combinations of characters are best for any particular task. (Minor spoiler alert!) In *Mass Effect 2*, for example, the final episode of the game requires that players assign tasks to different controllable characters. The outcome of the game depends on whether the player has assigned the characters to tasks appropriate to their abilities.

In order to survive in an FPS, players have to learn how to enter rooms, scout locations, snipe enemies, and hide behind cover, as well as identify the advantages and disadvantages of each weapon and their accessories. Tactical FPS put an additional emphasis on patience, timing, and planning. In more team-oriented FPS, where the focus is not on a solitary hero, players have to know which weapons to use and what roles to play (e.g., offense, defense, sniper, scout, etc.). Thus, the procedural literacy in FPS is related to understanding how to use the environment to your advantage. In multiplayer mode, it is not unusual for expert players who are most familiar with the maps to scatter quickly to the best locations early in the game. After repeated play, these experts know where the prime locations are for sniping and defense, what the weak spots are in any particular setting and how to anticipate enemies approaching these locations. Not surprisingly, the FPS genre has been used by the military to train personnel (e.g., *America's Army*). The new generation of game consoles and graphic cards have allowed designers to create increasingly realistic feeling environments, such that players have to take into account concerns such as visibility and weather conditions.

Players also often have to make quick decisions; instead of trigger-happy games where you shoot everything that moves, players have to consider who the target is in order to avoid friendly fire and collateral damage to civilians and other non-combatants.

One might say that all games are simulations of some sort, as they represent some aspect of reality in varying degrees of fidelity. Unlike games, simulations tend not have antagonists or predefined win-states. The flexibility of simulations means that it is difficult to affix a particular procedural literacy on any given simulation. If properly played, *SimCity* can potentially teach the player about how the different parts of the city works—for example, the relationship between residential, commercial, and industrial zones; the location of police and fire stations; the design of infrastructure; and so on. The kids playing *SimCity 2000* in Ito's (2009) study often had more fun building and destroying their own cities than in properly managing them as a city. Seen as authoring tools, simulations allow players to design their game according to their unique visions, and understand the consequences of different courses of action.

The Implications of Genre

The previous section outlined some of the conventions that distinguish various videogame genres. As Ito (2009) suggests, genre conventions develop as the result of intersecting social, cultural, and political developments in society. Many conventions fade or grow as the result of technological advancements, not only in hardware design but also in expanding broadband networks, increasing computer ownership, and other network effects.

Innovation in design frequently comes in stages through expansion packs and sequels. As designers receive feedback from players about what works, they are able to incorporate changes into subsequent series while ensuring that players do not become alienated by unfamiliar innovation. Most successful games are part of long-standing series that have proven the test of time over the years (e.g., *Civilization, Call of Duty, Grand Theft Auto, Final Fantasy, Street Fighter*). Even in these franchises, innovation has to be gradual and has to fit well with what players enjoy the most about prior games in the series. It is not uncommon for follow-ups of successful franchises to flop commercially if the innovations are

deemed too radical or too minor for the fan base. Good examples of recent failures are *SimCity Societies* and *Final Fantasy XIII* and *XIV*.

This analysis also adds a layer of complexity to surveys about videogames and players. The Pew Internet and American Life Project (Lenhart, Kahne, et al., 2008) reports that, among American teenagers, 99 percent of boys and 94 percent of girls play some kind of videogame. The report also describes the types of genres that teenagers play, which is summarized in Table 1.

Table 1. Genres in Order of Popularity Among American Teenagers

Genre (examples)	% teens who report playing games in this genre
Racing (*NASCAR, Mario Kart, Burnout*)	74
Puzzle (*Bejeweled, Tetris, Solitaire*)	72
Sports (*Madden, FIFA, Tony Hawk*)	68
Action (*Grand Theft Auto, Devil May Cry, Ratchet and Clank*)	67
Adventure (*Legend of Zelda, Tomb Raider*)	66
Rhythm (*Guitar Hero, Dance Dance Revolution, Lumines*)	61
Strategy (*Civilization IV, StarCraft, Command and Conquer*)	59
Simulation (*The Sims, Rollercoaster Tycoon, Ace Combat*)	49
Fighting (*Tekken, Super Smash Bros., Mortal Kombat*)	49
First-Person Shooters (*Halo, Counter-Strike, Half-Life*)	47
Role-Playing (*Final Fantasy, Blue Dragon, Knights of the Old Republic*)	36
Survival Horror (*Resident Evil, Silent Hill, Condemned*)	32
MMOGs (*World of Warcraft*)	21
Virtual Worlds (*Second Life, Gaia, Habbo Hotel*)	10

The report also notes that 65 percent of teenagers play with others in the room with them, thus making videogames largely a social experience that involves interaction within the same physical space.

This breakdown of genres also demonstrates that, although most teenagers might play videogames, they do not play every genre. The report suggests that most players only play games from a few genres and would not be interested in others. Regrettably, many of the more popular genres remain under-represented in research on videogames. The genres that rank low in popularity among teenagers (RPGs, survival horror, MMOGs, and virtual worlds) cannot be easily played on a single gaming system with other players in the room. Teenagers, who have less financial spending power than adults, might not have access to individual computers or consoles that would make social gaming easy or affordable (Andrews, 2008). But to better understand how teenagers interact with games, it would be necessary to look at how they interact with the game and with players in particular contexts, as well as to find what they enjoy about videogames.

Videogames as Embodied Interactions

Dourish defines embodied interaction as the *"creation, manipulation, and sharing of meaning through engaged interaction with artifacts"* (Dourish, 2001, p. 126, original emphasis). The notion of embodied interaction grows out of ethnographic research over the past two decades that studied people in workplace and technological settings. These studies have pointed out the inadequacy of cognitive models of the mind in explaining how people interact with technologies (Suchman, 2002). Suchman argues that cognitive models are useful as *resources* that guide users through their interactions but are insufficient in fully explaining how people interpret their action in specific circumstances, from moment to moment. Dourish (2001), like Suchman, was a researcher at the Xerox Palo Alto Research Center (PARC). He suggests three ways in which embodiment is relevant to understanding HCI. First, he notes that designers understand that interaction is connected to specific settings and that the physical environment has a significant impact on how people use interactive systems. Second, he suggests that computing and work has to be understood in more concrete terms (i.e., as people doing actual work in actual settings). This understanding, in turn, helps us understand how

interactive systems and interfaces are designed to facilitate work, especially if it involves more than one person (as it usually does). Third, the understanding that work takes place in "real" settings affects how we perceive the role of technology in relation to other activities unfolding in the workplace. Dourish uses the example in Nygren, Johnson, and Henriksson's (1992) study of patient record cards in hospitals, in which the researchers point out that the hospital staff often relied on the physical condition of the patient record (i.e., the handwriting, the wear and tear of the record) as an indication of the patient's history—indications that are lost when the patient cards are digitized.

Dourish notes that our relationship with computers has grown increasingly *tangible* over the years; through a mouse, we interact with icons or "folders" on a virtual desktop that is designed to reflect the metaphor of a real desktop. If the trend in touch-screen interaction is any indication, our relationship with technology might become even more direct, as we bypass the need for external input devices altogether. A similar trend can be seen in videogames. Nintendo's Wii allows players to treat its controller like an actual tool (e.g., tennis racket, baseball bat) through infrared sensors; Sony's Sixaxis controller is able to detect its position in three-dimensional space, and Microsoft's *Kinect*, an accessory to the Xbox 360 system, is able to interpret the player's bodily gestures and facial expressions and project them onto a game. Together, these innovations change the player's relationship with the game and virtual environment in profound ways.

Here are two examples to help illuminate the importance of embodied interaction in videogames. The first example involves the game controller; the second example involves the visual orientation and perspective of the game.

The Game Controller

The game controller is a rather sophisticated device that can be confusing for novices. Take, for example, the Nintendo Gamecube controller (Figure 1). The controller is designed to be held in both hands. The left thumb controls the left analog stick and the directional—or D-pad—whereas the right thumb controls the right analog stick (which is also a button), and the main action buttons (A, B, X, and Y). The left index finger controls the left analog trigger, and the right index controls the right analog trigger. Since

the main action buttons are located on the right side of the controller, there is a right-hand bias to how controllers—and most everyday tools—are designed (Clifford Hill, personal communication).

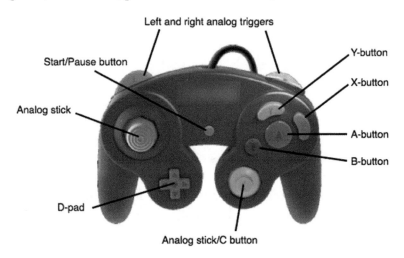

Figure 1. Videogame Controller

All actions in the game have to be mapped onto the controller. More complicated action might require a longer combination of buttons that have to be executed at the right time and sequence. Fighting games, in particular, require players to be familiar with the controllers in order to perform timely moves against opponents. While players might know the controls to a game, they might not always be aware of what buttons they pressed to make a particular move happen. Because the player's attention is focused on the screen and not on the controller, it can be difficult, if not impossible, for the player to pay attention to both the controller and the screen at the same time. Oftentimes, players have to ask another person in the room to look at what buttons they press while they perform a particular move. In other words, the player's fingers can know which series of buttons to press without the player *consciously* knowing what buttons have been pressed. (This is similar to the way we sometimes have trouble reciting a phone number but have no trouble dialing it.) Some designers understood this issue and have displayed the combination of buttons for the players to see. For example, in *Naruto: Clash of the Ninjas 2* (Figure 2), players can see which buttons they pressed when they are in training mode.

• CHAPTER FOUR — EMBODIED INTERACTIONS •

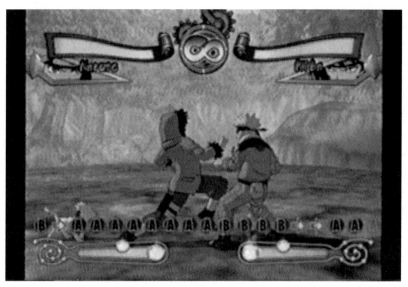

Figure 2. *Naruto: Clash of the Ninjas 2* screenshot

The inability to observe a controller means that other players do not necessarily know the *intention* behind the action that has been performed. In some cases, a player's character might accidentally strike another character without meaning to. The question of intention can be a source of conflict not only in videogames but also in playground games. For example, Goodwin (2006) documents how girls playing hopscotch often argue about whether cheating has occurred when a player steps out-of-bounds. In playground games, players are positioned such that spectators usually can see whether someone has stepped outside the boundary. In videogames, where action occurs onscreen and through the controller, it is more difficult to observe when a boundary has been transgressed and hence conflicts become harder to resolve.

Visual Orientation

Linguists have become increasingly aware of the role that language plays in the way we interpret, describe, and represent the spatial world we occupy. Lakoff and Johnson's (1980/2003) work on language as metaphor includes examples of spatial metaphors that are often used to describe relationships and emotions (see Chapter Two). For example, they argue that positive phrases are usually connected to an "up-orientation" and negative phrases to a "down-orientation." Phrases such as "cheer *up*,"

"things are looking *up*," "*lift up* your spirits," "*rising* to the *top*," "*lofty* goals," "*high* hopes," "take the *high* road," and so on signal positive circumstances whereas phrases such as "feeling *down*," "*down* in the dumps," "that was *low*," "that is *beneath* you," "that was *underhanded*," and so on signal negative circumstances. Lakoff and Johnson argue that our use of language is closely related to our embodied experience of the physical world where, typically, our bodies are more upright when we feel happy and healthy, and slouched when we are unhappy and sick.

Hill and Larsen (2000) note that there are significant differences between how people use language to represent spatial relations and how these differences can lead to serious consequences when not properly understood. In *Children and Reading Tests*, Hill and Larsen documented how third graders interpreted various test items on a sample reading test. Their study shows that there are significant differences between how African American and Caucasian American children understand certain spatial and temporal relationships. For example, time, as well as other phenomena, often gets spatialized in language. We talk of turning the clocks backward or forward in time. However, it is unclear whether "moving your clock back" means moving it from, let's say, 11 AM to noon, or from 11 AM to 10 AM. Since the directionality of time is forward, then moving *back* should mean 11 AM to noon. They refer to this as *in-tandem imagery*. However, Hill and Larsen note that, for many Western cultures, "moving your clock back" means to move it from 11 AM to noon. They call this *mirror imagery* because the speaker is anchored in her point of view (instead of time's). Thus, time is spatialized as an object that faces them, in which case, "moving back" is understood as back from the point of view of the speaker. Hill and Larsen note that there are cultural and gender variations in how people orient themselves in relation to other objects in the world. Some of these differences depend on whether the object has a noticeable *front* and *back* (e.g., a telephone has a front and back, while a rock does not), and whether the object can be perceived visually.

Videogame designers also seem to understand that players have different ways of orienting themselves spatially in the game. For example, certain genres—particularly RPGs and FPS—project the player's character onto a three-dimensional space, represented by the x-axis (horizontal), y-axis (vertical), and z-axis (depth). To move the

character in this space, the player has to be aware of two forms of movement, usually mapped onto the analog sticks of a controller. One stick controls the character's actual movement relative to the game's space (e.g., walking straight, turning left/right, etc.). The other stick controls the visual field—or what the player actually sees on the TV or computer screen. For RPGs, which usually have a third-person character perspective, the visual field is an imaginary camera that orbits around the character. For FPSs, which have a first-person perspective, the visual field is the character's gaze—that is, the direction the character is looking. Most games allow players to decide whether they want to invert the x- and/or y-axis for the camera controls. This choice is typically presented early in the game. For example, in an FPS, inverting the vertical axis would mean that, if you move the analog stick upward, the character looks down; if you move the analog stick downward, the character looks up. In some games, these choices are presented as "normal" and "inverted," which suggests that uninverted might be the norm for most players. However, different players prefer different combination of preferences: some invert both, some invert neither, and some invert only the x- or y-axis. Moreover, a player who has one preference will find another configuration disorienting and unintuitive.[3] Why players have these different preferences has not been addressed in research, but it is possible that it is related to the deep relationship we have with language, space, and embodiment, such as what was described in Hill and Larsen's research. Some players might be taking the point of view of the camera, while others are taking the point of view of the character. Regardless of the reason, this is an area of research that is worth further exploration, as it is likely to yield fascinating results.

Summary

The first section of this chapter points out that videogames come in many genres, each of which has their unique gameplay and configurations that are significantly different from other genres. This section describes some of the design conventions of various genres, which have stayed relatively stable over the years. These conventions help expert players recognize the representations and structural meanings of the game, which vary from genre to genre, game to game. As such, these conventions serve as resources that help shape the possible meanings within a game. The

second section argues that players are not simply playing videogames in abstraction, but are interacting in specific contexts. Using the notion of embodied interaction, I argue that meaning in videogames cannot be studied in isolation, but in context. Among the principles that Dourish (2001) suggests is that "Users, not designers, create and communicate meaning" (p. 170) and that "embodied interaction turns action into meaning" (p. 183). In other words, in analyzing interactive systems, researchers need to pay attention to design *and* user/player interaction, and that meaning is created locally by users, and not globally by the designers.

This last point is potentially a problem for educational game researchers. If it is true that the designers do not have full control over a game's meaning, then how is it possible to design a game that would teach a specific concept or make a specific point? One way to shed light on this problem is to follow the path that researchers such as Lucy Suchman, Paul Dourish, Marjorie Goodwin, Hugh Mehan, and others have laid out in other circumstances. That is, to describe how players construct their own contexts, organize their activity, and interpret meaning through action. For the remainder of this book, that shall be our focus.

• CHAPTER FIVE •

Situated Play
Instruction and Learning in Fighting Games

> It is the case that all developments in learning theory, from Vygostsky to Lave, have established that individuals do not learn by themselves. They learn with others, and the social worlds they build make all the difference for what all will be known to have been known. "Learning," thus, is always a political process, and there cannot be any learning without some form of teaching.
> —Hervé Varenne (2007, p. 1561)

The popularity of videogames has gained educators' attention, in part, because videogames often contain complicated rules and narratives that need to be taught to its players. Their popularity over the years suggests that game designers have been successful in communicating these complex systems to large number of players with different learning styles and backgrounds. But what do players learn when they play a videogame? Some game researchers suggest that, through playing the game, players acquire the game designer's underlying epistemology (Shaffer, 2007) or ideology (Squire, 2006). Others, such as Bogost (2007), suggest that games serve as rhetorical devices that have a persuasive component in their composition.

The goal of this chapter is to unpack some of the questions about what and how players learn when they interact with a videogame, specifically with fighting games. Much of what players learn depends on their prior knowledge of the game, the genre conventions, and of videogames in general. For this study, I had asked players to select games they have not played before, in order to describe their "first time through" experience with the game. This builds on the ethnomethodological notion that people's first experience with a phenomenon is an

interaction that cannot be fully recaptured in a post hoc recollection. Learning is messy. Learning tends not to be a linear progression that advances from Point A to Point B; instead, learning (as it unfolds in time) tends to be exploratory, filled with trial-and-error, ventures down blind alleys, and back-tracking, and the goal here is to capture and preserve this messiness in its qualitative richness.

This chapter focuses on learning between a novice and three expert players. The novice, in this case, is a non-player who not only has to understand the Nintendo controller, but also the conventions of fighting games as well as how to play with this particular group of players.

Methodology

This study was influenced by Suchman's (2002) study of users and photocopiers and Goodwin's (2006) study of playground games in a middle-school. As with these studies, the goal was to understand the participants' orientation to the activity through their social organization. Since the communicative work was the focus, I was interested in videogames that could be played as a group in the same physical space. While there are many game genres that afford this type of interaction, the participants all gravitated towards fighting games. The participants' conversations were recorded through a digital voice recorder, their off-screen interactions were captured with a video camera, and their onscreen interactions were captured with a videocassette recorder (VCR). The onscreen interaction and conversations were later spliced together using Final Cut Pro, thus having a final product that included both onscreen and conversation data. In addition to the recordings, I took fieldnotes during my observations. In most cases, my role as a participant was limited to an observer. However, there were some occasions when they needed me to "fill out" the game, during which I joined in the play (more on this in Chapter Seven).

All the participants were Asian adolescents, ages between 14 and 18, some of whom had recently immigrated to the United States and were English language learners. I met an initial group during an earlier pilot study, and through snowball sampling, some of them recruited their friends from high school to be part of the study described here. Since this study required considerable time commitment, there were seven participants whom I was able to observe on a regular basis (over a course

of a year)—six boys and two girls (although not all of them are mentioned here).

The sessions occurred after school, on weekends, or during their summer break. A few of the sessions lasted close to four hours, with the average being around two hours. Typically, the players mixed up their play within the session, occasionally breaking into smaller groups or trying out new facets of the game. Part of my attempt here is to preserve the essence of the session being described while highlighting key moments of their interactions. Whenever possible, I have preserved the chronology of the interactions as they occurred.

Fighting Games

Fighting games tend to involve a large cast of characters that players select to represent them. Each of these characters have unique abilities and weaknesses. Two of these fighting games used in this study are *Super Smash Brothers Melee* (SSBM) for the Nintendo GameCube, and *Super Smash Brothers Brawl* (SSBB), its follow-up on the Nintendo Wii system. Both are similar in their design. Chapters Five and Six focus on SSBM, while Chapter Seven describes SSBB as well as another fighting game, *Naruto: Clash of the Ninjas 2*.

The *Super Smash Brothers* series involves characters from the larger Nintendo universe, such as *Legend of Zelda, Super Mario Brothers, Donkey Kong, Pokémon,* and *Star Fox*. The characters in *Super Smash Brother* fighting games tend to be diluted versions of the characters they represent, usually reflecting only the main traits of the original character. For example, *Link*, the protagonist from *Legend of Zelda* series, carries his characteristic bow and arrow in SSBM but is less sophisticated in his design and capabilities than he is in the *Legend of Zelda* games.

Super Smash Brothers starts players with a dozen or so selection of characters, and additional ones to unlock after the player has achieved certain goals in the game. These goals are usually unspecified, so players can only unlock them by continuously playing through and trying out different characters and stages. The players usually do not know who the unlockable characters are (unless they look it up online), and part of the excitement seems to be to guess who might be unlocked next. When the players have met the requirements of unlocking a character (e.g., playing in a particular setting a certain number of times), the game would

announce that a new challenger has appeared. In order to unlock the new character and make it a playable character, the player has to first beat the character in a one-to-one duel. This also serves as a way for the players to see what abilities the new characters have.

The game also allows players to change its initial settings, such as the duration and the ability to respawn (the ability to return to the game after your character is defeated). In this case, the players kept the duration at two minutes and the ability to respawn. This means that the only way for the game to end is for the time to run out (as opposed to, when all the opponents are defeated).

For the sake of clarity, the "player" refers to the human person playing the game and the "character" refers to the virtual character the player controls in the game. At the start of each game, the player selects the character, then the stage in which the fight is to occur. The game can accommodate up to four characters, at least one of which must be a player-controlled character. The other three characters can either be player-controlled or computer-controlled. More than one player can select the same character. However, once the game starts, the player cannot change characters until the end of the game.

Like the playable characters, all the stages in *Super Smash Brothers* fighting games are based on preexisting settings drawn from other Nintendo series. These stages fall into two general designs. One design features a relatively stable camera perspective that zooms in or pans out, depending on where the characters are spread out. For example, if the characters are spread apart from one another, the camera will pan out so that the players can see where their characters are; if they are close together, the camera zooms in on the characters' location. Another design has a moving camera that continuously forces the players to keep up with where the camera is panning. If the players fail to keep up, their characters will disappear off the stage and they will lose a life. In addition to the camera, each stage also contains its unique features, such as speeding cars, sinking platforms, and collapsing roofs, all of which force players to pay attention not only to their opponents but also to how the stage is transforming.

• CHAPTER FIVE — SITUATED PLAY • 93

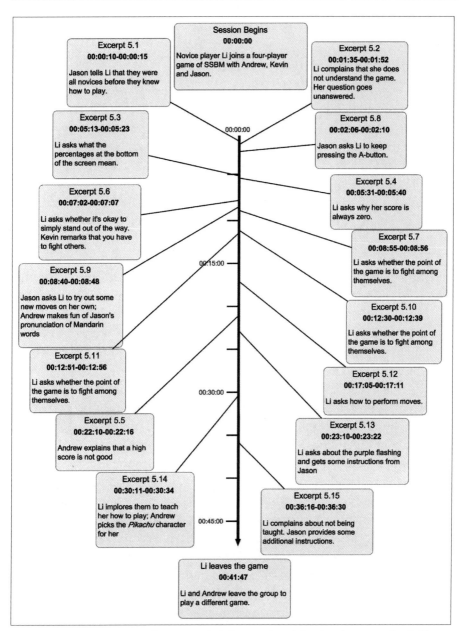

Figure 3. Sequencing of Events in Li's Instructional Session (excerpts 5.1-5.15)

The Novice

The Order of the Design

Balancing out the players seemed to be an important part of fighting games. Presumably, having an odd number of players in the game means that two players will always be ganging up on another player, thus creating unfairness (more on this in Chapter Six). Although the game itself permitted up to four characters, most games were either two- or four-player games. Thus, when the expert players—Jason, Kevin, and Andrew—found themselves one short, they always had to seek a fourth player to balance them out. On some occasions, I filled in as the fourth, but on this particular occasion, it was Li.

Li, the novice, did not play videogames as much as the other participants. Not only did she have to learn the specifics of SSBM, but also about the genre, the controllers, and how to interact with the other players. In addition to being new at videogames, Li also spoke mostly Mandarin, while the other players in this session spoke mostly Cantonese. Mandarin and Cantonese are both dialects of Chinese, but sound quite different, and while it is possible to infer general meaning by identifying a few words, it is not easy to understand the other dialect without knowing it relatively fluently. Jason and Andrew seemed most fluent in Mandarin, and spent most of the time communicating with Li in Mandarin; Kevin spoke less frequently to Li, and his Mandarin was also the least fluent. Li spoke only Mandarin, although she seemed to know a few Cantonese words. This linguistic complication meant that there were many times that Jason, Andrew, and Kevin would talk about Li without addressing her directly.

For conversation transcription purposes, I use (C) to indicate when a speaker is using Cantonese, and (M) to indicate when a speaker is using Mandarin. Cantonese is transcribed using the *jyutping* romanization system, and Mandarin is transcribed using the *pinyin* romanization system. (The conversation analysis (CA) transcription conventions can be found on pp. 54-55.) The numbers in brackets represent the amount of time that has transpired since the start of the recording. Figure 3 shows the chronological order of excerpts 5.1 to 5.14, which together represent a sequence of instructional work that ultimately ends in frustration and failure.

Let's start with excerpt 5.1, which occurs just as Li begins to learn about fighting games. This excerpt occurs right after a game of SSBM had

• CHAPTER FIVE—SITUATED PLAY •

ended. After the game displays the winners and losers, each of the players have to click a button on their controller to acknowledge that they are still there. After that, the game takes the players to a "Character Selection" screen, which lets them pick a new character. Then, it takes them to a "Stage Selection" screen, which lets them pick a stage or lets the game randomly assign on for them. I refer to these as *transition screens*.

In this excerpt, we see three kinds of instructions going on. Jason had picked the Pikachu character for Li to use. However, Pikachu was also the character he used most frequently, and it became confusing for Li to see two of the same characters on the screen:

EXCERPT 5.1 (00:00:10-00:00:15)

1	Andrew(C)	nei mhou tung keoi gaan jatjoeng
		you don't with her pick same
		(Don't pick the same color character as
2		ngaansik laa::::: diu:::
		color final particle fuck
		she does, damn it.)
3	Jason(M)	=women gang kaishi dou buhui
		=we just begin also don't know
		=(When we started playing, we didn't
4		da (yi da) jiu hui
		play (once play) then know
		know how to play either. Once we started
		playing, we knew [how to play].)
5	Kevin(C)	=gam gam gam
		=press press press
		=(Press it. Press it. Press it.)

Andrew instructs Jason (lines 1-2) not to use the same color, so that Li can have an easier time differentiating her character from Jason's. Jason addresses Li in Mandarin (lines 3-4), telling her of their own experience when they started with the game, and making it sound as if learning to play would come relatively easily with enough practice. Finally, Kevin (line 5) instructs them to press through the transition screens in order to get the next game started. This excerpt demonstrates a typical interaction between the experts and the novice. Among the three experts, Jason tends to provide the most instruction. Andrew tends to provide

instruction more indirectly, by commenting on how Li *should* be instructed; and Kevin tends to give no instruction and, instead, try to move the action along so that the next game can start.

Li spends the next game trying to orient herself to the game, repeatedly asking "where am I?" but most of her questions get ignored:

EXCERPT 5.2 (00:01:35-00:01:52)

1	Li(M)	*wo zai nali a? (1.5) () (2.0) (wo) fei*
		I at where final particle (I) flew
		(Where am I? (1.5) () (2.0) I flew
2		*zou (0.9) ta ma de kan bu mingbai*
		away that mother's see not understand
		away. (0.9) Damn it, I don't understand.
3		*(1.0) zhe ganma yong a?*
		this what use question marker
		what's going on. (1.0) What does this do?)
		(5.2)
4	Kevin(C)	*waa:: pukgaai:: aa! zeng! saat*
		wow damn exclamation great kill
		(Wow, damn it. Ah! Great, killed
5		*jatgo*
		one
		one (of you).)

The timescale of fighting games is such that there is no occasion to provide any detailed instruction when the game is in process without interrupting the play. In the two-minute duration of the game, the action is nonstop. While Li talks to herself throughout the game, this is one of many occasions when she asks a specific question (line 3). No one answers her and when Kevin speaks (lines 4-5), instead of answering her question, he comments about the ongoing game in general. In CA, questions are considered first-pair parts of adjacency pairs, which means that a second-pair part (a response to the question) is expected. Throughout this early episode, Li's many first-pair parts get ignored by the experts, which eventually leads to her voicing her frustration.

Li's questions in excerpt 5.2 also signal that her struggle is not simply about understanding the controls, but that she is having trouble identifying her character on the screen (line 1) and that she does not

know what is happening on the screen (lines 2-3). Her words *"kan bu mingbai"* (I don't understand what's going on) suggest that it is not just a sensorimotor issue but also that she does not understand what she is *seeing*. As described in Chapter Four, in videogames, there is a visual aspect to affordance that depends on the game genre, and that understanding a game requires that the player understand the visual meanings embedded in the game. As Li tries to learn the basic controls, she asks about the percentages that appear on the bottom of each screen (see Figure 4). The percentages for each character starts at zero percent. The more you are attacked, the higher the number climbs. The percentages can exceed 300 percent, and there is no clear indication of what the maximum percentage is. (Theoretically, the percentage indicator can go up to 999 percent if a player is able to execute a complicated combination move. This is, however, a rare occurrence.) As such, players do not always know exactly when their character is about to be killed, only that it is more likely to be killed when the percentages approach or exceed 300 percent. Furthermore, there isn't an indication of what the percentages refer to. The percentages do not seem to represent *damage, health, chance of survival,* or *chance of death,* nor are they used in the same way percentages are used in everyday life (i.e., to mark the fraction of something).

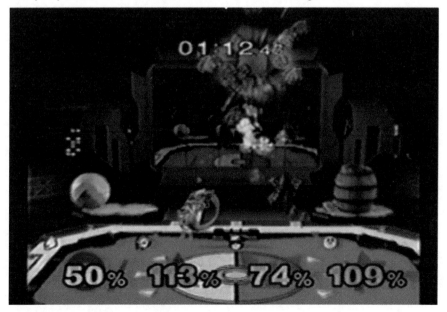

Figure 4. *Super Smash Bros. Melee* screenshot

In Excerpt 5.3, Li asks what the percentages mean:

EXCERPT 5.3 (00:05:13-00:05:23)

1	Li(M)	*xiamian de fenshu shi*
		Below possessive score is
		(What's the meaning of the score below?)
2		*shenme yisi a?*
		what meaning final particle
3	Andrew(M)	*shi ni*
		is you-
		(You-)
4	Jason(M)	=*shi ni shi ni dale dale duoshao*
		=is you is you hit hit how much
		=**(It shows how much you've been hit.)**
5	Andrew(M)	*shi a*
		Yes final particle
		(Right.)
6	Li(M)	*a shisi? shi bei ren dale*
		Ah fourteen? Is by someone beaten
		(Fourteen? It shows how much someone's
7		*duoshao ma?*
		how much question marker
		beat me?)
8	Kevin(M)	=*dui*
		=Correct
		=**(Correct.)**

As this excerpt unfolds in the midst of a game, the other players do not give a precise answer (lines 3-5). Even so, Li seems to have understood their explanation (lines 6-7) when she reiterates her understanding and receives an affirmation from Kevin. This is technically the correct response even though there appears to be possible confusion in her understanding. Her use of the word *"fenshu"* (score) suggests that she had interpreted the percentages to refer to a numerical score, as used in a test or a sports game.

Seconds after, in excerpt 5.4, she asks for further clarification on the percentage system and seems to veer further away from its designated meaning:

EXCERPT 5.4 (00:05:31-00:05:40)

1	Li(M)	*weishenme wo yizhi dou shi*
		why I continue still is
		(Why (does my score) stay at zero?)
2		*ling a?*
		zero question marker
3	Andrew(M)	*yinwei* [*ni yizhi ni si*
		Because [you continue you die
		(Because you keep dying.)
4	Kevin(M)	[*yinwei ni si a*
		[because you die final particle
		[(Because you died.)
5	Li(M)	*a* (1.4) *najiu shi xiamian fenshu*
		ah then I s below score
		(Ah. (1.4) So whoever has the higher score
6		*yuegao jiu shui ying luo?*
		higher then who wins final particle
		wins?)

Her continual use of the word "score" (*fenshu*) suggests that the conventional use of percentages to indicate the score is more salient than the game's intended meaning. Thus, even though, in excerpt 5.3, she seemed to understand what it meant and was able to articulate its literal meaning accurately, she found the need to clarify her understanding, as she seemed surprised that her "score" was not higher. She asks why her percentage remains at zero and the other players tell her it is because she keeps dying (lines 3-4). Their explanation is vague because it can be understood in at least two ways:

- *Explanation A*: high percentage is better, probably indicates your score; your percentage is zero because you just died and lost your score
- *Explanation B*: low percentage is better, probably indicates the amount of damage you sustained; when your character dies, your new character starts at zero damage

Explanation A seems relatively straightforward. In most games, scores count up while health counts down over the course of the game. If understood to mean score, then it makes sense for the score to drop if your character dies. It is possible to achieve higher than 100 percent on a

test, so this also helps explain why it is possible to exceed 100 percent. This seems to be Li's preferred understanding as well (lines 5-6). Explanation B makes less sense because the percentages lack a reference point. It should be noted that the game manual itself refers to the percentage as indicator of *damage*, but even that defies understanding. How is it possible for a character's damage to exceed 100 percent and still survive?

The percentage/damage indicator is a good example of the *et cetera provision* as used in ethnomethodology. Garfinkel (2002) uses it to refer to the unarticulated "stuff" that is glossed over in communication to allow us to carry on with the task at hand. The indexicality of language means that our communication is always ambiguous and situated. The fact that we can communicate, not only in conversation, but across space and time means that we have to rely on the *et cetera provision* to "fill out" all that is left unspoken, unwritten, or unexplained. The damage indicator may be difficult to explain but that does not bother the other players. They do not need to know what the percentages refer to, nor do they care. All they need to know for them to continue with the game is that if a character has a high percentage, it is weak. Everything else is part of the *et cetera provision* and does not need to be further clarified.

The *et cetera provision* is what allows games to be games. It helps players accept and move beyond the arbitrariness of rules and embrace them in the context of the game. What is part of the *et cetera provision* varies from genre to genre. As a novice, Li did not understand what should be part of the provision and calls for clarification. Finally, a few games later, when Li says:

EXCERPT 5.5 (00:22:10-00:22:16)

```
1   Li(M)        yo:::!      cong 130 ji        bian
                 exclamation from 130 something change
                 (Damn, I went from 130 something
2                cheng   ling!
                 to      zero!
                 to zero!)
                         (0.4)
3   Andrew(M)    duo   bushi hao  ni   zhidao
                 many  isn't good you  know
                 (It's not good to have a higher (number),
```

4	*ma?*
	question marker
	you know?)

A few things are worth pointing out. First, Li did not seem to notice a connection between how often her character was killed and the percentage indicators. Her exclamation that her "score" went from 130 to 0 suggests that she thought it was good to have a high number, which led Andrew to correct her (lines 3-4). In other words, although she was not a good player (she had died multiple times), there was no contradiction in her experience of the game. This could suggest either that Li *believed* herself to be a good player, or that Li did not see any relationship between her playing and the "score." This is an example of Li using Garfinkel's notion of the *documentary method of interpretation* to look for an underlying order or pattern in the game design. Whatever Li was experiencing, she was selecting certain aspects of the game and ignoring others in order for her experience to be coherent. Second, although Li was "misinterpreting" the game, she still played relatively well, finishing in second place in two of five games. This raises the question of whether it is possible to play a game and misunderstand its rules and still be considered a competent player. (I myself have "misinterpreted" games before and the games have made sense, both before and after I discovered my misunderstanding. In some cases, it was more fun to misunderstand a game because it made the game more challenging.) For Li, it seems that, provided that she continued to perceive an underlying order, it did not matter whether that underlying order was congruent to the game designers' plan. Third, it is just as interesting that Andrew found the need to re-orient her to the "accurate" interpretation of the game—that it is not good to have a high percentage. This is an example of "accountability work" emerging in context, during which members of the activity are oriented such that they are all *mutually* accountable to one another. Thus, the players felt that it was not enough for Li to be playing with them, nor was it enough that she was doing rather well for herself, despite being a novice; it was important that she is oriented to the game in the same way that they are.

Orientation to the Game

Sharing an orientation means that the players have the same way of interacting with the game. In other words, players understand that "this is the way you play this type of game" and others who play with them should share the same orientation. In conversation, we continually adjust one another's orientation through what CA scholars refer to as *repair*. We also do it through opening and closing sequences, such as when we start a conversation with "Guess what happened to me?" as a way of indicating to the audience that we are about to tell a story.

What should we consider to be the "right" orientation to a fighting game? What does it mean to play a fighting game? For Li, the initial goal was not to fight, but to survive:

EXCERPT 5.6 (00:07:02-00:07:07)

1	Li(M)	*na jiu shi yizhi zhan zai*
		then just is continue stand at
		(So, if I keep standing up here,
2		*shangmian jiu mei shi luo?*
		up there just no issue question marker
		I won't have a problem?)
		(0.9)
3	Kevin(M)	*danshi ni yao ying renjia*
		but you have to win others
		(But you have to win against the others.)
4		*ma:::::*
		final particle

Li had found a spot on the stage that was safe to stand on. In lines 1 and 2, Li continues to probe whether this was the "point" of the game. Kevin instructs her that the point is not simply to survive, but to fight other players (lines 3-4). Li eventually seems to realize this point later on in the session:

EXCERPT 5.7 (00:08:55-00:08:56)

1	Li(M)	*zhe shi zijiren da zijiren*
		this is ourselves attack ourselves
		(So, here we are fighting against one another.)

2	wo
	final particle

Dourish (2001) points out that, *"users, not designers, create and communicate meaning"* (p. 170, emphasis in original). While the game's design structures and constraints the possible meanings of a game, the eventual interpretation comes only through interaction that players have with the game. It is easy, especially for those familiar with a genre, to overlook how easy it is to assume the "point" of a given game. Fighting games usually do not have a context, so there is usually no explanation as to why these characters are fighting each other in the first place. Furthermore, Li's initial goal in the game—simply to stay at a safe location—seems perfectly reasonable. By staying out of the way, she managed to come out in second place a couple of times. However, even though she was ranking higher than a few of her fellow players, they did not consider her to be a proper part of the game unless she engaged in direct combat.

Li's gradual understanding of the game helps unravel the taken-for-granted elements we have toward game genres. The term "fighting game" (its Chinese name—*gedou youxi*—translates roughly to the same thing) is quite a vague concept, as it can be applied to nearly every other game genre that has a fighting component. Novices like Li are left to figure out on their own what makes a fighting game a fighting game. The phrase *zijiren* (line 1)—literally "self people" but usually translated to mean either "ourselves" or "one another"—implies a we-orientation to the players and shows her surprise that the "point" of this particular game is more antagonistic than she initially presumed. Her fellow players were not comrade in arms but opponents in combat. It should also be noted, however, that in SSBM, there are occasionally computer-controlled characters that make momentary appearances on the stage that typically last a few seconds. These are meant as an added challenge to the players, who have to fend off these other characters or seek a safe location. Thus, the players are not simply fighting among themselves but also navigating the stage. Furthermore, many of the stages in SSBM resembles another genre—called *platformers*—in which the goal is to move through the game as if it were an obstacle course, going from one location to the next and dodging any obstructions along the way. Although there might be brief encounters that require minor combat,

direct combat is usually not a central part of the game. One of the earliest and most recognizable platformer games is *Super Mario Bros.*, whose main characters—Mario, Luigi, Bowser, and Princess Peach—are playable characters in SSBM. Thus, it is no surprise that Li should think of SSBM more as a platformer than a fighting game.

When Is Instruction?

Li's orientation to the game eventually led to problems. She continually complained that her fellow players were ganging up on her and bullying her. This is further aggravated by her perception that the others were not properly instructing her on how to play. It is usually quite hard for a player to teach another to play a fighting game without interrupting the play itself. This is perhaps one reason why most of the instruction occurred only during the transition screens, and even those moments were short, as Kevin tried to hurry to start the next game (excerpt 5.1, line 5).

So, what does instruction between players look like and when does it happen?

In classroom interaction, the structure of the lesson and its participants are socially organized such that an instruction act consists of an initiation-response-evaluation sequence (Mehan, 1979). In videogames, the relationship between an expert and novice player might be more akin to an apprenticeship. For example, Steinkuehler (2004) describes instruction between expert and player in an MMOG using Gee's (1996) discourse analysis, paying particular attention to the relationship between expert and novice and the way the novice is guided into the "Discourse" of the game.

Fighting games pose a particular problem because the relationships between the players are essentially antagonistic. It could be argued that by "bullying" and "ganging up" on Li, the others are instructing her something about the identity of the player in fighting games and it could be argued that Li eventually did learn this by excerpt 5.7. Prior literature on learning in videogames have noted the benefits of the learning-by-doing aspect of games, where players are put into direct interaction with the rules of the game. But this form of "situated learning" does not always work well and can be particularly frustrating for a novice who needs to learn the more basic features of a genre.

To be able to play well in a fighting game, the player needs to know what the characters' moves are and how to perform them. In excerpt 5.8, Jason offers some guidance:

EXCERPT 5.8 (00:02:06-00:02:10)

1 Jason(M)　　*ni　　yizhi　　an　　A　hen　　lihaide*
　　　　　　　　you continue press A very powerful
　　　　　　　　(Keep pressing the A-button. It's very powerful.)

((Li taps the A-button repeatedly))

2 Jason(M)　　*dui!　yizhi　　yizhi　　an*
　　　　　　　　correct! continue continue press
　　　　　　　　(That's right, keep pressing it.)

In SSBM, the A-button is one of the main attack buttons. However, pressing the A-button only unleashes one of many combination attack moves. Jason's instruction itself is vague in that he states that it is "powerful" but does not clarify what it is used for. Li obliges and begins to tap on the button and Jason moves on to interacting with the other players.

EXCERPT 5.9 (00:08:40-00:08:48)

1 Jason(M)　　*ni　shishi　sheng　　de zhashu*
　　　　　　　　you try　"new"　　moves
　　　　　　　　(You should try some new moves

2　　　　　　　*ma...　　　　　ziji　shishi kan*
　　　　　　　　question marker self try　see
　　　　　　　　yourself, try and see.)

3 Andrew(M)　*sheng de [sheng de sheng de...]*
　　　　　　　　"new"　["new"　"new"　　]
　　　　　　　　("New, new, new..."　　　　　　])

4 Jason(M)　　　　　　　　[*zhao:::::shu*　　　　　]
　　　　　　　　　　　　　　[moves　　　　　　　　]
　　　　　　　　　　　　　　(["Moves."　　　　　　])

5 Andrew(M)　*zhao:::::shu*
　　　　　　　　moves
　　　　　　　　(Moves.)

6 Li(M)　　　　=*zhaoshu*

| 7 | Jason(M) | =moves
=(Moves.)
=*shi zhaoshu*
=try moves
=(Practice moves.) |

In excerpt 5.9, a game has ended and Li came out in second place. Jason asks Li to try some new moves on her own (lines 1-2). He mispronounces the word "new"—*xin* as *sheng*—and Andrew makes fun of it (line 3). Jason continues to struggle a bit with the pronunciation of "move"—*zhaoshu*—and Andrew and Li help him along. Jason's instruction to Li, however, is simply to try out new moves on her own. He did not try to show her what to press on the controllers, how many new moves there are, or what it even means to try out new moves.

Li eventually does figure out a new move, one that the other players have not seen:

EXCERPT 5.10 (00:12:30-00:12:39)

1	Li(M)	*wo wo yizhi an zhu A ranhou* I I keep press down A then **(When I keep pressing the A-button,**
2		*ta jiu you zisede nage* it then has purple that one **a purple thing appears.**
3		*dongxi shi shenme a?* thing is what question marker **What is that?)** (2.0)
4	Jason(C)	*waa gam ging ge?* wow so powerful question marker **(Wow, that's so powerful?)**
5	Li(M)	=*ni kan ni kan* =you see you see **(Look, look.)**
6	Andrew	()
7	Jason(C)	=*Li go ziu gam ging* =Li that move so powerful **=(Li's move is so powerful.)**

• CHAPTER FIVE — SITUATED PLAY •

In lines 1 to 3, Li asks about the "purple thing" that appears when she follows her given instructions and presses the A-button. However, she receives no feedback or response. Instead, while Li is talking to Jason in Mandarin, Jason addresses the others in Cantonese. After pausing to look at the move she describes, Jason remarks that Li has discovered a new, powerful move. Neither Jason nor the other players respond to her question about the new move. Seconds later, Andrew and Jason have this exchange:

EXCERPT 5.11 (00:12:51-00:12:56)

1	Andrew(C)	*waa pukgaai Li gam gang ging*
		wow damn Li so damn powerful
		(Wow, Li's gotten so powerful.)
2		*ge?*
		question marker
		(1.4)
3	Jason(C)	*hai wo go ziu1 m zi matje*
		yeah that move not know what
		(Yeah, I don't know what the move is.)
4		*wo (jathaa) hoji cong sei*
		final particle (suddenly) can crash dead
		(It can suddenly kill your character.)
5		*jandi ge wo*
		others final particles

Again speaking in Cantonese, Andrew and Jason do not address Li, even though they refer to her by name. They do recognize it as a powerful move, however, but they don't explain that to Li. When the game is in progress, Andrew, Jason, and Kevin are usually engaged in continuous taunts and challenges against one another, much akin to what some might call "smack talk" or "ritual insults." Li's questions are usually ignored or given vague responses. For example:

EXCERPT 5.12 (00:17:05-00:17:11)

1	Li(M)	*weishenme wo yi peng nimen*
		why I once touch you
		(Why is it that, once my character touches
2		*jiu hui fei fei zou diao?*
		will fly fly away

3	Jason(M)	yours, it will fly away?) *yinwei women yon zhaoshu* because we use moves **(Because we use attack moves.)**
4	Li(M)	*na wo yao zenme yong* then I want how use **(Then how do I use it?)**
5		*a?* question marker
6	Andrew(M)	=*yong shou* =use hand **=(Use your hand.)**
7	Jason(M)	=*ziji shi shi kan* =self try try see **(Try on your own and see.)**

Li calls for an explanation about particular elements of the game (lines 1-2). When she says "fly away," she is referring to how one character can suddenly kill a character with one hit. These attacks occur only when the character's percentage indicators are high (i.e., above 100%). When it occurs, the character that is attacked sails into the air and disappears off a horizon, a new character appears, and the percentage indicators turn to zero. Jason's response (line 3) is somewhat vague because he does not explain what constitutes a move. The word "move" (*zhaoshu*) in this context refers specifically to an attack move or style. In fighting game jargon, it is called a *combo move,* and knowing how to perform these moves at the right time is a key aspect of fighting games. When Li asks them how to execute a move (lines 4-5), she gets a sarcastic response from Andrew (line 6) and a suggestion from Jason to, once again, try it out on her own (line 7).

As the game progresses, Li persists in asking about the "purple thing" as well as what it means to attack others. Jason and Andrew try to provide more detailed explanations, but are given only 12 seconds to teach something new before the new game begins:

EXCERPT 5.13 (00:23:10-00:23:22)

		((game ends))
1	Li(M)	*wo zise nage wo zise nage yonglai* I purple that I purple that use

• CHAPTER FIVE — SITUATED PLAY •

2		**(That purple flashing thing, what is** *ganma ya?* do what question marker **that used for?)**
3	Kevin(M)	*da [renjia]* attack [other] **(Attacking others.)**
4	Li(M)	[*zenme da?*] [how to attack] **[(How do I attack?)]**
5	Andrew(M)	=*da renjia* =attack others **(Attacking others.)**
6	Li(M)	[()
7	Jason(M)	[*ni yao hen jin... duizhu renjia* [you have to very close facing others **[(You have to be very close and facing**
8		*an (ni zhidao) A a?* press (you know) A question marker **them, then press, you know the A-button?)**
9	Li(M)	*dui a::: an A ranhou ne?* right press A then question marker **(Right, press the A-button. Then what?)**
10	Jason(M)	*jiu hui yizhi an yizhi an* then will continue press continue press **(Then, if you keep pressing the button**
11		*duizhu renjia renjia jiu hui* facing others others then will **while facing another, it will cause them to**
12		*fei lai fei qu fei lai fei qu* fly here fly there fly here fly there **fly all over the place.)**
13	Li(M)	*o* Okay **(Okay.)**
	((game begins))	

Excerpt 5.13 occurs again during the transition between two games. Since she first discovered the purple flashing (about 11 minutes ago), Li had asked six times about its purpose and received no response. This time,

she manages to get some instructions. She asks specifically what it is *used for* (lines 1-2), as opposed to what it means visually or what it does to her character. Kevin and Andrew both give her the kind of vague answers that she has received in the past. Jason offers more specific instructions and tells her that she has to be close to the opponent and facing them (line 7). This is useful to know because not all attacks need to be done up close, and most characters have a long-range attack. He again talks about pressing the A-button (line 8) and Li acknowledges that she knows about the A-button, and asks for the next part of the instruction (line 9). Jason simply tells her to keep pressing the button (line 11) and that it would cause people to "fly all over the place" (line 12).

It should be noted that each character has seven to nine moves associated with the A-button, and four moves associated with the B-button. (This is from consulting the manual and online guides. There are likely to be additional moves that game designers have concealed.) Pressing the A-button alone executes a close-range attack but there are additional moves that can be performed if the A-button is combined with other moves, such as "A-button + up-direction," "B-button + down-direction," "jump + A-button," and so on. The expert players themselves do not seem to know all the possible combinations because they continue to discover them as they stumble across them over time. Interestingly, this group of players seemed to prefer this form of discovery instead of acquiring advanced knowledge about a character through online guides and other sources. From my interaction with the expert group, this discovery process is itself part of the "fun" because it allows individuals to develop their own expertise instead of depending on outsiders. This might explain why they seemed less interested in providing direct instruction to Li, leaving her to discover on her own. In other words, they are not teaching her to play this particular game, as much as they are teaching her to play this particular game *with them*.

Excerpt 5.14 is a slightly extended sequence. By this point, they have been playing for approximately 30 minutes, and Li implores them to teach her how to play. Andrew offers to change the character she was using to Pikachu, which Andrew and Kevin perceive to be slightly easier to use:

Excerpt 5.14 (00:30:11-00:30:34)

((game ends))

1	Li(M)	*jiao wo zhenme wan la:::::::: !*
		teach me how to play exclamation
		(Teach me how to play!)
2	Andrew	[()
3	Li(M)	[*hao jian a nimen laoshi*
		[very mean exclamation you always
		[(You're all so mean to always kill me.)
4		*sha wo=*
		kill me=
5	Kevin(C)	=*gam (nego) gam laa wai=*
		=press (this) press exclamation=
		=(Hey, press that button.)=
6	Andrew(M)	=*ni bie yong zhege la*
		=you don't use this exclamation
		(=Don't use this character, use Pikachu.)
7		*yong* Pikachu
		use Pikachu
8	Jason(M)	() Andrew *eryi a:::*
		() Andrew only final particle
		(() Andrew only.)

((players at the character selection screen))

9	Kevin(C)	*aa jung lego sin lego ging*
		ah use this first this powerful
		(Ah, I'm using this character, it's cool.)
10	Andrew(M)	*ai?*
		ah?
		(Ah?)
11	Kevin(C)	*gam laa diu nei loumou*
		press exclamation fuck your mother
		(Press the button, motherfucker.)
12		*hai aa?*
		vagina final particle
		(2.5)
13	Andrew(C)	*peikaajau*
		Pi-ka-chu
		(Pikachu.)

((Andrew chooses Pikachu for Li))

14	Kevin(C)	*peikaajau*	[*gam jungji waan4:::*
		Pi-ka-chu	[so easy play
		(Pikachu is so easy to use.)	
15	Andrew(M)		[*ni an xia ranhou*
			[you press down then
			[(Press the down-button, then
16		*an B jiu hao le*	
		press B just fine final particle	
		press the B-button, and you'll be fine.)	
17	Li(M)	*a*	
		okay	
		(Okay.)	

((new game starts))

18	Andrew(M)	*tiaolai tiaoqu*
		jump around
		(Jump around.)
19	Andrew(C)	*aai pukgaai gaanzo lego coeng*
		oh damn chose this stage
		(Oh damn it, it chose this stage.)

Li's complaints in lines 1 and 3 indicate her frustration that she has not been properly taught the game and that the others are treating her unfairly. Andrew suggests that she use a new character, Pikachu, instead (lines 6-7), and proceeds to instruct her how to execute one move (lines 15-16). He then tells her that that move alone should allow her to play, and that all she has to do it "jump around" the game (line 17). Throughout this exchange, Kevin is eager to move on to the next game. SSBM requires that each player click a button before they can move out of some of the transition screens. Kevin hurries them out of the victory screen (line 5) and character selection screen (lines 11-12). Soon after the game starts, Andrew switched back to Cantonese (line 19), complaining that the game, which was set to randomly select the stage designs, had picked one that was unfavorable to him. Throughout this (and earlier) instruction, Andrew and Jason had reduced the instruction to vague procedures such as "fly all over the place," "jump around," "keep pressing" and so on. These are, to some extent, accurate instructions but are not particularly helpful ones as they don't convey when or why you

• CHAPTER FIVE — SITUATED PLAY •

would perform any of these actions. In the next excerpt, Li claims that they have yet to teach her how to play:

EXCERPT 5.15 (00:36:16-00:36:30)

((players at the character selection screen))

1	Li(M)	*nimen you bu jiao wo* you again not teach me **(You never teach me.)**
2	Kevin	()
3	Andrew(M)	*jiaole ni a* taught you exclamation **(I taught you already.)** (0.3)
4	Li(M)	*na jiu meici yizhi an* Then every time keep press **(You always just tell me to keep pressing)**
5		*a::::::* exclamation
6	Andrew(M)	*ni yao tiao ma:::::::::::::::::* you have to jump final particle **(You have to jump,**
7		[*tiao dao renjia xiamian* [jump to others below **jump underneath others.)**
8	Jason(M)	[*ni an (zhege)* Li *an zhege* [you press (this) Li press this one **[(Press (this), Li, press this one to attack**
9		*da zhege an tui ren chuqu* attacks this one press push people away **Press this one to push people away.**
10		*haiyao an xia an xia* also press down press down **And also press down to—)**

((new game begins))

11	Andrew(M)	[*ni keyi dian ren* [you can electrocute people **[(You can electrocute people.)**
12	Li(M)	[*ba ren tui xiaqu*

13 [*preposition* people push down
 (Does it push people off the edge?)
 ma?
 question marker

Here, Li still expresses that they did not teach her how to play (line 1). Andrew says that he did (line 3), and Li tells him that all he did was telling her to keep pressing buttons (line 4). Jason, who is more familiar with the Pikachu character, steps in (lines 8-10) with more detailed instruction. He points to the controller to show her what to press. In the meantime, the next game has started and instruction promptly ends.

These series of instructional sequences have a few possible implications. First, we might characterize Jason, Andrew, and Kevin as poor instructors because they don't seem to teach Li anything. Their instructions are vague and they often do not respond directly to her questions. However, their vague instructions might partly be due to the difficulty in providing instruction while a game is in progress. Videogames, particularly action-packed ones, command considerable attention. Jason, Andrew, and Kevin do talk a lot during the game, but it is usually to comment on the game in progress. To provide instruction would require them to break out of that frame. It is hard for Li to know whether the instructions she receives during the transition screens are helpful until she tries it out for herself when the game is in progress.

Second, although the experts are not always clear, they do give her some idea of how to use the controller. However, participating in a fighting game is a lot more than just knowing the controls. While the game is in progress, the experts engage in constant conversation: they taunt and challenge one another; create alliances only to break them a few seconds later; feint and counter feint; argue about who's the better player, which character is stronger, which move is most powerful, which stage is most tedious; and so on. Li is left out of this interaction. Although none of what they said would have made her a better player—most of it being their opinions of the game—this talk is a significant part of what it means to play in that context, with these particular players.

Finally, these excerpts—particularly excerpt 5.15—bring us back to the questions: what does instruction between players look like and when does it happen? Li did not consider Andrew's instructions adequate, and he insists that instruction took place. The question "When is instruction?"

alludes to Varenne's (2007) question "When is education?"; specifically, what should we study if we want to study education? Varenne builds on Garfinkel's notion of social order and argues that instruction reflects the work needed to maintain the order. Instructional work occurs during the most mundane activities, every day, whenever one person speaks out about a perceived disturbance to the constitution of the order (e.g., when we explain to someone how something *should* be done). Li's circumstances are reversed in that she senses an underlying order—a way of playing the game—that she does not understand. She continually asks what the others are laughing at or arguing about through the games, but these questions are ignored. Li struggles to understand not simply the "how-to" part of the game, but the broader ethos surrounding it.

The excerpts so far (5.1-5.15) occurred within a roughly 40-minute segment, during which the experts tried to teach Li how to play. Li eventually left the game to play on a separate game with Andrew, leaving Jason and Kevin to play SSBM. For the remainder of the session, Jason repeatedly implored Li to return, but Li stayed away. Andrew returned to the SSBM game, but the three experts did not play at the same time. Li's departure created a fracture in the player configuration in SSBM. Between the three of them, there was an instability, in which one player was often being attacked by two others. Jason also felt that it was more fun to have more people in the game. After almost two hours, Li is persuaded to return to the game, but only under the conditions that they teach her properly how to play.

Educating the Novice

The following excerpt unfolds in around four minutes and shows a more earnest attempt by the experts to instruct Li. These have been broken down into smaller segments for easier discussion. It is worth comparing this extended sequence with earlier attempts at instruction and see why Li considered this to be more useful.

The instruction begins when Li rejoins the experts after having abandoned them for two hours. The experts break out of their two-player game to accommodate four players (e.g., moving chairs, creating more space, plugging in additional controllers to the console). However, they hold off on starting the game to provide time to instruct Li:

EXCERPT 5.16a (02:36:33-02:37:18)

((game ends))
((Jason and Andrew reorganize the room to accommodate more players))

1 Li(M) qu jiao wo wan la::::::
 go teach me play exclamation
 (Come and teach me how to play!)

2 Jason(M) ni zuo zhe
 you sit here
 (Sit here.)
 (1.0)

3 Andrew(C) [gaau keoi waan (0.9)
 [teach her play
 [(Teach her how to play.)

4 Jason(C) [() nei mhoji waan zyu ((to Kevin))
 [() you cannot play yet
 [(() You can't play yet.)]

5 Andrew(C) nei waa bingo gaau keoi waan
 You say who teach her play
 (Who should teach her how to play?)
 (1.0)

6 [bei jan waan lo
 [let people play final particle
 ["Let me play."

7 Jason(C) [(neidei) haigam saat Li..
 [(you all) keep killing Li
 [(You all) keep attacking Li.)

8 Andrew(C) nei m bei ngo gaau
 you don't let me teach
 (You don't let me teach.)

9 Jason(C) gaau keoi laa maa
 teach her final particles
 (Time to teach her.)

10 Andrew(C) =hai lo
 =right final particle
 =(That's right.)

((Jason moves them through the last game results screen))

11 Kevin(C) diu::::::::::::

fuck
(Fuck.)

((Li laughs))

First, the players reconfigure their group to include Li as a novice. Jason explicitly asks her to sit next to him (line 2) to facilitate instruction, suggesting that playing games are about interaction in actual spaces, and that it is likely easier for the expert to teach the novice how to use the controller by sitting close together and watching what buttons she presses. In lines 3 to 11, Andrew, Jason, and Kevin struggle to control the situation. As Kevin reaches for the controller, Jason bars him from playing (line 4). Andrew agrees with teaching Li (line 3) even though he wants to be involved (lines 5-6). Jason says that both of them just keep ganging up on her (line 7) without teaching her properly, apparently recalling the earlier failed attempt at instruction. Kevin, who in the past was eager to get the game moving, voices his frustration (line 11). This negotiation occurs in Cantonese, which means Li is not part of this exchange. Jason and Andrew's position suggests that they understand the need to find time to teach Li specific instructions, and that doing so while the game is happening might not be the most effective way to teach.

Excerpt 5.16b

((Jason moves to the character selection screen))

12 Andrew(C) (*hou lo) gaan jan laa*
 (fine) choose person final particle
 (Fine, choose the character.)

((Li begins picking her character))

13 Jason(M) *ni::: shi:::*
 you are
 (You are—)
 (1.0)
14 Li(M) *wo xiang nage [jiu—*
 I think that one [then
 (I think, that one then—)
15 Jason(M) [P2 *a?* (0.9)
 [P2 final particle

		[(Player 2?
16		*(ni shi* P2) *shibushi?*
		(you are P2) aren't you?
		Are you player 2?)
17	Kevin(C)	*gam laa*
		press final particle
		(Press it.)
18	Li	()
19	Jason (M)	*ni an zhege shi:::::* (0.9) *ni qu*
		you press this one is you go
		(Press this one.
20		*zheyangzi* [()
		like this
		Go like this.)
21	Li(M)	[*xian le ma?*
		[choose already
		[(Choose now?)
		(0.6)
22	Kevin(C)	*wulei laa:::::::::: wulei ciu ging*
		fox final particle fox super great
		(Choose Fox. Fox is really awesome.)
		(0.7)
23	Jason(M)	*na guolai* ()
		bring over here ()
		(Bring (the cursor) over here ().)
24	Li(M)	*o*
		okay
		(Okay.)
25	Andrew(M)	[*yong zhege… ranhou xuan*
		[use this one then choose
		(Use this (button) to select your character.)

((Li selects the character Mewtwo))

26	Li(M)	*wo haishi yao zhege*
		I still want this one
		(I still want to use this character.)
27	Kevin(C)	*ciumungmung*
		Mewtwo
		(Mewtwo.)
28	Jason(M)	=*zhege buhao yong* (0.7)

29		=this one not good use **=(This one is not easy to use** *hennan yong* very difficult use **Very difficult to use.)**

When instruction starts, Jason switches back to Mandarin. First, he tries to understand which player represents Li (lines 15-16). In prior situations, Li had little say in choosing the character. She is usually rushed along to the next game as the other players—usually Kevin—move the game forward. Kevin tries to do this again (line 17) but is ignored. Instead, Jason shows her how to navigate the character selection screen with her controller (lines 19-20) and Li tries to follow along (line 21). In lines 23 to 25, Jason tries to teach another unusual feature in SSBM, in which players select their characters by moving a token across the screen (Li gets confused by this later, see excerpt 5.17). Li expresses wanting to use a kangaroo-like character called "Mewtwo" (line 26) but Jason cautions her against it, saying that it would be hard for her to use (lines 28-29).

After teaching Li how to pick the Pikachu character, Jason starts a new game with only the two of them as players:

EXCERPT 5.17 (02:37:56-02:38:05)

1	Jason(M)	*you ji zhao la zheyang* there are few moves final particle like this **(There are a few moves, like this.)**
((new game starts))		
2	Jason(M)	*ni kan a ni guolai* you see final particle you come over **(Look at this, come over here**
3		*ni buyao dong* you don't move. **and don't move.)**

4	Li(M)	*buyao dong*
		don't move
		(Don't move.)
5	Jason(M)	*ni an xia ranhou an B*
		you press down then press B
		(Press the down-button, then the B-button.)
6	Li(M)	(*ranhou ne?*)
		(then question marker)
		((Then what?))
7	Jason(M)	*xia B*
		down B
		(The down-button, then B-button.)

((Li's Pikachu character creates thunderbolts))

8	Kevin(C)	(*si ziu laa*)
		(try move final particle)
		(Let me try some moves.)
9	Jason(M)	(*kanbukandao?*)
		(do you see?)
		((Do you see?))
10	Li(M)	=*en he*
		=uh huh
		=(Uh huh.)
11	Jason(M)	*ranhou:::a an A zai an*
		then ah press A then press
		(Then, press A, and then press)
		(2.5)
12	Li(M)	*zhe— ta zai ganma?*
		this it at doing what
		(What is it doing?)
13	Jason(M)	*tiao a*
		jump final particle
		([Make it] jump.)
14	Andrew	()
15	Jason(M)	*tiao a*
		jump final particle
		([Make it] jump.)
		(1.5)
16	Jason(M)	*wo jiao ni yi zhao a*
		I teach you one move final particle

		(I'll show you [another] move.)
17	Li(M)	*ranhou ne?*
		then question marker
		(Then what?)
18	Jason(M)	*zheyangzi tiaoqilai an zhege*
		like this jump up press this one
		(Like this, jump up, then press this.)
19	Li(M)	*dengyixia man yidian*
		wait a moment slow a little
		(Wait a moment, slow down.)

Unlike earlier attempts at instruction, this time, Li has more control over the timing of the lesson. After Jason teaches a move, he watches Li perform them, and lets her signal for him to continue (lines 6, 10, 17, and 19). He also switches between letting her perform the moves herself (lines 5, 7, 11) and demonstrating it himself (line 18). The instructions are also broken down into smaller steps, which takes roughly the form: 1) expert describes the button combinations; 2) expert watches as the novice tries the move; 3) expert repeats instructions or starts the next set of instructions. Most game tutorials seem to follow a similar format when providing onscreen instructions, giving players opportunity to fail and correct their moves. Many of the instructions (e.g., line 5, 7) represent indexical expressions that are difficult to understand. For example, "press down"—in both English and Chinese—can mean both "press the down-directional button" or "press down the button." This is made clear when Jason shows Li the controller and points to what action he wants her to perform.

Excerpt 5.18 involves two simultaneous conversations. Up until now, Jason and Li have been passing the same controller back and forth, leaving the second controller unused. Kevin and Andrew have been sitting back and watching them interact. Eventually, Andrew picks up the unused controller and begins trying out some moves of his own. Kevin joins in, and takes the controller from him.

EXCERPT 5.18 (02:38:27-02:38:45)

1	Li(M)	*dengyixia ni an ni an*
		wait a moment you press you press
		(Wait, show me for a second what

	2		*yixia wo kan*
			a moment I see
			[buttons] you press.)

((Andrew picks up the unused controller))

	3	Andrew(C)	*ngo () ngo taihaa nego jau matje ziu*
			I () I see this has what moves
			(Let me see what moves this character has.)
	4	Kevin(C)	*gaau gaau nei jat ziu*
			teach teach you a move
			(Let me teach you a move.)
	5	Jason(M)	()
	6	Kevin(C)	*gwolai aa ngo gaau nei jat ziu*
			come here ah I teach you one move
			(Come over here. I'll teach you one move.)
	7	Li(M)	=*zenme yong a?*
			=how use question marker
			(How do I use it?)
	8	Kevin(C)	=*ngo gaau nei jat ziu*
			=I teach you one move
			=**(I'll teach you a move.)**
	9	Jason(M)	*tiaoqilai an zhege*
			jump up press this one
			(Jump up, and then press this [button].)
	10	Li(M)	*ni yao (dong) zhege de ma*
			you have to (move) this question marker
			(Do you have to move this?)
	11	Jason(M)	=*tiaoqilai an shang zai an B*
			=jump up press up then press B
			=**(Jump up, press the up-button, then the B-button.)**

Both Andrew and Kevin are allowed to participate in the game provided that they do not interrupt the instruction. Kevin, who had been denied a role earlier frames his participation in terms of teaching Andrew some new moves (lines 4, 6, 8).

Excerpt 5.19a (02:39:03-02:39:26)

	1	Jason(M)	*zhege a? () an xia*
			this one final particle () press down

• CHAPTER FIVE — SITUATED PLAY •

		(This one? () press down.)
2	Li(M)	*ganma ya?*
		do what question marker
		(What are you doing?)
3	Jason(C)	Andrew *bei ngo bei ngo* Andrew
		Andrew let me let me Andrew
		(Andrew, let me, let me, Andrew,
4		*bei ngo bei ngo si ziu bei ngo*
		let me let me try move let me
		let me show her a few moves.
5		*si di je bei heoi tai*
		try some things let her see
		Let me show her a few things.)
6	Jason(M)	*an xia*
		press down
		(Press the down-button.)

((Pikachu zaps the other character with thunderbolt. Li laughs.))

7	Jason(M)	*haiyou haiyou haiyou zheyang*
		also also also like this
		(Also, also also, like this, push it,
8		*tui guoqu zuo you [dou keyi*
		push over left right [also can
		either left or right.)
9	Kevin(C)	[*ne ziu*
		[this move
		[(This move.
10		*lo zungjau* (0.4) *si sihaa*
		final particle also try try
		There's this move, too. Try this move,
11		*ne ziu lo nei ziu*
		this move final particle this move
		this move.)
12		*lo*
		final particle

In excerpt 5.19a, instead of showing only the button combinations, Jason shows Li what effect certain moves have on opponents. He asks Andrew to stop playing (lines 3-5) and then demonstrates the effect of thunderbolts. In the mean time, Andrew and Kevin pass the controllers

back and forth, taking turns to show what additional moves they can perform.

Excerpt 5.19b

13	Jason(M)	*haiyou*
		also
		(Also)
14	Li(M)	=*shibushi keyi diansi ta ma?*
		=is it can electrocute him final particle
		=**(Can it electrocute him?)**
15	Jason(M)	*haiyou haiyou*
		also also
		(Also, also)
16	Jason(C)	Andrew *mhou gaau*
		Andrew don't play
		(Andrew, quit playing.)
		(0.7)
17	Kevin	()
18	Jason(C)	=(*ganzyu* [*zoi*—)
		=(then [again—)
		=**((After that, then—))**
19	Andrew(C)	[*haa B lo*
		[down B final particle
		[(Then, the down-button and B-button.)
20	Jason(C)	*mhai hai lo ganzyu zoi*
		no yes final particle then again
		(No, [I mean] yes, then you press this.)
21		[*gam nego lo Andrew*
		[press this final particle Andrew
22	Kevin	[()
23	Jason(C)	*nei zoi gam nego hoji*
		you again press this can
		(When you press this, you can fling
24		*fing dou jandei*
		fling others
		others away.)

As the instruction continues, Jason tries to maintain control over the game and stop Andrew from interfering (line 16). Jason seems to lose track of his instruction, as he switches back to Cantonese (line 19), after

which Andrew joins in and discusses with Jason on what combination of moves to use in this given situation (lines 19-21). Specifically, Jason suggests that there are moves that can cause characters to fly off into the horizon and be killed (lines 23-24).

At this point, the instruction has transitioned to a new phase, in which Jason is not just showing Li the buttons to press, but also how to use them against other characters. In excerpt 5.20, Jason tries to explain the percentage indicator to Li (which had confused her earlier, see excerpts 5.3-5.5):

Excerpt 5.20 (02:39:28-02:39:52)

1	Andrew(C)	din　　kyun　mou matje jung
		electric power not　much use
		(Thunderbolt isn't very useful.
2		jausi　　　jaujung jausi　　　moujung
		sometimes useful　sometimes useless
		Sometimes it is, sometimes it isn't.)
3	Kevin(C)	(nei　aamaa　　waa?)
		(your mother　say)
		(Says who?)
		(0.7)
4	Andrew(C)	din　　kyun　jausi　　　jausi
		electric power sometimes sometimes
		(Thunderbolt sometimes, sometimes
5		[daa dak ()
		[hit
		[can hit ().)
6	Kevin(C)	[()
7	Jason(C)	[nei jiu　heoi do　　percent lo:::
		[you need him　many percent final particle
		[(You need [your opponent] to be at high percentage.)
8	Kevin(C)	[ngo　seizo mei aa:::　　　　wai!
		[I　　died yet final particle hey
		[(Is my character dead yet? Hey!
9		[wai! (0.8) diu:::::::
		[hey　　　fuck
		[Hey! Fuck!)
10	Jason(C)	[aa zik　　　haang

		[ah straight go
		[(Ah, go straight.)
		(1.4)
11	Li(M)	shi [ganma ya?
		is [do what question marker
		(What does it do?)
12	Kevin(C)	[sei sei bei heoi tai sei [bei heoi tai
		[die die give her see die [give her see
		[([I'll] show her how she can kill.)
13	Li(M)	[ni ni
		[you you
		[(You, you)
14	Jason(M)	=() ni you ni you xie zhao
		=() you have you have some moves
		=(() For some of your moves,
15		zhaoshu ni shi—
		moves you try
		you should try—)

((Andrew goes to the TV and points to the percentage indicators on the screen))

16	Jason(M)	ni zheli [percent
		you here [percent
		(The percentages here)
17	Kevin(C)	[sei bei heoi tai
		[die give her see
		[(Show her how to die, okay?)
18		haa?
		question marker
19	Jason(M)	=percent yueduo de hua ni zhe—
		=percent more you here
		(The higher the percentage here—)

((to Kevin))

20	Jason(C)	aai aa mhou gaau zyu sin laa
		hey don't play yet exclamation
		(Hey, don't play yet.)
		(0.8)
21	Jason(M)	ni zheli percent yueduo de hua
		you here percent more

22		**(The higher the percentage indicator here,**
		ni an shang zhexi () jiu keyi
		you press up these then can
		when you press the up-button, you can
23		da () renjia fei zou
		hit others fly away
		attack others and send them flying.)

This excerpt shows the multilayered conversations that can occur simultaneously during a game session. It also shows how difficult it is for experts, who have the jargon needed to understand a game between themselves, to switch to a different vocabulary in order not to confuse the novice. As Jason teaches Li how to use thunderbolts, Andrew begins commenting about whether it is an effective attack (lines 1-2, 4-5). Jason jumps back and forth between his conversation with Andrew and his instruction of Li, while Li almost gets sidelined during this exchange, barely getting a word in. Jason tells Andrew that thunderbolts are useful if the opponent's percentage indicator is high, and then explains this to Li (lines 16, 19, 21-23). Jason uses the slightly clumsier wording that Li uses to describe characters dying (as "sending them flying"). Kevin tries to play around with the character, and frames his actions to make himself seem helpful. He takes control of the second, unused character and says that he will "show her how to die" (lines 12, 17) by raising its percentage indicator, presumably to get it high enough that it will die when attacked. However, Jason finds this distracting and stops him (line 20-21).

Excerpt 5.21 (02:40:07-02:40:18)

1	Li(M)	na ni gangcai an nide—
		then you just now press your
		(Then, just now, you were pressing—)
2	Jason(M)	=zhege shi zhuazhu ren lai da
		=this one is grab onto someone come hit
		=(This [button] lets you grab onto someone and attack.)
3	Li(M)	zhuazhu ren lai da?
		grab onto people come hit
		(Grab onto people and attack?)
4	Jason(M)	a danshi yao hen jin

		ah but needs very close
		(Ah, but you have to be very close.)
5	Li(M)	o
		okay
		(Okay.)
6	Jason(M)	=suoyi ni.. zou jin deshihou
		=so you move close when
		(So, when you move close,
7		keneng hui gei ren da
		maybe will let others hit
		you might be attacked by others.)
	((Li laughs))	
8	Li(M)	[zheyang mingbai la
		[like this understand final particle
		[(In that case, I understand.)
9	Jason(C)	[aa ngodei hoici () hoibo hoibo
		[ah we begin play ball play ball
		[(Ah, we can start now, let's go, let's go.)

By the end of excerpt 5.21, Jason finishes his instruction with Li and moves onto the real game. This instruction activity has been more successful than the previous attempts because the activity was more of a collaboration between Jason and Li, instead of it being unidirectional (from expert to novice). Since action occurred both on the controller and the screen, instruction had to be given on both these spaces. More importantly, Li had to be instructed on how to connect the events on the screen with the moves she can perform on the controller. Excerpt 5.21 is also an example of the importance of using backchanneling to provide feedback to the speaker. In lines 3, 5, and 8, Li provides different forms of backchanneling to signal whether she has understood a remark made by Jason, and this helps facilitate the instructional process. Interestingly, when Jason calls for the actual game to begin (line 9), he switches into Cantonese, excluding Li in the process. This suggests that he considers actual-play to be what he does with Andrew and Kevin, while what he does with Li is more instructional and not-really-play. (In Chapter Seven, Jason makes a statement to this effect.)

Discussion

This chapter addressed what instruction looks like in situated play; that is, what players do and say when they try to instruct another player how to play the game. Their interaction has been presented in all the messy complexity and has shown that learning in videogames is not always smooth.

It is also worth pointing out again that what the experts are teaching is not so much "how to play SSBM," but "how *we* play SSBM." Embedded within their instructions are signs of their own orientations to the game, such as which characters are easier or better to use, which moves are powerful, what stages benefit certain characters, and so on. The experts are continuously learning about the game themselves, and their individual orientations are made visible through their discussions, or what Varenne (2007) calls "deliberations" about the game's design as an observable "fact."

Game researchers often talk about "situated learning" or "just in time" learning in videogames (Gee, 2003, 2004, 2008; Squire, 2008), specifically as it relates to how games teach people how to play. Situated learning builds on Lave and Wenger's (1991) theory of learning, which describes learning as an "integral part of a generative social practice in a lived-in world" (p. 35). Central to this theory is the notion of *legitimate peripheral participation,* which is embedded in power relations within the "community of practice." Lave and Wenger point out that this theory is more of an analytical viewpoint on learning, not a pedagogical strategy (p. 40), and should be seen as a way of describing how learning takes place. "Just in time" (JIT) learning refers to learning that occurs when an individual is given information needed to accomplish a task at hand (Collins & Halverson, 2009). This is often used in comparison to learning in schools, where students learn skills and knowledge for situations they need in the future. Oftentimes, this means that learning will be decontextualized and reduced to memorization or rote learning. JIT builds on new capitalist vocabulary and alludes to an ideal organization in operations management aimed at reducing inventory costs. Suppliers provide materials *just in time* for a manufacturer to put together the end products, thus lowering the need to carry unused materials in inventory.

While the notion of JIT makes sense, it does not fully address what it means for learning to happen "in time." To say that good instruction is

provided just in time is a tautological statement. To give an instruction "just in time" tells us nothing about whether the *right* instruction was given in time. Hand a non-gamer a controller and you are likely see that even the most well designed game tutorials can be hard to follow. Both game designers and expert gamers have to assume a basic level of understanding of how games work; when novices, like Li, enter at a level that is below this expected level of competency, misunderstanding and frustration can happen.

Instruction is a mutually constituted event between an instructional source (a game tutorial or an expert player) and the learner. We can compare the two phases of instruction that Li went through: one that resulted in frustration (excerpts 5.1-5.15) and one that resulted in enough understanding to allow for meaningful participation (excerpts 5.16-5.21). Much of what occurred in the early phase resembled situated or JIT learning, but this had failed. Clearly, providing an instruction "in time" alone is not enough for it to be a successful instruction. The experts thought that they were teaching Li, but Li did not feel the same. In the later phase, Li seemed to have learned better because Jason broke the instructions into smaller steps and addressed some of Li's questions. Li's case has shown the importance of the instructional act to be co-constructed between the expert and novice. The expert needs to know what instruction the novice needs, and the novice needs to give feedback to the expert in order to communicate whether the instruction was heard correctly and whether they can move onto the next skill. These backchannels played a significant role in helping Jason break the instructions down. In the earlier segments (excerpts 5.1-5.15), even though instruction was given, it was not understood properly, and learning did not happen. In other words, the act of giving someone an instruction to follow does not mean that learning happened, regardless of whether it was given "in time" or not.

• CHAPTER SIX •

Forms of Play
Training and Dueling

> It appears...that play is a phenomenon in which the actions of "play" are related to, or denote, other actions of "not play." We therefore meet in play with an instance of signals standing for other events, and it appears, therefore, that the evolution of play may have been an important step in the evolution of communication.
>
> —Gregory Bateson (1985, p. 181)

Scholars from different disciplinary backgrounds have sought to theorize and describe the essense of play behavior, in adults, children, and animals. The general consensus is that play is a behavior that transcends species, culture, time, geography, age, and language. The ubiquitous nature of play, however, also makes it difficult to define. It is easier to identify play when it occurs, but harder to define it *a priori*.

Some scholars who studied play behavior have noted the importance of the boundary that distinguishes "play" from "non-play." Johan Huizinga (1955) refers to this as the "magic circle," which separates the play activities from the reality of the world; Erving Goffman (1961, 1974) describes play as a framing device that helps people make meaning out of their experience; and Gregory Bateson (1985) describes play as a metacommunicative frame that communicates the denoted intent behind play and non-play actions, so that playful behavior does not get misinterpreted as more aggressive behavior.

This chapter looks at how players create new contexts in fighting games by establishing frames of interaction that structure meaning-making possibilities within their game. These new frames are usually created by adding new rules or altering or suspending preexisting ones.

Some of these rules can be altered by customizing the game design. In these cases, game designers have understood that players want different ways of interacting in the game and supplied predesigned rules that players can alter. For example, in online FPS games, players can usually pick between games that have different sets of rules with regard to teamwork, weapons, maps, timing, goals, respawning factors (whether and how often players who are killed can reenter to the game), the scoring system, and so on. Many of these predesigned rules have become standard for FPS games. The same is true for fighting games, which allow players to customize any number of rules that alters the gameplay. Understanding how to customize rules requires a fair amount of sophistication. Not only does it require players to be fairly aware of what rules are in place, it also requires players to understand what jargon such as "spawning" means.

In addition to altering design rules, players can change the way they interact with one another by making certain moves permissible in some contexts and impermissible in others. I call these *house rules* because they only govern local contexts of play, between specific players. Although house rules vary across contexts, the emergence of house rules in general is fairly common, particularly in cases where players share the same physical space and are able to articulate these rules explicitly. These rules are less formal in that the players cannot rely on the game to understand what these rules are. Since these rules are arbitrary, they are only enforceable insofar as the players involved mutually agree to be governed by these rules.

House rules give videogames added complexity and variation, allowing different groups of players to experience the game in different ways. It also provides feedback to developers, who can find out what rules players are enforcing and use that to improve their games. The ability for games to encompass so many forms of play makes them appeal to a broader range of players. While all games have a basic set of rules, there is considerable flexibility in how players can interact with the rules. The more complicated the game, and the more players involved, the more ways that players can create their own forms of play. The Internet has made it possible for us to verify the diverse ways that players interact in a game. These forms of play circulate in online

message boards such as those on Gamespot, YouTube and other social networking sites, allowing other players to adopt their own rules as well.

Fighting games provide a fascinating arena to study these player-created forms of play because they are competitive games; players who are playing against one another need to feel a sense of fairness during the game. What constitutes "fairness" changes with the house rules; thus it is crucial for all the players to agree on any newly created rules to ensure that it is mutually binding.

Over the course of the sessions, I have observed three kinds of play: training, dueling and regular play. "Training" (*siziu*) and "dueling" (*zekcau*) are terms used by the players, and "regular play" refers to when they are neither training nor dueling. The rest of this chapter focuses on *training* and *dueling*, the next chapter focuses on *regular play*.

Training

In general, training sessions—sometimes designed as tutorials in other games—are short because they are not particularly interesting for the player. Training is when there are truly no "costs" to losing; no scores are tallied and no one wins or loses. Training sessions tend to occur early on in the game so that players can figure out the basic moves that would allow them to navigate through the early parts of the game. In some cases, this is also an opportunity for the game to assess the player's level of competence and offer him/her a choice of changing the level of difficulty.

In fighting games, training occurs when players need to figure out new moves or new characters in the game. Because of the action-packed events that can occur in a fighting game, it can be difficult to keep track of the effects of an attack unless the action is slowed down or suspended. In Chapter Five, we saw the experts suspending their play to accommodate the novice. During this period, players can identify how much damage a particular attack does and what new moves can be performed, and they also have to discuss among themselves whether the moves had the observed effect. Since fighting games are short, it is easy to make an entire game into a training session; at times, however, players who discover something new in the midst of play might call for a "timeout" that would allow them to reframe the gameplay into a training session.

134 •THE WORK OF PLAY•

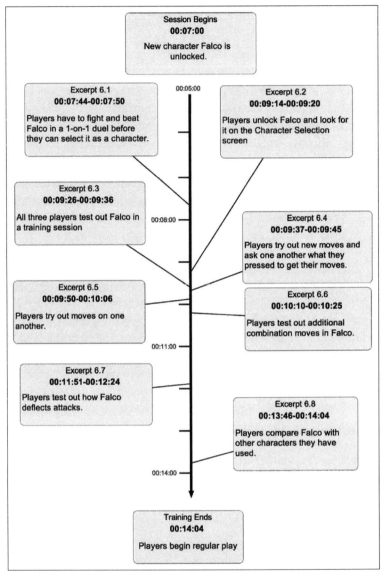

Figure 5. New character, Falco, unlocked for the first time (excerpts 6.1–6.8)

Excerpts 6.1-6.8 demonstrate a spontaneously occurring training that occurs (see Figure 5). A new character—Falco—has just been unlocked, and all three players (Jason, Andrew, and Kevin) have not seen or used it before. In SSBM, the new character is unlocked at the end of a game, after the players have accomplished a certain goal. In general, these goals

encourage players to explore different facets of the game. These goals are not known to the players ahead of time, but can often be found on the Internet.[1] (None of the players I observed looked up the goals online.) There is usually more than one way to unlock any given character. For example, to unlock Falco, the players have to either complete the *100-man melee* mode (in which they fight against 100 opponents) or play the multiplayer mode (called *vs. mode*) a certain number of times (most guides say 300 times, but some say 50 times). The player who won the previous game would have to fight against the new character and win. If they lose, they get another chance in the next round. In excerpt 6.1, Jason has just won the game and has to face Falco:

EXCERPT 6.1 (00:07:33-00:07:50)

((The game screen shows the message: "A new foe has appeared!"))

1	Kevin(C)	*wulei wo::: zung mhai* fox final particle still isn't **(It's fox. I bet it's the fox.)**
2		*wulei?* fox
3	Andrew(C)	=*san wulei wo* =new fox final particle =**(A new fox character.)**
4	Kevin(C)	*ngo dou waa ngo dou waa jau* I also said I also said has **(I told you, I told you there would**
5		*wulei ge laa nei mseon:::* fox final particles you don't believe **be fox, you didn't believe me.)**
6	Andrew(C)	=*waa gam jing ge?* =wow so stylish final particle **(Wow, it looks amazing.)**
7	Kevin(C)	()
8	Jason(C)	*waa—waa jau je dong ge?* () wow wow has thing block final particle **(Wow, it can block.)** (0.9)
9	Tim(C)	*waa laamsik ge wulei wo* wow blue-colored fox final particle

10	Kevin(C)	**(Wow, it's a blue fox.)** =*ngo dou waa*— =I also said **=(I told you—)**
11	Andrew(C)	=(*dangjatzan sin*) =(wait a moment first **=((Hold on first.))**
12	Kevin(C)	() *ngo ngo gozansi mhai waa* I I that time isn't say **(() Remember that time I said there**
13		*jau san wulei ge:::?* has new fox final particle **was going to be a new fox character?)**
14	Andrew(C)	=*hai aa* =right final particle **=(Right.)**
15	Kevin(C)	*ngo ngo gu ge wo zanhai* I I guess final particles really **(I, I was just guessing, really.**
16		*zanhai san wulei wo* really new fox final particle **(I wasn't expecting) a new fox character.)**

Part of the fun of fighting games is to see what new characters are unlocked. SSBM contains multiple versions of the same character, for example, Mario and Dr. Mario, Link and Young Link, and so on. In excerpt 6.1, it is unclear whether the "new fox character" that Kevin and Andrew meant to refer to another version of the Fox McCloud character, or another character from the *Star Fox* game series. Falco is, in fact, not a fox but a falcon from the *Star Fox* game series. Excerpt 6.1 is a good example of the conversation analysis (CA) notion that the meaning of an utterance (or series of utterances) is not always clear until we see how the entire sequence plays out. The character Falco appears small on the screen and moves quite fast. Kevin first interprets it to be a fox-like character (lines 1-2). Interestingly, he tells Andrew that he had been predicting "fox" to show up (lines 4-5), then backtracks later on (lines 12-13, 15-16), when he says that his prediction had been a wild guess.

After Jason defeated Falco, they got a better look at the character, and saw that it was a bird:

Excerpt 6.2 (00:09:14-00:09:20)

((Andrew, Jason, and Kevin at the character selection screen.))

1 Jason(C) *mhai mhai mhai wulei lai gaa:::::*
 not not not fox final particles
 (It's not a fox.)
2 Kevin(C) *dangzan sin*
 wait moment first
 (Hold on first.)
3 Andrew(C) *zoek lei gaa* (0.8) *zek hai zoek*
 bird final particles a damn bird
 (It's a bird. A damn bird.)
4 Kevin(C) *hai wo::: zoek lai go wo:::*
 yes final particle bird final particles
 (Oh right, it's a bird.)

Note the parallel between excerpts 6.1 and 6.2, in which all players take turns publicly acknowledging what they saw. In excerpt 6.1, Kevin's comment (line 1-2) is acknowledged by Andrew (line 3) and Tim (line 9); in excerpt 6.2, Jason's comment (line 1) is acknowledged by Andrew (line 3) and Kevin (line 4). This confirmation, while not mandatory within the interaction, is similar to Li's "misinterpretation" of the percentage indicators in Chapter Five, in which the players have to all share a similar orientation to the game. This successful confirmation affirms that each player is oriented the same way to the game. Even though the initial orientation was wrong, they all perceived the same error; likewise, when they corrected their orientation, they all attained a new perception to the game.

After Falco is unlocked, Andrew, Kevin, and Jason started a new game, all picking Falco as their character. (Tim only watched and seldom played SSBM with them.) Having two or more players share the same character is rare because it is hard to tell one apart from the other on the screen, even if they made their characters a different color. The only time it is commonplace is if they are in training, which is the players' methods of discovering the features and abilities of a particular character:

Excerpt 6.3 (00:09:26-00:09:36)

((A new game begins.))

1	Jason(C)	*jatjoeng ge di ziu?*
		same question marker these moves
		(Its moves are the same?)
		(2.4)
2		*wai mhou daa::mhou daa zyu*
		hey don't hit don't hit yet
		(Hey, don't hit me yet, (I'm) trying
3		*si ziu zaa::*
		try move only
		out some moves.)
		(1.9)
4		*tung wulei (dit) ziu jatjoeng*
		with fox (possessive) move same
		(Are its moves same as Fox's?)
5		*gaa?*
		question marker
		(3.2)
6	Kevin(C)	*hai wo*
		right final particle
		(Oh yeah.)

The first thing that players usually attempt when encountering a new character is to try button combinations that worked with previous characters. The down-direction on the analog stick combined with the B-button executes the thunderbolt on Pikachu; the same combination executes a hand slap from Donkey Kong, and so on. In excerpt 6.3, we see Andrew and Kevin discussing whether Falco has the same moves as Fox. When Andrew executes a move and says that it's similar to Fox's (line 7), Kevin tries out the move himself and agrees (line 6). However, same-ness can be difficult to distinguish because most characters share a basic set of attack moves (e.g., punch, kick, projectile attack) but also have a few unique attacks. Even if the action is the same, the damage effect could be different.

During training, players are essentially collaborating to discover new knowledge. Although any new attacks can potentially be used against you later in a game, these players did not withhold information from one another during training. Instead, they had to organize the training such that there was opportunity to test out new moves on one another, which

can be difficult since everyone wanted to be the first to discover a new move:

EXCERPT 6.4 (00:09:37-00:09:45)

1	Andrew(C)	*waa ji ziu matje* wow this move what **(Wow, what is this move?)**
2		*lei gaa?* question markers
3	Kevin(C)	=*bin ziu aa?* =which move final particle **=(Which move?)** (0.9)
4	Andrew(C)	*wai gwolei wan jan gwolei* hey come here find someone come here **(Hey, come here. Someone, come here and**
5		*sihaa ziu* try move **let me try out some moves.**
6		Kevin *mhou juk* Kevin don't move **Kevin, don't move.)**
7	Kevin(C)	*dimjoeng cok [aa:::::?* how execute [final particle **(What buttons do you press?)**
8	Andrew(C)	[*mhou juk* [don't move **[(Don't move.**
9		*nei gwolei sin aa* you come over first final particle **Come over here first.)** (0.5)
10		*wai gwolei wan jan gwolei* hey come here find someone come here **(Hey, come here. Someone, come here.**
11		*lok— loklei haabin* down—down come down here **Come down here [to me].)**

The interaction between these players when they are training is similar to when they tried to teach the novice how to play (see Chapter Five, excerpts 5.16-5.21). In both cases, there was a need to stop the action in the game in order to see what was happening when the character performed a certain action. This becomes tricky when everyone is trying out a character and wants everyone else to stop moving. At the same time, these players are also keeping track of what others are doing with their characters, to see if someone else had discovered a new move.

Since they all wanted to be the first to discover a new feature about the character, there were numerous times when one player would put off answering another player's question about a new move until they have fully understood it themselves. In excerpt 6.4, Andrew discovers a new move (line 1), but as Kevin asks him repeatedly for more information (lines 3, 7), Andrew postpones answering him. In Chapter Five, a similar situation occurred with Li, during which she discovered a new move ("the purple thing," excerpts 5.10, 5.11) that the experts did not know about, and when she repeatedly asked about the move, the experts ignored her question. While their refusal frustrated Li, among themselves, this hedging was not necessarily a selfish move because they did eventually share their knowledge of moves after they figured things out own their own:

EXCERPT 6.5 (00:09:50-00:10:06)

1	Andrew(C)	*nei sihaa jyundei jung:: ji ziu*	
		you try on the spot use this move	
		(Try using this move on the spot.)	
2		[*mou jung go wo (jyundei−)*	
		[no use final particles (on the spot)	
		[(Can't use it (on the spot).)	
3	Kevin(C)	[*dimjoeng dimjoeng jung gaa?*	
		[how to how to us question marker	
		[(How do you use it?	
4		*dimjoeng jung gaa?*	
		how to use question marker	
		How do you use it?)	
5	Jason(C)	=*neidi sihaa mhou juk*	
		=you try don't move	
		=(Don't move.	

6		*neidi sihaa mhou juk*
		you try don't move
		Don't move.)
7	Kevin(C)	*jau jung aa*
		has use final particle
		(The move works.)
8	Jason(C)	*neidi1 sihaa mhou juk*
		you try don't move
		(Don't move.
9		[*neidi sihaa mhou juk*
		[you try don't move
		[Don't move.)
10	Kevin	**(Okay.)**
11	Jason(C)	*wai mhou juk zyu sin laa wai!*
		hey don't move yet first exclamation hey
		(Hey, don't move yet!)
		(1.5)
12		*wai!*
		hey
		(Hey!)
13	Andrew(C)	() *daa*
		hit
		(() hit.)
		(2.3)
14	Jason(C)	*dang sin dang sin mhou juk*
		wait first wait first don't move
		(Wait, hold on first, don't move
15		*mhou juk m juk m juk zyu*
		don't move no move no move yet
		don't move, stop moving, don't move yet
16		*zanhai mhou juk zyu*
		really don't move yet
		don't move yet, seriously.
17		*sihaa ji ziu sin*
		try this move first
		Let me try this move first.)

In excerpt 6.5, Andrew asks Kevin to try out a move "on the spot" (line 1), which means without jumping upward or sideways. Some attacks have to be performed in combination with another action and Andrew

wants to know whether it is a valid move on its own. However, Andrew never tells Kevin what the move is and Kevin has to get this information out of him first (lines 3-4). After Andrew shows him, Kevin tries it out for himself and points out that the move can be executed on the spot. As Andrew and Kevin continue to study the move, Jason discovers a move as well and repeatedly asks one of them to stop moving so that he can try it out (lines 5-6, 8-9, 12, 14-17).

The players use the word "try" (*sihaa*) several times in this brief exchange (lines 1, 5, 6, 8, 9, 17). While "try" can mean "to test out," it can also be used to soften a request, especially when it is used in the form "you try" (*nei sihaa*). For example, Jason uses it repeatedly when he requests one of them to stop moving so that he can practice a move on them. Unlike the actual attacks that come during regular play, attacks during training are less aggressive in two ways. First, by softening the request and being more polite, the players help defuse the problematic implication that one is, in fact, requesting permission to attack. Second, instead of the attacker going to where the other player is, training attacks occur when the attacker requests the other player to come over to be attacked. This puts the attacker in a more passive role and makes the attack itself less aggressive. We saw this passiveness in excerpt 6.4, lines 4 to 6 and 8 to 11, when Andrew repeatedly asks Kevin to come over to him. This form of request continues in excerpt 6.6:

EXCERPT 6.6 (00:10:10-00:10:25)

1	Jason(C)		*tek dak hou jyun wo:::*
			kick can very far final particle
			(It can kick very far.)
2			Andrew *nei sihaa loklei*
			Andrew you try come down
			(Andrew, try coming down here.)
3		Andrew	**Okay.**
4	Jason(C)		() *ngo kei gobin*
			() I stand over there
			(() I'll stand over there.)
5	Kevin(C)		*wai! dimjoeng* [*hoji—*
			hey! how [can
			(Hey, how do you—)
6	Jason(C)		[*waa! hoji gamjoeng*

		[wow! can like this
		[(Wow, it can do this?)
7		*gaa?*
		question marker
8	Kevin(C)	=*wai wai dimjoeng hoji*—
		=hey hey how can
		=(Hey, how do you—)
9	Andrew(C)	[=()
10	Kevin(C)	[=*hoji hoji dimjoeng*—
		[=can can how
		[=(How can you—)
11	Jason(C)	*daan hou jyun go wo nei sihaa*
		bounce very far final particle you try
		([The enemy] bounces away very far. Try
12		*gam gam gam zo jau C C zai*
		press press press left right C C-button
		pressing left-right, then the C-button.)
13	Andrew(C)	*o::: zekzek dou hai gam gaa laa:::*
		oh each also is like that final particles
		(Oh, all the characters can do that."
14	Kevin(C)	=*hai lo*
		=yes final particle
		=(That's right.)
15	Jason(C)	*daanhai nigo houci tek dak jyun di*
		but this seems kick can further a bit
		(But this seems to be able to kick further.)
16		*go wo*
		final particles

In excerpt 6.6, Andrew and Kevin disagree about an observation Jason makes about a character. First, Jason and Andrew organize themselves in the virtual space so that Jason can attack Andrew's character (lines 1-3). Once Jason makes the attack, he exclaims that the Falco character seems to have a powerful attack (line 6, 11). He then tells them the controls and asks the others to try it for themselves (lines 11-12). Andrew points out that the other characters have a similar move (line 13), and Kevin agrees (line 14), but Jason insists that this kick seems to be more powerful because it causes the enemy to fly further away (line 15).

Excerpt 6.6 demonstrates a kind of verification work, during which one player makes a claim (lines 1, 11-12) and others verify it (lines 13, 14).

We see it throughout their training session. In excerpt 6.1 and 6.2, we already saw that verification isn't so much about the truth-value of their experience as much as it is about arriving at consensus on their shared experience. In ethnomethodological terms, it is a form of *accountability* that ensures that each player sees what the others see. Additional verification work can be found in excerpt 6.3, when Jason makes a claim about Falco's abilities in comparison to Fox (lines 1-6), and Kevin agrees (line 7). In excerpt 6.5, Andrew makes a claim that a certain move doesn't work (line 1), and Kevin disagrees (line 8) after verifying it himself. Verification work is an integral part of training because it allows players to share their expertise and understanding of an aspect of a game and test it for themselves. In fact, verification work is a significant aspect of any form of collaborative learning. Note that some aspects of the game are easier to verify than others. For example, it is easy to verify how much damage a certain move makes by looking at the percentage indicator on the screen. An attack that causes a large rise in the indicator translates to a powerful attack. Other features, such as how high a character can jump, or how far it causes the enemy to fly off, is harder to ascertain with accuracy and objectivity. In these cases, the players would have to agree among themselves as to whether a particular feature of the game exists.

Verification work is part of the social activity of playing videogames. Excerpt 6.6 shows verification work at the most local level, but this work continues among larger numbers of players, across space and time. Online walkthroughs are the best example of ongoing verification work, during which a player begins writing and sharing a guide for a game and revises it over time, usually with the help of dozens of other players. Websites such as gamespot.com, ign.com, gamefaqs.com, and neoseeker.com are some sites that allow players to share and collaborate on walkthroughs. Some of these guides are devoted to the entire game, whereas others focus on just one character; some of these latter kinds provide in-depth analysis on how to handle a character on each of the different stages and against each of the playable characters. Verification work also goes on in online forums, which are usually housed in the same websites mentioned above. Oftentimes, authors of walkthroughs would use the discussion that began on the message boards and include them in the walkthroughs.

In excerpts 6.3 to 6.6, the training appeared haphazard because the players were trying out combination moves that they were familiar with.

• CHAPTER SIX — FORMS OF PLAY •

Excerpt 6.7 occurs after they have test piloted Falco for one game and are now trying to compare it against other characters:

Excerpt 6.7 (00:11:51-00:12:24)

1	Andrew(C)	wai sihaa jat coeng percent geido hey try one shot percent how much **(Hey, try seeing how much damage one shot does.)**
2	Jason(C)	=wai dimjoeng hai dimjoeng hai fei =hey how is how is fly =**(Hey, how do you make it fly,**
3		dimjoeng hai cyu hei aa? which is store energy final particle **and how do you store energy?)** (1.3)
4		fo go ziu le::: tungmaai— fire that move final particle and **(The move with the fire, and—)**

((Jason performs the move on the screen.))

5		ni ziu le::: tungmaa fo this move final particle and fire **(This move, and the fire move.)**
6		gam sat aa? press solid final particle **(Do I hold down [the button]?)**
7	Kevin(C)	gam gam gam soeng zai press press press up button **(Press the up-button.)** (2.8)
8	Jason(C)	gam sat tungmaai m gam sat press hold and not press hold **(It makes no difference whether I**
9		hai jat hai m jatjoeng gaa? is is not same question marker **hold down the button or not?)**
10	Kevin(C)	hai aa right final particle **(That's right.)** (1.4)

11		*bingo hai ngo aa?* *bingo*
		who is me final particle who
		(Which character is mine? Which character
12		*hai ngo aa?*
		is me final particle
		is mine?)
		(1.3)
13	Jason(C)	*ngo hai hung sik*
		I am red color
		(I'm the one in red.)
14	Kevin(C)	=*wai sihaa bei ngo se se jat*
		=hey try give me shoot shoot one
		=(Hey, let me shoot one of you, see
15		*coeng::::: tai haa geido*
		shot see how much
		how much [damage it does].)
		(0.9)
16	Andrew(C)	*lei aa se ngo*
		come shoot me
		(Go ahead, shoot me.)

((1.3 - Andrew's character stands facing Kevin's, but Andrew puts up a shield. Kevin's shot bounces off the shield and reflects back to him.))

17	Andrew(C)	*waa faandaan go wo*
		wow reflects final particles
		(Wow, it can reflect shots.)
18	Kevin(C)	*hai faandaan ze::: wai mhou*
		yes reflects only hey don't
		(Yes, it can reflect. Hey, don't put up
19		*faandaan laa::: diu*
		reflect exclamation fuck
		the shield, damn it.)
20	Jason(C)	*hai matje dou faandaan gaa?*
		is what also reflect question marker
		(Can it also reflect everything else?)
		(1.0)
21	Andrew(C)	[() *gunggik keoi*
		[attack it
		[(() attacks it.)
22	Jason(C)	[(*hai matje—*)

		[(is what)
		[(Does it—))
23	Kevin(C)	[*peikaaciu peikaaciu*
		[Pikachu Pikachu
		[(Pikachu, it can reflect against
24		*go ziu je hoji faandaan lo*
		that move thing can reflect final particle
		that Pikachu move.)
25		*keoigo din*
		his electricity
		(His electrocution attack.)

The purpose of training goes beyond simply trying out a new character. Players in fighting games tend to specialize in a small number of characters. Thus, a new character can potentially be either a character to specialize in or a character to fight against in the future. Training is not always restricted to learning about the new character; it can also lead to discussion about the potential of other characters' abilities or other features of the game. In excerpt 6.6, line 13, Andrew points out to Jason that a feature that he has discovered was actually common to other characters as well. We see this in excerpt 6.7 as well, when players build on their prior knowledge of other characters' abilities as a basis of comparison. First, Andrew suggests checking out how much damage Falco's long-range weapon (i.e., a gun) does (line 1). Jason interrupts him and asks him about the controls for flying and storing energy. He expresses confusion because the two combinations appear to be similar and he asks whether it makes a difference whether he holds down the buttons or not (line 6, 8-9). Kevin tells him there is a difference (line 10), and continues with Andrew's earlier question regarding the gun's damage (line 14-15). Andrew allows Kevin to shoot him (line 16), only to put up a shield that causes Kevin's attack to reflect back (line 17). Kevin asks him to put the shield down (line 18-19), and Jason follows by asking whether the shield can deflect all attacks (line 20). Kevin's response in lines 23 to 25 is interesting because he claims that it can deflect Pikachu's electricity attack even though, at that point, none of the players had tested Pikachu on Falco yet. (Pikachu also happens to be a character that Jason specializes in.) It is also a claim that they cannot verify until another game, when someone chooses Pikachu against Falco. Jason then suggests trying another move that is available to other characters and Kevin follows his lead.

Excerpt 6.8 occurs at the end of the Falco training, during which the players sum up their observations about the new character:

EXCERPT 6.8 (00:13:46-00:14:04)

 1 Jason(C) ngo dou hai gokdak peikaaciu
 I still is feel Pikachu
 (I still feel Pikachu is (better).)
 2 (houdi jung)
 (better use)
 3 Kevin(C) waa gam gang jing ge wai
 wow so damn awesome hey
 (Hey, look how awesome it looks.)

((Kevin comments on the victory screen and laughs.))

 4 Jason (C) ciumungmung zung ging batgwo
 Mewtwo more powerful but
 (Mewtwo is more powerful than [Falco].
 5 ngo dou gokdak ciumungmun
 I also feel Mewtwo
 I think Mewtwo is more powerful than
 6 zung ging gwo nigo ngo gokdak
 more powerful than this I feel
 this.)
 7 Kevin(C) ngo gokdak.. bobo zeoi ging
 I feel Jigglypuff most powerful
 (I think Jigglypuff is the most powerful.)

((Players selecting their character for the next game.))

 8 Andrew(C) sihaa zoi jung faan nigo sin
 try again use back this one first
 (Let me try and use Falco again.)
 9 Jason(C) (junghaa zigei di jan sin)
 (use self person first
 ((Let me use my own characters.))
 10 Andrew(C) =()

((1.0 – Jason picks Mewtwo; Andrew and Kevin stay with Falco.))

 11 Kevin(C) bobo zeoi ging
 Jigglypuff most powerful
 (Jigglypuff is the most powerful.)

12	Jason(C)	*ciumungmung*
		Mewtwo
		(Mewtwo.)
13	Kevin(C)	*ngo jiu lin nigo zoek*
		I want practice this bird
		(I want to [specialize] in this bird (Falco).)

All three players specialized in different characters: Jason specialized in Pikachu and Mewtwo; Kevin specialized in Jigglypuff and, eventually, Falco; and Andrew specialized in Marth. Specialization does not mean that they never play other characters, only that they tend to stick with one or two more frequently. Since fighting games usually provide players with a large number of choices, it is not surprising that players do not specialize in all of them. In excerpt 6.8, Jason declares that he still thinks Pikachu and Mewtwo are the most powerful (lines 1-2, 4-6), and Kevin says the same for Jigglypuff (lines 7, 11). None of these characters are more powerful in the objective sense, but some might be better suited for some players' styles of play than others. These declarations should be seen more as assessments on which characters fit their styles the most. However, these declarations are part of the enjoyment of the game as it gives players the opportunity to share their expertise by arguing which character is better and why. While these declarations are subjective, they are not empty opinions; instead, they can be backed by points regarding which character can jump the furthest, or has a more powerful weapon, and so on.

As Gee (2003, 2004, 2007) points out, the player is in a tripartite relationship with the virtual character. There is the identity of the player (Gee calls this the *real identity*), the character (the *virtual identity*), and the player-as-character (the *projective identity*). The projective identity is what allows the player to think in terms of *what I can do with this character's skills*. He argues that this projective stance allows people to role-play what it means to possess a skill that they do not have in their real identities, and use this skill in a relevant context. In excerpt 6.8, the players begin to develop a relationship with a certain virtual character, and may or may not grow to like it over time. If they don't, they do not specialize in it. If they do, they may then find out more about what a certain character can do under different circumstances or against other opponents. (More is said on this topic below.)

The Meaning Potential of Videogames

As the examples in excerpts 6.1 to 6.8 show, these players spend considerable time discussing the merits of a character. These discussions evolve over time as players make claims that are verified by other players.

Videogames, like other literary artifacts, have open-ended systems of meaning. In other words, it is impossible to fully understand the meaning potential—to use a Hallidayan term (1978)—of a game. *Meaning potential* refers to the possible meanings that a word, utterance, or action can have. This potential is closely related to the participants, the context of the interaction, as well as broader social-cultural environment. Meaning potential is open-ended in the sense that meanings change over time and across interactions, where time can refer to a long timescale (measured in years) or a shorter one (measured in seconds and minutes). Throughout the excerpts, Falco's potential changed as the players interacted with it. First, its visual identity was mistaken; then, the players understanding of the character's potential changed as they interacted with it individually and as a group. Much of its potential was also measured against other characters' abilities, which means it was seen as a weak or strong character depending on who it was compared against.

Observing the players' process of discovering Falco's potential is comparable to the scientists' process of discovering a pulsar (Garfinkel, Lynch, & Livingston, 1981), in that the process is uneven until some consensus is made among the players. This training session is analogous to scientists in the laboratory, experimenting, engaging in trial and error, and testing hypotheses. Since the meaning potential is open-ended, players are never fully done with discovery, and they continue to learn new things about their characters, as well as the game in general, as they continue to play. The players do not need to have all the information about the game in order to play but they do need *enough* of it to move forward. It can be difficult to ascertain how much any given player needs to know in order to continue (as witnessed in Chapter Five). Furthermore, it is also possible to continue playing even with mistaken knowledge of the game. The "experts" in Chapter Five became novices here as they learned about a new character in the game. On several occasions, they were not only learning about Falco, but about other features of the game, such as when Andrew tells Jason, in excerpt 6.6, line 13, that "all the characters can do

[that move]." Players also learned from one another, with Jason and Andrew doing most of the discovery and Kevin doing the verification.

In addition, their sharing of knowledge during training also sheds light on the kind of play they are engaging in during their regular play session. They could have withheld information about a move so that they can be in a better position to win later on. We can contrast this with Li's learning experience, during which they did withhold information from Li. Li, in turn, complained about them "bullying" or "taunting" her and eventually abandoned the game and refused to return until they agreed to teach her properly. This suggests that the same players can be both selfish and unselfish, depending on the way they interact, specifically with regards to the tacit social rules that they use to organize their actions.

Dueling

Play theorist Roger Caillois (1961) suggests four categories to classify games. *Agôn* (e.g., chess, football) are games in which opponents share a common ground and compete over a particular set of skills; *alea* (e.g., slot machine, dice) are games of chance, in which players have little direct control over the outcome of the game; *mimicry* (e.g., simulations, role-playing games) are games of make-believe, in which the players take the role of a part within the game; and *ilinx* (e.g., rollercoaster, bungee jumping) are games of vertigo, where fun is often derived from the thrill of feeling a brief moment of controlled physical danger. While these categories are broad, they do serve as a useful way of considering the different things that are at stake in different games. Some games might fall under more than one category, and my concern here is to contrast the features of *agôn* and *alea* in fighting games, specifically with regard to how they can change from one category to the other, depending on what rules the players decide to highlight.

The Cantonese term they use for dueling—*zekcau*—literally means going one-on-one with an opponent. The focus of these games is not simply to win, but to win *fairly*; and what constitutes "fairness" is something that the players have to agree on.

As mentioned before, in SSBM, when a player kills an opponent, either by maxing out their percentage indicator and sending them flying off the screen horizon, or by knocking them into a gap or off a ledge in the game's stage, the player receives a +1 while the vanquished opponent receives a -1 to their score. If, however, a player falls off a ledge on his own, then the player

gets a -1, and no one receives a +1. At the end of the game, the player with the most score is designated the winner. In addition, SSBM's stage designs interact with the players in various ways. Sometimes, they force the players to have to jump around from one platform to another as the point of view changes; players who are unable to catch up are killed. Other features include items that are dropped that can damage or extend a character's abilities.

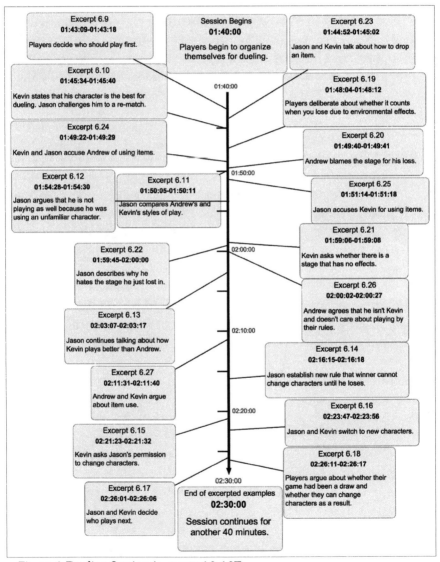

Figure 6. Dueling Session (excerpts 6.9-6.27).

• CHAPTER SIX — FORMS OF PLAY • 153

The following excerpts describe how dueling emerged as a form of play between Jason, Andrew, and Kevin, focusing specifically on the rules they generated to redefine their play. Prior to this, they had often argued about who the better player was among them, but had not made any changes to their configuration that allowed them to measure one another's skill. As with Chapter Five, the following excerpts are grouped thematically and are presented out of order. The entire dueling session lasted about 80 minutes. The examples here come from the first 50 minutes, during which the players establish the ground rules for their dueling. To see how the excerpts fit chronologically, see figure 6.

Character Skill and Player Style

The rules for dueling started simple. They were free to pick any characters they wanted, they were free to pick up items, and they let the game randomly pick a stage. In other words, there was little to distinguish it from regular play, except that only two players are allowed in the game. The rules did not stay simple, though. As the dueling progressed, the players began adding rules to make it harder for any player to stay a champion. These rules also served as a way of distilling the essence of being a good player — whatever that meant to this particular group — and through their articulation of rules, we can come to understand what these players value.

To decide which two players gets to start, Andrew, Jason, and Kevin did a version of the rock-paper-scissor, which determined that Jason and Kevin were to be the first to duel. After that, they reconfigured the game into a two-player game. Since players tend to specialize in certain characters, they had free reign over which characters they initially chose. Choosing the right character to fight against a particular opponent was an important strategy to understand.

Jason already had Pikachu selected from the prior game:

EXCERPT 6.9 (01:43:09-01:43:18)

((At Character Selection Screen))

1 Kevin(C) *jun bingo sin zekcau?*
 use who first duel
 (Who should I duel with first?)

2 Andrew(C) =()

3 Jason(C) *nei lo.. bobo maa::::*
 you final particle Jigglypuff final particle
 (You (use) Jigglypuff.)

4 Kevin(C) =*ngo m soeng bobo gaa*
 =I not think Jigglypuff final particle
 (I'm not thinking of Jigglypuff.)

5 Andrew(C) *gaan zeoi koeng go*
 pick most strong one
 (Pick the strongest one.)

6 Jason(C) *aa wo mhai mhai mije wo*
 ah isn't isn't what final particle
 (Ah, it's not that.)

7 Andrew(C) *zeoi ging daa zeoi ging*
 most powerful attack most powerful
 (Have the most powerful fight against the most powerful.)

((1.3 – Jason switches his character from Pikachu to Mewtwo.))

8 Kevin(C) *waa gamjoeng mou zoeksou*
 wow like this no advantage
 (Wow, this doesn't give me an advantage.)

9 *wo gamjoeng*
 final particle like this

Character selection is especially important during dueling because the player has to know the opponent's strengths as a player and what characters he might have to fight against. Since it is a two-player game, the player cannot rely on other players to help him fight. Jason had assumed that Kevin would pick Jigglypuff against his Pikachu (line 3), but when Kevin decides to pick something else (line 4), Jason changes his mind and switches his character to Mewtwo. Kevin, in turn, notes that there isn't another character that would give him an advantage. He ultimately selects Falco, with whom he had been practicing since it first became a playable character. Andrew, who is a spectator in the next game, suggests that they pit the "most powerful against the most powerful" (lines 5, 7), which seems to reinforce the idea that players think of characters as part of their individual repertoire instead of as isolated entities. Here, "most powerful" refers to the most powerful character among those they have specialized.

• CHAPTER SIX — FORMS OF PLAY •

Kevin's Falco ends up beating Jason's Mewtwo in the game, and the discussion about characters continue:

EXCERPT 6.10 (01:45:34-01:45:40)

((Game has just ended.))

1	Kevin(C)	*hou gang ging nigo zekcau* very damn powerful this one duel **(This character is so damn powerful**
2		*zanhai gam gang ging* really so damn powerful **for dueling, so damn powerful.)**
3	Jason(C)	*m gok lo::::::::* not feel final particle **(I don't feel (that way).)**
4	Andrew(C)	*zekcau!* [() duel **((Let's) duel!)**
5	Jason(C)	[*ngo jung peikaaciu nei* [I use Pikachu you **[(If I use Pikachu, you won't**
6		*jatding m gau ngo daa* must not enough me beat **be able to beat me.)**
7	Kevin(C)	=*sihaa!* =try =**(Try it!)**
8	Jason(C)	*hou!* fine **(Fine!)**

((Kevin laughs.))

These kinds of between-game assessments of the prior game are common, not only in dueling but during their regular play as well. The assessments, like verification work, serves to continually readjust the players to what is going on in the game. That's not to say that they agree. In excerpt 6.10, Kevin argues that Falco is a powerful character for dueling (lines 1-2) and Jason disagrees (line 3). Part of the reason may be that he had died a few times when he could not navigate his character through the stage. So, even though he had lost the game, he argues that

Falco is not really that powerful and certainly not against Pikachu (lines 5-8). The banter between Jason and Kevin can be seen as posturing, especially after Kevin laughs about their discussion in the end. It also suggests that the game's outcome is not always as straightforward as one presumes. The game might have declared Kevin to be the winner, but there is disagreement about whether that win was justified or an accurate reflection of Jason's abilities.

Note again that the players first attribute the win to the character's abilities (lines 1-2); even when they talk about individual skills, it is done in reference to a particular character (lines 5-6). This continues throughout their dueling; for example, in excerpt 6.11, Jason, who is observing Kevin and Andrew, comments on Kevin's style of play:

EXCERPT 6.11 (01:50:05-01:50:11)

((Kevin vs. Andrew; Jason observing.))

1	Jason(C)	Kevin *waan bobo* *godi hai jau*
		Kevin play Jigglypuff those is has
		(When Kevin uses Jigglypuff, he does it
2		*geiseot () keoi janwai keoi zeon*
		style he because he good shot
		with style, because he's a good shot.
3		*keoi jau geiseot*
		he has style
		He plays with style.)

((Kevin laughs.))

4	Jason(C)	*nei lidi mhai wo* *nei*
		you these isn't final particle you
		(You're not like that. You only know how
5		*zinghai sik* *zap je haijan dou sik*
		only know pick up anyone also know
		to use items. Anyone can do that.)
6		*laa::::::::::::*
		final particle

Jason contrasts Kevin's style (lines 1-3) with Andrew's (lines 4-6), whom he criticizes for constantly using game items to enhance his play. In Cantonese, style (*geiseot*) connotes a meaning that combines aesthetics and skill. The idea of playing *with style* is a common feature of

videogames that many designers implement. This often means that players are not only encouraged to beat the opponent, but to do it in an elegant way, for example, by pulling off a difficult combination move or to strike as many opponents as possible without being hit. In this example, style is something that the players continually redefine over the course of their play.

Excerpts 6.12 and 6.13 are further examples of players discussing their play in terms of particular characters. In excerpt 6.12, Jason has switched from his usual specialized characters (Pikachu and Mewtwo) and chosen Pichu—a variation on the Pikachu character. When he plays poorly, he points out that it is because of his unfamiliarity with the character:

EXCERPT 6.12 (01:54:28-01:54:30)

((Jason vs. Andrew; Kevin observing.))

1	Jason(C)	*ngo hai janwai junggang peiciu*
		I am because using Pichu
		(It's only because I'm using Pichu that
2		*zaadi zek waa*
		poorer only final particle
		I'm playing so poorly.)

In excerpt 6.13, Jason once again argues that Kevin and himself play beautifully (lines 1-3, 8-9). He does not attribute the skill to himself, but to his *use* of a certain character:

EXCERPT 6.13 (02:03:07-02:03:17)

((Jason vs. Kevin; Andrew observing.))

1	Jason(C)	Kevin *godi hai daa dak hou leng*
		Kevin those is can fight very beautiful
		(Kevin here fights really beautifully.
2		*lo::::: houci ngo daa ngo*
		final particles like I fight I
		Like when I fight and use Pikachu—)
3		*jung peikaaciu—*
		use Pikachu
4	Andrew(C)	=*aai dak laa dak laa dak laa*
		=exclamation okay okay okay

5		=(Oh, okay, okay, okay, okay, *dak laa* [*aai::::::: zenghai syumhei* okay [just cannot afford to lose **you're just a sore loser.)**
6	Kevin(C)	[() (0.9)
7	Kevin(C)	*diu zanhai go wo* fuck really final particles **(Fuck, it's true.)**
8	Jason(C)	*hailo Kevin godi zanhai daadak* that's right Kevin those really can fight **(That's right. Kevin can really fight**
9		*leng houci* Andrew *godi gam* beautiful like Andrew those such **beautifully, (un)like Andrew.)**
10		*me?*[2] question marker

Andrew's style of play becomes a constant topic of discussion among the players, with Jason and Kevin painting him as a poor player who depends on external factors (i.e., item use) to win. Andrew resists this portrayal in the beginning (lines 4-5), arguing that they are just sore losers.

Over the course of the dueling, character selection becomes more than a topic of conversation, but a *factor* that required additional restrictions. These factors helped the players define what constituted having "skill" in fighting games; or, alternately, it is how players adjust the game to make it less about chance (*alea*) and more about skill (*agôn*). Excerpts 6.14 to 6.18 demonstrate how player-created rules are maintained and how they reorganize themselves in light of small deviations in their routine. Prior to these occurrences, the players had a choice to pick any character they want, regardless of whether they had won or lost the previous game. In excerpt 6.14, Jason suggests an additional constraint: the winner cannot change characters for the next game (line 1):

EXCERPT 6.14 (02:16:15-02:16:18)

((Game has just ended.))

CHAPTER SIX — FORMS OF PLAY

1	Jason(C)	*jengzo gogo le mhoji wun jan*
		won that one cannot change person
		(The winner cannot change characters
		in the next round).)
2	Kevin(C)	okay *hou*
		okay fine
		(Okay, fine.)

One way to think about this rule is that it gives the incoming player a slight advantage over the incumbent winner because the incoming player has a choice of characters and can pick one that is better suited against the incumbent's character. The rule serves to create continuous flow in the interaction, so that the champion does not continually dominate the game.

New rules, especially those created by players, have to be maintained through mutual accountability and self-enforcement. Excerpt 6.15 is a particularly interesting example because it demonstrates that these seemingly arbitrary and spontaneous rules that the players come up with can take hold of the players quickly. In this example, Kevin, who had been using Jigglypuff for most of the dueling, asks Jason for permission to change:

EXCERPT 6.15 (02:21:23-02:21:32)

((Game has just ended.))

1	Kevin(C)	*homhoji zyun jan aa:::*
		can I switch person final particle
		(Can I change characters? I've been
2		*zingjat waan bobo::::: (0.9) haa?*
		entire day play Jigglypuff huh
		playing Jigglypuff all day. Huh?)
3	Jason(C)	*haa?*
		huh
		(Huh?)
4	Kevin(C)	*hom homhoji zyun jan*
		can can I switch person
		(Can I change characters, Jason?)
5		*aa::: Jason?*
		final particle Jason
6	Jason(C)	*haa?*

		huh
		(Huh?)
7	Kevin(C)	*homhoji zyun jan?*
		can I switch person
		(Can I change characters?)
8	Jason(C)	*nei daa pou sin laa:::* Andrew
		you play round first final particle Andrew
		(Play another round first. Andrew
9		*daadinwaa*
		on the phone
		is on the phone.)

Andrew having to use the phone became grounds for them to suspend their turn-taking rules temporarily (lines 8-9). This was not Andrew's turn; Andrew had lost the game to Kevin, and left to use the phone. By leaving the game, however, Andrew had disrupted the routine. This suggests that the players had not perceived their games as isolated dueling games, but as a series of continuous dueling games. Until Andrew returns, Jason and Kevin can continue playing, but the previous rules they enforced are now up in the air.

We can once again look at the question-and-answer adjacency pairs to see how the social relationship is organized. Recall that, in CA, adjacency pairs are units that tend to occur in paired units—in this case, a first-pair part that consists of a question, and a second-pair part that consists of an answer. Adjacency pairs inform the first speaker whether the utterance was properly heard and whether it was properly understood. They also serve as constraints to the conversation because a second-pair part is expected to follow soon after a first-pair part. In certain kinds of adjacency pairs, the absence of a second-pair part could be seen as a "noticeable absence" (Schegloff, 1968), and lead the first speaker to infer a reason. In excerpt 6.15, Kevin had to continually ask Jason for permission to change characters (lines 1-2, 4-5, 7) until he received a response. Moreover, Kevin had not only made the request, but also gave a reason for it (line 2), and he did not act until he had received a response. The fact that Kevin waited for permission and accepted Jason's decision shows that these players often cooperated and took one another seriously. In this case, we also see who holds the power in this relationship. Kevin often allowed Jason to make decisions and willingly

• CHAPTER SIX — FORMS OF PLAY •

followed. Jason was also free to come up with rules on his own, although he still needed others to accept them.

Jason and Kevin managed to get almost two games in while Andrew is on the phone. In excerpt 6.16, Jason had just won against Kevin:

EXCERPT 6.16 (02:23:47-02:23:56)

((Game has just ended.))

1 Jason(C) *tai nei wun bingo*
 see you change who
 (Let's see which character you change to.)

((At the Character Selection Screen.))

2 *(gau mgau) peikaaciu*
 (enough not enough) Pikachu
 (Had enough of Pikachu?)

((2.5 – Jason switches from Pikachu to Mewtwo; Kevin switches from Jigglypuff to Falco.))

3 Jason(C) *o mgau nei daa wo:::*
 oh not enough you fight final particle
 (Oh, I can't beat you with that.
4 *jatding mgau nei daa*
 definitely not enough you fight
 Definitely can't beat you with that.)
5 *lo:::*
 final particle

Since Andrew was still unavailable to resume their turn-taking, they went for an additional round. This time, in addition to the turn-taking rule, the winner-doesn't-switch rule also gets suspended and Jason allows himself to pick a new character.

In the midst of this game, Andrew returns from the phone and complains that they had gone an extra round without him. They have to resolve this issue. However, since Kevin and Jason had both won a round while Andrew was away, they had to find a "fair" way to remedy this:

EXCERPT 6.17 (02:26:01-02:26:06)

((At the Victory Screen))

> 1 Jason(C) *soeng pou nei syu wo Kevin*
> last round you lost final particle
> **"You lost the last round, Kevin."**
>
> 2 Kevin(C) *gam pou nei syu wo wai!*
> this round you lost final particle hey
> **"You lost this round."**
>
> ((Jason and Kevin do a rock-paper-scissors. Jason wins.))

Since Andrew has returned to their game and they have decided that Jason has the right to the next game, the new rules go back into effect—somewhat:

EXCERPT 6.18 (02:26:11-02:26:17)

> ((At the Character Selection Screen))
>
> 1 Andrew(C) *jengzo mhoji gaan jan*
> winner cannot pick person
> **(The winner can't pick a new character.)**
>
> ((Stops Jason from picking a new character.))
>
> 2 Jason(C) *aa wai!*
> exclamation hey
> **(Hey!)**
>
> 3 Andrew (C) *jengzo mhoji gaan jan aa::::::::!*
> winner cannot pick person exclamation
> **(The winner can't pick a new character!)**
>
> 4 Jason(C) *ngo mhai jeng:::: daawo*
> I didn't win draw
> **(I didn't win. It was a draw.)**

When Jason attempts to pick a new character, Andrew reminds him of the new rule (lines 1, 3). However, Jason argues that even though he had won at the rock-paper-scissors, it was still a draw when he played against Kevin (line 4) so the new rule doesn't apply.

Excerpts 6.14 to 6.18 gives an example of how social order is maintained among the players. Through a simple disruption in their routine, we can see what mechanism players use to keep one another accountable. These examples also demonstrate that they take this social order so seriously that they have to declare new rules (excerpt 6.14), ask

for permission to suspend new rules (excerpt 6.15), give reasons for rules to be suspended (excerpts 6.15, 6.18), and resolve discrepancies in a fair manner (excerpt 6.17). More importantly, fairness is based on consensus and depends on whether the players accept the reasons that are given when one of them deviates from the rules they had agreed to follow.

Chance vs. Skill

Chance often plays a contradictory role in games. Sometimes it is used to mediate potential conflict, such as when deciding which player gets to make the first move. The coin toss that occurs before sports games or political debates functions in such a role. Likewise, Andrew, Jason, and Kevin used rock-paper-scissors whenever they had to find a fair way of organizing turn-taking during dueling (excerpt 6.17). However, since dueling is about skill, the players need to ultimately reduce or eliminate the effect that chance has over the outcome of the game or, more precisely, their measurement of skill. Players also have to decide how to balance the game such that no player is given an unfair advantage. In some cases, this can be managed with a new rule, such as the winner-cannot-change-characters rule (excerpt 6.14). In other cases, the players need to change rules that are built into that game, thus overriding the game's design. Two features of the game that became problems for these players were the selection of stages and the use of items.[3]

Stage Selection[4]

The stages in SSBM are based on the Nintendo games that its characters are drawn from. Some of the stages act like *platformer* or *side-scrolling* games, in which the game's camera perspective pans upwards or sideways as the character moves through the game; other stages have a static camera perspective but evolving environments that force characters to jump or dodge obstacles in order to avoid injury. (Search "super smash brothers melee" in YouTube to get a better understanding of how stages appear in SSBM.)

During regular play, Andrew, Jason, and Kevin usually let the game choose the stage randomly. They continued letting the game pick the stage during dueling, up until it became a persistent issue that had to be resolved:

EXCERPT 6.19 (01:48:04-01:48:12)

1	Jason(C)	*bei zaadaan zaa sei m gai*
		let bomb explode death not count
		(Doesn't count if you get killed by a bomb.)
		(2.3)
2	Andrew(C)	*bindou dak gam:: gaa:::?*
		where can like this question marker
		(How can we play like this?
3		*diu::: seizo zau seizo laa::*
		fuck died then died final particle
		Fuck. Dying means dying.
4		*mhai haajatgo jaupaai—*
		isn't next one long time
		Otherwise, the next [turn] will take a long time—)
5	Jason(C)	*gam nei..* ((to Kevin)) *gai m gai*
		then you count not count
		(Should we count it?)
6		*aa?*
		question marker
7	Andrew(C)	[*gai:::*
		[count
		[(Count it.)
8	Kevin(C)	[*gai gai*
		[count count
		[(Count it, count it.)

Over the course of their dueling, Jason and Kevin repeatedly criticized Andrew's style of play. We observed that in excerpt 6.11 and 6.13, and there are more examples later. As such, we might ask whether the players are being fair to Andrew, or whether they are picking on him because they gang up on him. However, this and other examples suggest that fairness is a carefully balanced interaction that requires constant maintenance. If they are openly unfair to Andrew, he can leave the game and disrupt the player configuration (as Li did in Chapter Five). They can try to force Andrew to follow certain rules, but these have to be reasonable enough for him to be willing to abide. In excerpt 6.19, Jason tries to suggest a new *death-by-environment-doesn't-count* rule. This means that every time a character is killed by an environmental effect—in this

case a bomb—then that death doesn't count. If permitted, though, this would mean that they would have to recalibrate their scores after every game, and that there would possibly be constant rematches. In line 4, Andrew argues that it would take a long time for the next player to have a chance. Jason defers the decision to Kevin (line 5), implying that this would be based on a majority decision. Kevin sides with Andrew (line 8) and votes that death by environment should still count toward the final score, and the matter is temporarily settled.

In excerpt 6.20, however, after Andrew was killed and mocked by the others, he argues that it was because of the stage:

EXCERPT 6.20 (01:49:40-01:49:41)

1	Andrew(C)	*go coeng m leng zaa::*
		that stage not pretty only
		"[I only died] because the stage isn't good"

Eventually, Kevin recognizes the problem too and asks:

EXCERPT 6.21 (01:59:06-01:59:08)

1	Kevin(C)	*jaumou ge coeng () matje*
		is there any stage what
		"Is there a stage that without
2		*dou mou gaa?*
		also without question marker
		any thing in it?"

Kevin's question formulates what he is looking for: a plain stage that does not contain any features. At this point, all three players have complained about the stage. In excerpt 6.22, Jason finally makes an elaborate argument on how the stage disadvantages him:

EXCERPT 6.22 (01:59:45-02:00:00)

1	Jason(C)	*nigo coeng ngo zanhai hou zang*
		this stage I really very hate
		(This stage, I really hate this stage
2		*nigo coeng ngo [cici—*
		this stage I [every time—
		a lot. Every time—)

3	Kevin(C)	((to Andrew)) [*wai zigei*
		[hey myself
		[(Hey, ah
4		*aa gaan gogo:::::*
		ah pick that
		pick that [stage].)
5	Andrew(C)	[()
6	Jason(C)	[*ciumungmung peikaaciu ngo*
		[Mewtwo Pikachu I
		(Regardless of whether I use Mewtwo or
7		*dou hou zang nigo coeng*
		also very hate this stage
		Pikachu, I still hate this stage.)
		(1.3)
8	Jason(C)	*keoi hou hatjanzang*
		it very hateful
		(The thing I hate the most is—)
9		[*le::: hai aa—*
		[final particle is ah—

((Lines 10-14: Kevin and Andrew are navigating through the character screens, interrupting Jason.))

15	Jason(C)	*keoi hou hatjanzang lei::*
		it very hateful final particle
		(The thing I hate about this stage is
16		*nei ditzo godou le::—*
		you fell over there final particle—
		when you fall off [that platform] there—)
17	Kevin(C)	OK *ngo lei gaan ngo gaan*
		OK I come pick I pick
		(OK, I'll come and pick I'll pick.)
18	Jason(C)	*nei ditzo lokheoi godou seoi*
		you fell down over there water
		(When you fall off that platform into the
19		*le::: keoi jat soenglei*
		final particle it once come up
		water, when you come back up, you
20		*le () dou gobin wo*
		final particle arrive over there final particle
		reappear in [that part of the stage].)

In excerpt 6.22, Jason had just lost the game to Andrew. They had been playing in a stage called *Jungle Japes* (from *Donkey Kong*), and Jason had been confused when his character fell off one side of the stage and re-emerged on the other side. This confusion led him to lose control and die. Despite repeated interruptions, Jason persists in explaining why he lost (lines 1-2, 6-9, 15-16, 18-20). In particular, he points out that he dislikes this stage regardless of which character he uses (lines 6-7). In the meantime, Kevin knows of a stage (called *Pokemon Stage*) that has fewer features, and he tries to get Andrew to pick that stage (lines 3-4, 17). This stage resembles a floating poker table. While the stage itself does transform, these transformations are less distracting when compared to the other stages and becomes the one they use consistently from then onwards. This change of rules did not require any voting or declaration because everyone had already complained about the stage. Furthermore, by using the same stage, the players knew beforehand what to expect; they were no longer at the mercy of the game's random selection, which might provide an unfair advantage to some characters over others. In other words, chance had been removed.

Using Items[5]
Another feature of SSBM is that usable items randomly appear on the stage, either dropped from above or emerging from a crate. These items can enhance a character in a number of ways and all characters are allowed to use any item that appears. Most of the items are offensive items that cause damage when you shoot or throw them at your opponent.

During dueling, the unofficial consensus had been that players should not use items during the fights. However, unlike the stages, which players can control by selecting a specific stage before the beginning of the game, it is harder to control the use of items when they appear all over the stage. The best way would have had been to customize the game and turn off the items, but these players did not realize that option was available. Thus, they had to trust each other not to use the items. This turned out to be complex because it was possible to accidentally pick up an item and there was no easy way to verify the intention of the player. The (mis)use of items became a recurring issue that the players had to manage as the game unfolded.

In excerpt 6.23, Jason accidentally picks up two items and tries to get rid of them:

EXCERPT 6.23 (01:44:52-01:45:02)

((Jason vs. Kevin; Andrew observing. Jason's character has picked up an umbrella item.))

1	Jason(C)	*wai mhai jiu nibaa* (1.2) *wai dim*
		hey not want this hey how
		(Hey, I don't want this [item]. Hey how
2		*dam aa::*[:::?
		drop question marker
		do I drop it?)
3	Kevin(C)	[*wai mhou (gamjoeng)*
		[hey don't be (like this)
		["Hey, don't (like this)
4		*mhou m mhou dam je*
		don't don't drop thing
		don't drop the item [yet].)

((Kevin shoots at Jason, causing him to drop the umbrella. Jason picks up an orb item. Kevin laughs.))

5	Jason(C)	*nei waa mhou dam aa?*
		you say don't drop question marker
		(You said not to drop the item?
6		*dam!*
		drop
		Drop it!)
7	Kevin(C)	*dam lo::::::::*
		drop final particle
		(Then drop it.)

((Both players stop using their weapons and go back to hand-to-hand combat.))

At this early stage of their dueling, the players lapsed briefly into training mode, with Jason allowing Kevin to shoot him with a gun without fighting back. Jason's question (lines 1-2) communicates that he has accidentally picked up the items. Since the A-button is involved in picking up and using the items, it is possible that items can be accidentally picked up. However, we don't know for sure whether he

really does not know how to drop an item or whether he just wishes to announce that he didn't mean to pick up the item, especially since he doesn't have trouble dropping the item eventually. He also seems to make sure that, by holding onto the item, he is simply complying with Kevin's request (line 5), and that he does not intend to actually use the item. This performance allows him to dispel any potential misunderstanding that might occur.

Andrew receives the most complaints about items:

EXCERPT 6.24 (01:49:22-01:49:29)

((Andrew vs. Jason; Kevin observing.))

1	Kevin(C)	jau zap je laa (hai waa)?= again pick thing final particle (isn't it)?= **(You're using items again, see?)=**
2	Jason(C)	=nei gau—= =you dick—= **=(You dick—)=**
3	Andrew(C)	=diu =fuck **=(Fuck.)**
4	Jason(C)	hai lo nei zinghai sik zap je yes final particle you only know pick item **(That's right, you only know how to use items.)**
5	Andrew(C)	ngo deihaa jau maa [diu! I on the floor has final particle [fuck! **(It was on the floor in front of me, fuck.)**
6	Jason(C)	[ngo [I [(Have
7		() jau zapgwo je me? () have picked thing question marker **you] seen me use items before?)**
8	Kevin(C)	ngo dou mou laa::::: I also not final particle **(Neither have I.)**

Even though Kevin isn't in the game, he still participates in the play activity—in this case, pointing out that Andrew is using items again (line

1). This leads to Jason's complaint that Andrew doesn't know how to play without using items (line 4). Andrew defends himself by saying that the item was right in front of him (line 6), but Jason dismisses that argument (lines 6-7). As we saw in excerpt 6.23 (a few minutes earlier), Jason did in fact accidentally pick up an item but did not use it. By using the item instead of dropping it like Jason did before, Andrew weakens his position that his item use was unintentional. Kevin stands with Jason in saying that neither of them had purposefully used an item before.

But even Jason and Kevin can be tempted by the use of items when the opportunity presents itself. In the next game, when Kevin and Jason are playing against each other:

EXCERPT 6.25 (01:51:14-01:51:18)

((Kevin vs. Jason; Andrew observing. A heart container item appears on the stage. Kevin and Jason both advance towards it.))

1	Kevin(C)	*zing!*
		perfect
		"Perfect!"
2	Jason(C)	*nei mhai zap je::::::::::?*
		you not pick thing
		"Aren't you using items too?"

The heart container item instantly lowers your percentage indicator to zero percent. When it appears on the stage, both Kevin and Jason approach it. Kevin gets there first (line 1) and Jason criticizes him (line 2) even though he was going to use the item himself.

The next few excerpts are additional examples that show the constant back and forth that goes on between the players, particularly in judgment of Andrew's style of play:

EXCERPT 6.26 (02:00:20-02:00:31)

((Andrew vs. Kevin; Jason observing.))

1	Jason(C)	Kevin *gei hou jan jyuncyun m lo*
		Kevin so good person entirely not take
		(See how good Kevin is? He never uses
2		*je houci lei gam aa?*
		thing like you final particle

items, unlike you.)

((1.0—Andrew's character picks up an item and starts shooting at Kevin.))

3	Andrew(C)	[*ngo mhai* Kevin! *ngo mhai* Kevin!] [I not Kevin! I not Kevin!] **[(I'm not Kevin! I'm not Kevin!)**]
4	Kevin(C)	[*naa! naa! nidi zauhai*] [look! look! this is exactly] **["Look! Look! This is the kind of asshole**]
5		*gau laa haimhai gam sin?* asshole final particle are you like that **he is. Are you going to be like that?)**
6	Jason(C)	[*maudai laa:::::*] [crouch down final particle **[(Crouch down.)**
7	Andrew(C)	[*ngo mhai* Kevin!] [I not Kevin!] **[(I'm not Kevin!)**
8	Jason(C)	*maudai laa::::: Kevin* crouch down final particle Kevin **(Crouch down, Kevin.)**
9	Kevin (C)	*mau mau mdou aa:::=* crouch cannot final particle= **(I can't crouch.)=**
10	Andrew(C)	=*ngo mhai* Kevin! *ngo hai jatgo* =I not Kevin! I am a **=(I'm not Kevin! I'm an asshole!)**
11		*gauhai* asshole

Jason and Kevin have been labeling Andrew as a bad player for using items. Jason frames the situation in moral terms (lines 1-2), saying that Kevin is a good person for not using items. As Garfinkel (1967/2008) notes, morality and trust are integral to everyday interactions because people need to be able to trust that others are oriented to the interaction in a similar way, such as following the conventions of conversation or the shared rules of a game. Likewise, Andrew embraces the villainous label he is given, and declares that he is not good like Kevin (lines 3, 7, 10). In doing so, Andrew subverts the meaning of their dueling—where the goal

is to fight in an honorable way—and changes the rules of the game, even if only for a moment.

Playing the Rules

In her study of girls' playground games—such as hopscotch and jump rope—in a middle-school, Goodwin (2006) demonstrates that the girls often test out the rules and see how far they can stretch them to their favor. In hopscotch, they might try and see whether they can get away with taking larger steps than they are supposed to. With playground games, the action occurs on a space that is open for all participants to see and the only way to cheat would be to do so before others notice. With videogames, the action occurs both on the screen (which is public) and on the controller (which is private). Since the action on the screen is a manifestation of the action performed on the hidden controls, there is more room for players to debate about intentions.

Excerpts 6.19 to 6.26 show that player-generated rules can be difficult to maintain, especially when it has to rely on trust. With the case of the stage selection, it was easy for the players to pick a stage that was appropriate for everyone without much controversy. However, with the use of items, it was evident that the players were not good at following the rules that they expected others to follow. This often led to instances where one player would cheat just to counteract their opponent's prior cheat. Or, it would lead to instances such as the following, which occurs after a game has ended:

EXCERPT 6.27 (02:11:31-02:11:40)

1	Andrew(C)	*ngo jinggoi houci mou zapgwo*
		I probably maybe not picked
		(I don't think I used an item.)
2		*je=*
		thing=
3	Kevin(C)	*=tausin lo ceoi aa*
		=just now take hammer final particle
		=**(You used the hammer just now,**
4		*pukgaai:::::!*
		damn it
		damn it!)

5	Jason(C)	[()
6	Andrew(C)	[*ngo lo ceoi nei bin daai gam—*
		[I take hammer you turned big then—
		[(I used the hammer, but [you used the enlargement item].)
7	Kevin(C)	[()]
8	Jason(C)	[()]
9	Andrew(C)	[() *nei jau zaa coeng*
		you also hold gun
		(You also used a gun.)
10	Kevin(C)	*wai go ceoi hou wo* ()
		hey that hammer good final particle
		(Hey, that hammer was [better].)
11		*ngo zikhak deuzo keoi laa:::*
		I quickly threw it final particle
		[Besides] I quickly threw [the gun] away.)

Kevin, who had just lost a game to Andrew, had been arguing that Andrew wasn't playing fair. When Andrew suggests that he doesn't think he used any items (lines 1-2), Kevin reminds him that he had used the hammer (lines 3-4). It is possible that Andrew was trying to get away with having used an item when he first suggests that he hadn't used anything, especially since he seems to recall quite well what others have used. It is also possible that players are better at remembering others' transgressions than their own. When Kevin brings up the item he used, Andrew switches tactics and points out that Kevin had used *two* items—an item that makes you grow large (line 6) and a gun (line 9). Kevin counters that the hammer is a more powerful weapon (line 10), and that he had thrown away the gun instead of using it (line 11). This suggests that it is not the frequency of the transgressions that mattered to him as much as it is the impact of the items as a whole.

The consequences of cheating seem to vary according to the activity. When Goodwin's participants were caught cheating, they usually lost their turn in the game. In this present study, however, players did not lose a turn for cheating; the only penalty they got was to be labeled as a cheater or a weak player. One possible explanation is that the cheat itself—in this case, the use of items—was not easily enforceable, and therefore it was hard to hold players accountable, even when they are caught. Another explanation might be that, in dueling, being labeled as a

weak player is worse than any other possible penalties, including losing a turn. Thus, although cheating permeated the players' conversations, the consequences laid not on their turn-taking structure but on their social indexing.

Discussion

The goal of this chapter had been to describe the different forms of play that players create among themselves in fighting games, using CA techniques to describe how these different forms are articulated and maintained over time. There are a few key points that need to be highlighted.

First, one of the goals of CA is to describe the formal properties of a phenomenon (Hutchby & Wooffitt, 1998/2008), which means providing descriptive details that explain a phenomenon's role in achieving order, coherence, and meaningful interaction. As such, the focus on details serves to demonstrate that coherence is achieved in a way that is empirically observable and describable by the participants (including the researcher) of the interaction. Rules in CA are not inviolable constraints; instead, as Hutchby and Wooffitt note, rules serve as "interpretative resources" that help people make sense of action. Consequently, the goal of the present analysis is to describe the formal properties of videogame interaction, specifically with regard to how players switch between the different forms of play. While the specifics of these forms of play (i.e., training, dueling) might be different for other game genres (or different players within the same genre), further research would need to be done to see how and why players modify rules when they play. Many games have built-in training and dueling modes that help players manage their games more easily. FPS games, for example, have multiplayer modes that have any number of customizable rules that players can use to design their game. Most players understand the concept of "training" and "dueling" and how it differs from "regular play," (see Chapter Seven), even if the definitions may vary from player to player.

Second, however the players define their forms of play, this definition is articulated and maintained locally on a moment-by-moment basis. This finding is congruent with what CA studies have shown in regard to conversation, and what Suchman (2002) has demonstrated in human-computer interface. In CA, *local production* refers to the

phenomenon where meaning is created when *and only when* people interact with the context. In any given situation, there could be multiple contexts and identities that can be simultaneously relevant to the situation. Which contexts and identities are relevant cannot be known *a priori* and it is only through interaction over time that their relevance is revealed. For example, the players are, simultaneously, competitors, collaborators, fellow classmates, spectators, instructors, learners, novices, experts, and so on. They flow from one role to another quite fluidly. One moment, they can be competitors trying to beat the others in the game; the next moment, they can be collaborators trying to learn a particular feature of the game. As we saw in this chapter, the rules continue to change as they interact and fine-tune their interactional rules. These particulars cannot be determined or predicted ahead of time because they emerge out of local contexts.

Third, although I have categorized their play as *training* and *dueling*, it is possible for them to switch from one form to another in the midst of a game. The short turn-structure of fighting games makes it easier for players to make each game into discrete forms of play. Like most player-initiated changes, any player who wants to change the form of play in the midst of a game would need the consensus of the other players, as can be seen in the following example, where Jason had picked a character he was not familiar with (Pichu) and wanted to try it out to see what moves it has:

EXCERPT 6.28 (01:54:42-01:54:48)

((Andrew vs. Jason; Kevin observing))

1 Jason(C) (*jyugwo*) *sihaa gam soeng go ziu*
 (if) try press up that move
 ([I wanted to] try and see if pressing up
2 *keoi keoi jaumou gunggik lik*
 it it can it attack power
 gives it a higher attack power.
3 *goudi Andrew jauhai haigam mije*
 higher Andrew again keeps what
 [But] Andrew keeps [attacking me].)
4 *wo*
 final particle

5	Andrew(C)	*ngonggau gaa?*
		idiot question marker
		(Are you an idiot? We're
6		*daangangtiu nei si ziu*
		dueling you try move
		dueling, and you want to try moves.)

Jason criticizes Andrew for not letting him try out new moves (line 3) because, as mentioned before, trying out new moves requires a willing opponent who would let you attack them. Andrew calls him an idiot and points out that they are dueling and suggesting that this isn't the context for trying out new moves. This example shows that shifts between forms of play can be attempted but only with the cooperation of the players you are interacting with. It also shows that, to the players, these forms of play have clear differences that should not be transgressed.

 Finally, the examples in this chapter show that there is mutual give-and-take when players get together to play a game. None of them have the same definition of what it means to play a particular game in a certain way. There are issues that need to be discussed and managed over time. These conversations *are* the meaning-making practices at work, and their arguments about who's the better player or which is better character are very much part of their play. Having a proper description of these details across different groups of players and across genres of games will improve our understanding of how meaning-making works in broader contexts.

• CHAPTER SEVEN •

Construction of an Opponent

> Games operate under a test of practical efficacy.
> —Harvey Sacks (1980, p. 324)

Although fighting games are comparatively shorter and simpler than other genres, a great deal of work is placed on players to create rules that maintain fairness—however it is defined—within the game. As we saw in Chapter Six, there can be many ways of playing any given fighting game, and notion of fairness can vary from player to player.

This chapter expands beyond the group of players and games that has been the focus of prior chapters. All the games are still fighting games, with slight variations between them. Some of these can affect gameplay and fairness in significant ways. The first part of the chapter defines *regular play* as the most basic form of play within fighting games, on which other forms of play (i.e., training and dueling) are based on. The second part of the chapter looks at a different group of Asian adolescents and compares their styles of play with the players we have seen before. This part touches briefly on gender as a problematic lens of analysis of player interaction, and looks at how interaction in fighting games need not always be combative (as they were between Jason, Kevin, and Andrew) but mutually encouraging and cooperative as well.

Regular Play

Throughout the discussion about the training and dueling forms of play, I have alluded to *regular play*—which is my term for describing the type of play where players are at their most natural, where rules seldom need to be modified or added.

The idea of including regular play as a form of play borrows from a similar notion in CA. As mentioned in Chapter Three, Sacks et al. (1974) refer to everyday conversation as one of many speech-exchange systems, each of which have their unique rules regarding the organization of turn-taking. They envision speech-exchange systems existing on a continuum: on one end is everyday conversation, where turns are not pre-allocated among the speakers but are, instead, locally organized over the course of the conversation. On the other end are more formal kinds of speech-exchange systems, where turns are pre-allocated among the participants, such as interviews, debates, testimonies, hearings, and lectures. Differences in the way turns are allocated would also impact other features of turn-taking, for example, turn size (how long someone talks), turn order, and turn allocation (who picks the next speaker). Sacks et al. argue that:

> It appears likely that conversation should be considered the basic form of speech-exchange system, with other systems on the array representing a variety of transformations of conversation's turn-taking system, to achieve other types of turn-taking systems. In this light, debate or ceremony would not be an independent polar type, but rather the most extreme transformation of conversation—most extreme in fully fixing the most important (and perhaps nearly all) of the parameters which conversation allows to vary. (1974, pp. 730-731)

The significance of their argument is that these mundane turn-taking features make the interaction orderly and mutually meaningful to the participants. It also lets us understand why and how participants repair their turns when order is disrupted. Everyday conversation is the most basic form of speech-exchange system because we learn how to participate in conversation early in life, before we learn how to participate in other kinds of speech-exchange systems; we also have practice with it everyday of our lives in varying degrees. As such, we have the most experience and familiarity with it.

Sacks et al.'s notion of turn-taking is relevant not only for speech-exchange systems, but for any activity that involves turn-taking, such as regulating traffic, managing queues, and making moves in a game. (They refer to these types of activities are turn-taking systems.) Likewise, I argue that *regular play* is analogous to everyday conversation in that it is the most basic form of play that participants engage in, and that all other

forms of play—training, dueling, and others—modify the basic rules that are relevant in regular play.

What, then, are some of these rules?

Some of these have been covered in the prior examples described in training and dueling. For example, in regular play, moves are usually not pre-announced (as they are during training) and chance is allowed to play a role in the outcome (as they are not during dueling). However, the most persistent feature goes back to turn-taking and organization: during regular play, all action is distributed equally among the players. In other words, while every player is open to attack, no player should receive an unfair burden of attacks and no player should be left in peace. In other words, during regular play, everyone has an active role to play.

Rules of Engagement

The two most visible manifestations of *equal participation* is observable in how:

1. players organize themselves *before* the game
2. players interact *during* the game

In order for players to achieve equal participation, they would have to ensure they have the right number of players in the game. The easiest way to accomplish this is to have an even number of players, since, with an odd number, two players will always gang up on one. (Perhaps this is why most games require an even number of total players. Games that allow odd numbers of players typically create balanced distribution through chance—for example, a dice roll. Chance makes it harder for players to gang up on one another unfairly.)

Andrew, Kevin, and Jason—the most frequent participants of the study—formed an unbalanced threesome. In the entire time I observed them, these players *never* participated in a regular three-player game; the only time they did was briefly during a training session, when Falco appeared (excerpts 6.1–6.8). Even though they could have made the computer into a fourth player (they knew how to do that), they never did.

When Li, in Chapter Five, left their game, their four-player game collapsed. Even when the three of them were available, they preferred to duel instead of play together. Jason even repeatedly asked Li to return

and promised to properly teach her how to play if she participated. Furthermore the only time they ever asked me to participate as a player was when they could not find a fourth player. In fact, it was through participating as a player that I noticed how consistent this feature was to these players.

However, organizing themselves is only the start of creating equal participation, as this balance has to persist when the game is in progress. Recall that, when Li thought that she could stay safe and alive by avoiding confrontation with the other players:

EXCERPT 5.6 (00:07:02-00:07:07)

1 Li(M) *na jiu shi yizhi zhan zai*
 then just is continue stand at
 (So, if I keep standing up here,
2 *shangmian jiu mei shi luo?*
 up there just no issue question marker
 I won't have a problem?)
 (0.9)
3 Kevin(M) *danshi ni yao ying renjia*
 but you have to win others
 (But you have to win against the others.)
4 *ma:::::*
 final particle

Here, Kevin instructs her that participation requires contact with other players. Thus, even though avoidance can possibly result in a better ranking at the end of the game, this defeats the purpose of their interaction in the fighting game. Furthermore, if she doesn't participate, she creates an imbalance between the remaining three players.

The clearest examples of equal participation occurred in another fighting game—*Naruto: Clash of Ninjas 2* (NCN2). I had asked the players to pick any game they wished to play, provided that they haven't played it before, with the intention of seeing them learn a new game for the first time and also seeing whether anything from SSBM transferred to the new game. NCN2 is similar to SSBM in many ways: it has the same large group of character—drawn from the popular *Naruto* manga series—each with unique attacks and special abilities. Even though both are fighting games, there are still plenty of differences between SSBM and NCN2.

•CHAPTER SEVEN—CONSTRUCTION OF AN OPPONENT• 181

Here, I describe just the ones that pertain to our discussion. Like SSBM, NCN2 also features a large selection of stages that players can choose from. However, unlike SSBM, the stages serve more as background decoration. They vary in size, but the stages themselves do not interact with the players. There are also no items that randomly appear for players to use. Like SSBM, the games are timed; however, one game cycle consists of at least two rounds. Players who die within a round do not get to come back (or "respawn") until the next round and the player who wins the most rounds wins the game.

One feature that is unique to NCN2 helps us better understand the issue of equal participation. In SSBM, a player is able to attack any character who is within range. In NCN2, players are only able to attack one character at a time. When a fight is in progress, an arrow with the player's color (either blue, yellow, green, or red) appears underneath each character, and this arrow points to whoever your target is. Any other character that the target does not point to will not be attacked, even if they are within range. The game does allow the players to manually switch the arrow to a different target, and this action allows us to see who players are targeting.

Since the goal of fighting games is, presumably, to be the last player left standing, I assumed that players would do so through any means possible. However, an etiquette emerged during regular play where players who are left standing will wait for the other pair to finish fighting before engaging in attack.

For example, imagine a game where Kevin is facing off against Aaron, and Jason is facing off against Andrew. Kevin finishes off Aaron before Jason and Andrew are done. What should Kevin do? If he attacks the remaining pair, he would be at an advantage because he could weaken his potential opponent, who would be under attack from two sides. That might also leave him in a better position to be the final winner. But this did not happen. Instead, players asked others to wait their turn before engagement. In other words, while it is difficult to decipher intention of attack in SSBM, it is much easier to see this in NCN2.

Although these players were familiar with fighting games, it was interesting to observe that some of the rules of engagement had to be re-negotiated. Again, it is possible to see this only because this observation

was made before these rules had hardened into their routine. Excerpt 7.1 describes the first time the players brought up the issue of engagement in NCN2:

EXCERPT 7.1 (00:23:08-00:23:14)

1	Andrew(C)	zyundeng [zyundeng heoi] Kevin
		switch [switch to] Kevin
		(I'm switching over to Kevin
2	Jason(C)	[gam cyun]
		[so fuck]
		[(Such a fucker.)]
3	Andrew(C)	godou sin
		over there first
		there first.)
4	Kevin(C)	mhou wai ngo gamjoeng
		don't surround me like this
		(Don't surround me like this
5		houmhou? mhou wai ngo
		all right don't surround me
		all right? Don't surround me.
6		mhou wai ngo jatgo jatgo lei
		don't surround me one one come
		Don't surround me. Come one-by-one.)

Since players could not respawn in the game, there were often times when there would be three players left standing, leaving one player to wait for the other two to finish. Andrew, in lines 1 and 3, suggests that he and Jason should gang up on Kevin, while Kevin implores him not to "surround him," instructing them to fight one-by-one (lines 4-6).

Excerpts 7.2 to 7.5 are some further instances when players remind one another about their rules of engagement. For example, in excerpt 7.2, Kevin announces that he will not bother the remaining two players until they are done:

EXCERPT 7.2 (00:23:50-00:23:52)

((Aaron has just been knocked out.))

1	Kevin(C)	m zo neidei m zo neidei
		not bother you not bother you

• CHAPTER SEVEN — CONSTRUCTION OF AN OPPONENT • 183

2
 (I won't bother you [two], won't bother
 daazyu sin
 fight first
 you, let you [finish your] fight first.)

When one player is knocked out, the remaining player's target will randomly point to one of the two remaining players. Presumably, the announcement that Kevin makes in excerpt 7.2 serves as a declaration of intent, such as what we saw in excerpt 6.23 (when Jason declares that he had accidentally picked up an item). The announcement can defuse any potential misunderstanding, and signals to the remaining players that he does not intend to interfere.

However, like other player-created rules, players might still want to test the boundaries of the rules and not follow them as closely as they expect others to:

EXCERPT 7.3 (00:45:16-00:45:22)

1 Jason(C) *wai* Aaron *wai* Aaron
 surround Aaron surround Aaron
 (Surround Aaron, surround Aaron.)
2 Kevin(C) *diu mhou gam laa wai*
 fuck don't like this final particle hey
 (Fuck, don't be like this.)

((Jason laughs.))

3 Jason(C) *wai neidi jigaa wai ngo::*
 hey you now surround me
 (Hey, you [all] are surrounding me now.
4 *wo::::: mije jisi aa?*
 final particle what meaning final particle
 What's the meaning of this?)

Although Jason teases that the remaining players should surround me (lines 1), he laughs to indicate that he was not being serious. His strategy also backfires as he quickly notices that he is the one being surrounded (lines 3-4).

Likewise, in excerpt 7.4, Kevin tries to get me to surround Andrew (lines 2-4):

EXCERPT 7.4 (00:46:30-00:46:39)

((Jason has just been knocked out.))


1 Andrew(C) wai ngo aa::::?
 surround me final particle
 (You're surrounding me?)
 (2.0)
2 Kevin(C) Aaron wai keoi Aaron (0.2)
 Aaron surround him Aaron
 (Aaron, surround him.
3 diu Aaron mhou gam
 fuck Aaron don't like this
 Damn it, Aaron. Don't be like this.
4 laa:::: wai keoi Aaron=
 final particle surround him Aaron
 Surround him.)
5 Jason(C) =jigaa mhai ngaam lo::::::
 =now isn't correct final particle
 =(Isn't it correct now?
6 gogo daa gogo gogo daa gogo
 that fights that that fights that
 That fights that one, that fights that one,
7 gogo daa gogo:::
 that fights that
 that fights the one.)


Jason announces that the "right order" is for each person to have one opponent (lines 5-7)—in other words, for Aaron to attack Kevin, Kevin to attack Andrew, and Andrew to attack Aaron. However, the problem is that this is difficult to maintain because players typically respond to an attack by counterattacking and, in doing so, breaks up the balance of the game.

An alternative to achieving balance was for the players to stay in pairs, like a mini-dueling game. For example, if Jason is fighting Aaron and Andrew is fighting Kevin, once Aaron gets knocked out (which happened quite frequently), then Jason is supposed to wait for either Kevin or Andrew to be knocked out before interfering. This became the routine rule they established. For the remainder of their play in NCN2, this rule of letting a couple finish their fight held up consistently.

However, as with Goodwin's study of cheating in playground games, players sometimes tried to skirt the boundaries of acceptance:

EXCERPT 7.5 (00:54:39-00:54:47)

((Aaron has just been knocked out. Kevin starts firing shots at Jason.))

1	Jason(C)	Kevin *(jauhai) gam gaa:::?*
		Kevin (again) like this question marker
		(Kevin, you're being like this again.)
2	Kevin(C)	OK *m zo neidi*
		OK not bother you
		(OK, I won't bother you [two].)
3	Jason(C)	[*(hou) hatjanzang lo::::::::*]
		[(very) despicable final particle]
		[(You're very despicable.)]
4	Kevin(C)	[*m zo neidi m zo neidi*]
		[not bother you not bother you]
		[(I won't bother you, I won't bother you.)]
		(1.0)
5	Jason(C)	*jigaa m zo dou mdak laa:::!*
		now not bother also can't final particle
		(It doesn't matter if you stop bothering me
6		*dou zaulei sei lo!*
		also almost dead final particle
		now that I'm almost dead!)

Kevin fires shots at Jason while he is fighting with Andrew. Jason calls him out (line 1) and Kevin states that he won't bother them again (lines 2, 4). Jason's reprimands are quite strong, calling him "despicable" *(hatjanzang)* and he even raises his voice at the end (lines 5-6).

This pattern of interaction resembles a phenomenon identified in CA called *schism*. Sacks et al. (1974) note that, even though the number of people in conversation can vary, the tendency is for the conversation to have few people because the turn-taking system works best in two-party conversation, where speakers can more easily follow who the next speaker is. They argue that, in a three-party conversation, one would often get left out of the conversation, and in a four-party conversation, two would have to be left out. In other words, while a two-party (e.g., Speaker A and Speaker B) group's turn-taking would take the form of

ABABAB, a three-party group does not take the form of ABCABCABC. They write that:

> If there is an interest in retaining, in a single conversation, some current complement of parties (where there are at least four), then the turn-taking system's means for realizing that effort involve 'spreading turns around', since any pair of parties not getting or taking a turn over some sequence of turns can find their mutual accessibility for getting into a second conversation. (1974, p. 713)

In other words, with a four-party conversation, schism occurs when the conversation splits into two separate conversations, thus serving as a "check" on turn-distribution. Schegloff (1996a) argues that turn-taking is formally organized and that a two-party conversation might represent a "special case of a more general and formal type of organization" (p. 20).

I have suggested that *regular play* is, like everyday conversation, "representative of the means by which one polar possibilities is organizationally achieved" (Sacks, et al., 1974, p. 730). The resemblances between videogame interaction and conversational interaction supports Sacks et al.'s (1974) notion that these are all turn-taking systems, each of which contains formal properties that can be analyzed and described in empirical detail. Conversation serves as a unique form of speech-exchange system because most people engage in it every day, whereas most people engage in other speech-exchange systems less frequently. As such, it is not surprising that the other, more formal types of speech-exchange systems modify the basic set of rules present in everyday conversation.

One significant difference between conversation and regular play is that the rules of conversation remain relatively stable over time. The only time this might change is when a new form of communication is introduced into society—for example, telephones, email, chat, or instant messaging. In these cases, people still rely on conventions of conversation to guide them through the interaction, such as interpreting a telephone ring as a "summoning." *Regular play* in videogames is a more nebulous concept because people have different ways of playing games. Players would have different ways of deciding what it means to play a particular game or a particular genre of games, and as games become more complex and open-ended, these possibilities will only multiply. When games enter a different context—such as a classroom—the form of play changes. Furthermore, in a classroom context, there would be some

players who are familiar with a particular genre, and others who are not. As such, some would have more time to establish conventions that make sense to them, while others would only have encountered the genre for the first time. To design a game meant for one context and implementing it in another context would change the meaning of the game, just as gameplay and meanings in SSBM during regular play differs from those during dueling and training. However, just as game designers become aware of what players need during these different forms of play, they may be able to design features in their games to accommodate classroom-like contexts. Further qualitative research would need to be done to better understand how players produce meaning locally for different game genres and contexts.

Cooperation and Competition

One of the challenges in describing videogame research (or any human-computer interaction) is the extent to which we can attribute the interaction to be a consequence of the game's design or to the players' backgrounds and relationships with one another. While it is safe to say that both design and players contribute to meaning-making in videogames, it is difficult to describe these precise influences satisfactorily, and all too easy to treat either design or player as the dominant (or only) factor in meaning-making and interaction.

We can use gender both as an example and as a segue into the second topic of this chapter—which is, how players in a fighting game construct the opponent(s) of the game through their interactions. More specifically, if the underlying principle of fighting games is antagonistic, how do players maintain the antagonism and tension within the game without letting it interfere with their preexisting social relationships? In this sense, playing a multiplayer game with people you know differs significantly from playing with anonymous people on the Internet, with whom you do not have any particular inclination to maintain a social relationship. In other words, playing multiplayer games with friends creates an additional social layer that requires attention.

Gender and videogames is a complicated topic of discussion, and many researchers have addressed it from a variety of perspectives (Cassell & Jenkins, 2000; Kafai, Heeter, Denner, & Sun, 2008), often critiquing the false dichotomy of boy games (violent, competitive) and

girl games (social, cooperative). At the same time, it is difficult to argue against the fact that most game design teams, particularly those behind the best-selling game franchises, are still male-dominated, and that the best-selling game titles are usually action-oriented games.[1] In addition to polarizing views on gender, there is also concern that studies of gender and play have been oversimplified in their analysis. Marjorie H. Goodwin (2006), who has been studying gender relations among children for the past 20 years, argues that many prior studies of gender and play tend to follow the "Separate Worlds Hypothesis" view. This hypothesis describes boys' and girls' games as fundamentally different in structure and content—boys' games focus on rules and hierarchy, while girls' games focus on cooperation and relationship building. Her study of girls' playground games (e.g., hopscotch, jump rope) in a middle-school shows that these girls can be just as confrontational, rule-oriented, and hierarchical as boys. Furthermore, girls can use tactics such as bullying, exclusion, and gossiping to sustain the social order among them. As such, the simplistic view that boys' games are always violent and confrontational or that girls' games are always cooperative are misguided views that require further and more critical investigation.

Gender's role in structuring videogame play is equally challenging to analyze, especially since the visual representation and the gameplay can easily slant the researcher into over-interpreting the influence of gender as a factor in the interaction. We return to Li a final time to demonstrate this issue.

Li's interactional style was certainly different than her male opponents. She did not engage in ritual insults with them the same way they did with one another. She did not taunt her fellow players and did not seem to want to directly confront them in the game, even going so far as to apologize when she attacked them:

Excerpt 7.6 (02:41:46-02:41:53)

1	Jason(M)	ni shasile wo
		you killed me
		(You killed me.)
2	Li(M)	wo shasi ni (le)? duibuqi
		I killed you sorry
		(I killed you? Sorry.)

3	Andrew(M)	*duibuqi* ((laughs))
		sorry
		(Sorry.)
4	Andrew(C)	*aai::::* Li *ho gaauje*
		oh Li very playful
		(Oh, Li's very funny.)

When Jason points out to Li that her character has killed him, she apologizes, eliciting laughter from Andrew. The humor of the situation is that, in a fighting game, you are supposed to be attacking your opponent and, therefore, shouldn't feel the need to apologize (unless you have transgressed some social rule).

At one point, Jason makes an observation that sounds almost in support of the "Separate Worlds Hypothesis":

EXCERPT 7.7 (03:21:14-03:21:22)

1	Jason(C)	*dimgaai* Li *houci keoi zigei jau keoi zigei waan*
		why Li like she self has her self play
		(It's like Li is playing her own game,
2		*ngodi jau ngodi jau ngodi saamgo waan*
		we have we have we three play
		and we—the three of us are playing
3		(0.4) *houci zigei waan gamjoeng*
		like self play like
		our [separate] game. It's like she's playing
4		*go::: lo:::::*
		final particles
		a [different] game on her own.
5		*hou zeng go wo*
		very cool final particles
		It's cool.)

Jason notes that Li seems to be playing her own game within the game they are playing together because she does not interact with them as much as the others do with one another. Here, we might be tempted to think that Li did not fit in because she was a girl and the other players were being too rough with her. However, Jason later also remarks:

EXCERPT 7.8 (03:24:20-03:24:27)

((Game ends.))

1	Jason(M)	*ni hao meiyou qiantu*[::::: you very lack future **(You have no future.)**
2	Li	[((laughs)) (1.3)
3	Jason(C)	*jihau jau mije* game [()— in the future has what **(Next time there's a game—)**
4	Li(M)	[*wo you (bu)—* [I also (not) [**(I wasn't—)**
5	Jason(C)	*jihau jau mije* game *jyumaai keoi* in the future has what include her **(Next time there's a game, include her.**
6		*lo tun bou hei lo* final particle same step begin final particle **We have to (learn) the game together.)**
7		*jiu* must

First, he jokes with Li, lamenting that she has no future with them in this game (line 1). Then, he codeswitches to Cantonese and suggests that the next time they start a new game, they should include her because it would be easier for them to play together if they all started out as novices. In other words, he was suggesting that it was her identity as a *novice* that was making it difficult for her to keep back, and that, by learning together, none of them will have an upper hand against anyone else. In this case, we see the importance of 1) not offering unsophisticated arguments with regard to gender and 2) observing an interaction over a longer stretch of time to fully understand its contextual meaning.

While we might consider "competitive" and "cooperative" styles of play as binaries, actual observations of play reveals that it is not so easy to separate the two. Competitive games still require the cooperation of all participants to be part of the game. When cooperation fails, then the competitive game cannot begin. Furthermore, games still require the cooperation of the players to agree to the same set of rules, and this can

• CHAPTER SEVEN — CONSTRUCTION OF AN OPPONENT •

require considerable negotiation and organization between the players. Looking at interaction in games through these gender lenses alone can distort what actually unfolds between the players during the game.

Presentation of Self as a Player

In prior chapters, we saw that interactional style between Jason, Kevin, and Andrew was characterized by smack talking and bolstering, particularly when they were dueling with one another. My initial reaction was that this was "normal." After all, it was a fighting game, and from my experiences playing FPS with others online, I knew that this type of interaction was not atypical. However, after meeting Mark and Eddie, I realized that the interaction between players depended more on how they framed the game within their activity system than it had with the genre of the game itself.

Mark and Eddie were two Asian adolescents attending the same New York City high school. Both of them were fluent English speakers. As with the other players, I had requested that they pick a game they had not played before. The game they chose was *Super Smash Brothers Brawl* (SSBB) on the Nintendo Wii. This was the follow-up to the same fighting game (SSBM) that Andrew, Kevin, Li, and Jason had been playing. As such, the basic gameplay was the same, with some slight variations in some of the characters and stages available in this game.

As they were fluent in English, it was easier for them to customize the game. One of the first things they did was to put one another on the same team. This meant that their characters would be playing against computer-created opponents and that they would not accidentally hurt each other during the game. They also customized two game rules: 1) Eddie, who seemed more familiar with this game series, adjusted it so that only certain items would appear in the game and 2) they changed the win-condition such that there is no time limit in the game; instead, all players are limited to ten lives for their characters. After all ten lives are gone, players are out of the game; however, a player who is out of the game is able to take a life from his/her teammate and come back into the game. I observed Mark and Eddie a total of eight sessions, for approximately two hours each. The following excerpts are taken from the first observation, during which they had just started learning about SSBB's game mechanics.

There were some overlaps in the interaction styles between this pair and the other players I had observed. For example, when Eddie and Mark were in training mode, their interaction was characterized by the similar need to negotiate when one character can attack another:

Excerpt 7.9 (00:03:25-00:03:31)

1	Eddie	OK I'm just seeing wait a minute
		(0.9)

((Mark strikes Eddie's character))

2		WAIT A MINUTE! HEY STOP IT WAIT
3		MINUTE I need to know how to [use this
4	Mark	[I'm
5		learning] how to use this too.
6	Eddie	control]

Furthermore, Eddie and Mark engaged in collaborative learning similar to what we saw in training mode:

Excerpt 7.10 (00:04:54-00:05:06)

1	Eddie	How'd you get the items?
		(0.9)
2	Mark	I'm not sure. (1.0) But man I love (Ike's)—
		(5.0)
3		OH! oh oh you [press 2.]
4	Eddie	[Take that.]

Like the other players, Eddie and Mark did not withhold information from each other, and willingly shared it when the other player had a question.

However, their interaction style during regular play was more of a contrast. In their self-assessments, Mark and Eddie were often hard on themselves, saying things like "I totally stink" or "That was the stupidest move I've ever made." For example, in excerpts 7.11 and 7.12, Eddie puts himself down for being a bad teammate:

EXCERPT 7.11 (00:17:58-00:18:02)

((Eddie's character is killed))

1	Eddie	Sorry.
2	Mark	=Oh.
3	Eddie	I've not been a loyal friend.
4	Mark	Don't worry.

In excerpt 7.11, Eddie apologizes because his character died and, being a team battle, this affected the team's chances of winning. Likewise, in excerpt 7.12, he argues that he does not deserve the cheers that the game is giving him:

EXCERPT 7.12 (00:18:59-00:18:02)

| 1 | Eddie | Yeah they're cheering for me (0.4) |
| 2 | | although—oh I don't deserve it |

Eddie was slightly younger than Mark, but he seemed to know more about the game. He knew what the rules were, what each of the items did, and which he wanted to turn out. Thus, when they started playing, Eddie served as the more expert player to Mark, who was less knowledgeable about the game mechanics. Eddie's interaction with Mark was characterized by careful scaffolding. He told Mark which items to get, what they did, and continuously encouraged him during play:

EXCERPT 7.13 (00:21:03-00:21:14)

1	Mark	Oh, I need—I should have thrown that at
2		you look at you
3	Eddie	Don't..trust me (0.6) you're wh—you're the
4		last hope
		(0.9)
5	Eddie	[I'm just here to help]
6	Mark	[Well I'm a very bad] at being the last hope.

In this excerpt, Mark's character was reaching for a healing item when he notices that his character's percentage is at 20 percent and Eddie's is at 107 percent (remember that higher percentage means weaker health); Mark suggests that he should have given the item to Eddie instead (line 1-2). Eddie says no (line 3) and positions himself as a supporting character (line 5), a role that Mark was not entirely comfortable with (line

6). This exchange reveals their underlying participation structure, in which one team member supports the other against the opponents.

This relationship repeats again in excerpt 7.14, when the players are passing another healing item between them:

EXCERPT 7.14 (00:21:44-00:21:54)

1	Mark	OK don't throw it at me
2	Eddie	I have to
		(1.8)
3	Mark	There I threw it at you=
4	Eddie	=wow that heals a lot
5	Mark	I know. Why do you think I was trying to
6		throw it at you?

Note that the players did not simply heal each other, but also felt the need to verbally *formulate* the action in words, such that the other player knows what he is doing. Here, Mark shows that he, too, can be a supportive teammate and help heal his fellow teammate.

Like the other players in the previous chapters, Mark and Eddie also defined what they each consider cheating. In excerpt 7.15, Mark argues that a particular item is too powerful, while Eddie remarks that it is fine as long as you win:

EXCERPT 7.15 (00:55:05-00:55:22)

1	Mark	Oh come on why do I have to get it again=
2	Eddie	=Because you're so good
		(1.3)
3	Mark	But I don't like this
		(5.1)
4	Eddie	Thank [God]
5	Mark	[It's a] cheating way to win
		(1.1)
6	Eddie	As long as you win=
7	Mark	=Yeah but I like to use my actual strength

Note that the discussion is the polar opposite of what Kevin, Jason, and Andrew had been arguing about during their dueling. While Kevin and Jason often declared Andrew a cheater for using items, Mark (the one using the item here) is saying that he feels that using the item feels like

cheating (line 5) because he prefers using his character's own abilities (line 7), while Eddie is saying it is fine to use it to win (line 6). Unlike the other players, however, this restriction was self-imposed and not extended to the other player. Eddie was free to use any of the items that appeared, and Mark was making a self-imposed restriction on himself. (Of course, Eddie and Mark were not dueling and never did during their sessions. If they had been dueling, one would expect both parties to abide by the same set of rules.)

Discussion

The goal of this chapter was to describe what *regular play* looks like across players and games. These descriptions suggest that there can be significant differences depending on the players and their relationships with one another. Both groups of players were friends and both groups defined their interaction through the fighting games in different ways.

The organization between Jason, Kevin, and Andrew demonstrates some of the complex negotiations that has to go on in order to ensure that each member has a fair part in the game. These rules have to be transparent so that everyone understands what they are, and can use them to hold others accountable. One of the oft-touted benefits of videogames is that they permit multiple ways of engagement. This benefit allows players with different styles to find their own paths into the game. However, when players have to interact with other people, this creates potential problems, especially when players are playing against one another and need to be on a (perceived) and mutually agreed level playing field. In other words, while players can have different orientations to a given game, these differences need to be sorted out if they are to play together in a shared game space. This sorting constitutes the meaning the game will have to this particular group of players. As seen in this and prior examples, this sorting consists of value assessments of particular moves, and additions, subtraction, and/or modification of existing rules.

This chapter also brought up gender as a problematic lens for describing interaction in videogames. Even fighting games, which on the surface appear to be competitive games, need not necessarily be so. Goodwin (2006) notes that girls can be competitive and exclusive in their construction of play as boys. Correspondingly, the examples with Eddie

and Mark suggest that boys can be critical of themselves and mutually supportive of one another during their play. Together, these studies suggest that using only gender as the solitary frame for studying play activities, be it playground games or videogames, is inadequate and prone to oversimplification. The definition of play as competitive and/or cooperative remains a locally constructed situation that varies across contexts and actors. The identical game can be played different, even by the same group of players, depending on the social relationships they want to enhance.

• CHAPTER EIGHT •

Meaning-Making in Videogames

> Users, not designers, create and communicate meaning.
> —Paul Dourish (2001, p. 170)

In the most recent of his edited works, Garfinkel (2008) reveals that his sociological interest in games, game theory, communication, and the nature of information started early in his career, even before he fully conceived his notion of ethnomethodology. His editor and frequent collaborator, Anne Rawls, writes that:

> In order for anything to be intelligible to more than one person, in Garfinkel's view, it must display an order—and that order must be social—and created by those actors who are engaged in a situation together and committed to a shared practice. There must be stable and shared background expectations in order for an order to be achieved and displayed. But participants must be able to alter those expectations—to change the rules, so to speak—or make up new ones to fit new situations or contingencies. Later, Garfinkel will refer to this as "ad hocing."
> (Rawls, 2008, p. 47)

Order and meaning are opposite sides of the same coin. For anything to be meaningful (i.e., intelligible), people need to see orderliness to the activity, and this orderliness emerges only through social interaction.

Throughout the book, we have looked at order in videogames. This order can take many forms: the designed order of the videogame itself, as programmed by the game designers; the interaction order of the players, as negotiated among the players both tacitly and explicitly over the course of their interaction, which determines who gets to play when and with whom. Intersecting these orders are others that may or may not be relevant, depending on the situation. The videogame genre itself represents the loose set of expectations that all players of the particular genre understand and expect others to conform to. This order appears whenever players inform one another on how a particular game *should* be played, or how games *should* be won. There are moral orders that define

and control cheating in the game. There are orders of hierarchy as dictated by the players' social relationships, backgrounds, and culture. And so on.

There are as many layers of orderliness as there are possible meanings to any given game. As such, it is probably impossible to define them exhaustively. For now, it is enough to suggest that *meaning*-making is precisely the construction of order by the player or players. This is an ongoing, locally managed process that requires players to continually adjust their definitions as the game reveals itself to them.

The perceived order and the designed order are not necessarily one and the same thing. The perceived order represents the order that the player perceives through his/her experiences in the game. As with Li, these perceptions are likely to be shaped by background experiences (e.g., expectations of how percentages work in everyday use). These perceived orders are constructed through the documentary method of interpretation, allowing players to selectively build the order based on what they expect the order to be. The designed order is the order that the game designers program into the game. Game designers do not necessarily want players to know *everything* about the game, only enough for them to engage with it in an entertaining manner. In time, players might come to discover a significant part of the designed order, but there are always additional things—sometimes in the form of hidden surprises, or *Easter eggs*—that serve to continually invite repeated play. In other words, players seldom come to know the precise design of the game, because knowing the design is not really the ultimate goal of the game. Few players would claim that they know everything there is to know about any given game. One might even say that games are meant to be played, not understood. This is, in fact, in line with studies in ethnomethodology, which suggest that even the most mundane interactions are open to endless interpretations (Garfinkel, 1967/2008).

Serious Games Redux

Game researchers have been thinking of ways to use games for education for many decades. These early attempts had been met with limited success. Games and simulations have been used in military exercises, but have met with more resistance in formal education, where shifting political attitudes on school reform have made it difficult for games to

•CHAPTER EIGHT—MEANING-MAKING IN VIDEOGAMES• 199

make significant entry into classrooms. In the late 20th and early 21st century, the growing popularity of videogames has reignited the interest in the serious games movement, and new scholars and game designers have involved themselves in this endeavor.

This chapter builds on the findings presented in this book and discusses the challenges and opportunities of the use of serious games in both formal and informal education. The first part discusses the implication of order and meaning to the design of educational games. The second part discusses the potential problem of shifting the status of games from voluntary play to involuntary involvement. Finally, the chapter closes with a discussion on the implications of the findings presented in the book and suggestions for further research.

The Problem of Order

Game researchers are understandably optimistic about the potential of using games and simulations as educational tools. As Duke (1974) notes, games are ideal tools to communicate complex ideas, which have become more important in terms of preparing people for the 21st century society. It seems reasonable to assume that, if we can adequately model a system or social issue (e.g., poverty, terrorism, health, etc.), users who can successfully interact with the game will also learn about the game's design and how the underlying system of meanings work. In other words, by engaging with the game, we will eventually come to learn the message of the game when we interact with its design.

In games designed solely for entertainment, the problem of order is less of a problem as long as it does not prevent a player from engaging in the game. In Chapter Five, even though Li had misunderstood the underlying designed order of the game, she was still able to engage with the game in a way that was meaningful to her. Commercial games might even benefit from players having diverse interpretations of the game, as this permits a multiplicity of possible meanings to emerge.

Games for education have slightly less flexibility. To the extent that these games are designed to teach a specific issue or skill, the success of this game depends on the player grasping the objectives of the game in the way that the game designer has planned. If players of educational games miss the point of the game, then they might misinterpret the game's objectives and/or give up on the game entirely. As such,

"successful" serious games have a more restricted system of meaning. If a serious game that is designed to teach about, let's say, the hazards of drug use fails to get that message across, then that game has failed in its endeavor, regardless of whether players had fun with the game.

To date, there are more studies that describe how players interpret the game than on how they *mis*interpret the game. As such, we have a vague understanding of how meaning-making unfolds across players of different demographics and across genres. We also have little understanding on how the different semiotic modes (i.e., visual, textual, audio, and so on) interact to form meaning for the players. In Chapter Five, we saw that the numerical percentages meant one thing to Li and another thing to the other players. Having a better grasp of meaning-making can help designers see the potential misunderstandings that might occur.

One thing that commercial game developers do that helps them win their audience is the continual feedback they receive from players. Games usually go through multiple quality assurance testing before they are released. After that, game designers continue to address any problems by issuing patches and updates. Some of these patches fix programming bugs, while others respond to players' needs and expectations. Furthermore, designers release expansion packs and sequels that continue to build upon the feedback.

Educational game designers face a bigger challenge. The financial incentives are less attractive than for commercial games. Oftentimes, serious game designers have to rely on grants for their funding, and the funding covers only for the initial development phase (Al Meyers, personal communication). As a result, educational games can seldom respond to feedback the same way commercial games can. Ideally, game developers who sell their games to schools should maintain communication with the school and its users, to understand how the games were implemented and whether they were well received. The lack of feedback means that the success and failure of educational games remain a mystery. Without concrete evidence, it will be challenging for educational games to make much segue into formal educational settings.

The Context of Gaming

Shifting the context of the game from a voluntary situation (most games are played voluntarily) to an involuntary one poses additional problems. The most fundamental problem is that, by changing the context, we change the potential meaning of the game. We saw that, by simply adjusting some rules in the game, the players are able to change the fighting game from dueling to regular play to training. Each form of play was significantly different from the other, with different guidelines and rules for fairness and cheating. Play theorists such as Huizinga (1955) have noted that play has to be voluntary. How do meanings change when games are implemented into a formal structure?

Squire (2005) suggests that the problem is not about games fitting into the classroom structure; instead, the problem is for schools to change their culture to embrace other forms of learning. This would entail radical changes to the traditional curriculum unit or class period to make them more responsive to how students learn. Leander (2007) offers a similar observation with regard to technology in the classroom, noting that certain technologies, such as individual laptops, often fail to make an impact in schools because they do not fit in with the school's authoritative culture of control.

Another problem with using games in a formal setting is that not all students will enjoy videogames; even those who do play games are not likely to enjoy all the different genres. The challenge that Li faced in trying to understand a game she was unfamiliar with led her to give up in frustration. Certain genres are better suited to present certain content than other genres. This would mean that most educational games would be simulations (to teach systems), strategy games (to teach history and economics), FPS (to teach physics), and RPGs (to teach social issues). Even if schools were able to embrace gaming as a form of learning, it would still privilege some game genres over others, leaving out a large portion of gamers and non-gamers. Furthermore, would the use of games in the classroom mean that certain students would be better prepared than others? If so, how would schools accommodate these differences in experience and maintain an equitable learning context? One possibility is to provide games as an alternative in out-of-school contexts such as after-school programs. This way, games serve as an

alternative means of learning and are not restricted by the more traditional structure of a classroom environment.

Most studies of players focus on individuals who are already players; few look at how non-players perceive and interact with games. This book presented the point of view of Li as a non-player, and revealed that she had significantly different but still reasonably coherent interpretations of the game. For games to achieve broader appeal, researchers would need to study more non-players and see whether their methods of meaning-making differ from others and how games can adjust to accommodate them. We also want to study non-players to test the oft-cited hypothesis that videogames have good learning principles. It is possible that videogames have good learning principles *for those who are already players*, and that these learning principles would be less successful for those who are unfamiliar with videogames in general.

Finally, in addition to the issue of the school's culture is the problem of *when* educators should use games as an educational tool. As Duke (1974) notes, although games can offer deep learning, one drawback is that games and simulations require more time involvement than other media. There is a trade-off between the depth of learning that games can provide and the time it takes for the game to communicate that deep learning to the players. A game of *Civilization*, for example, generally takes several hours to complete, depending on how it is customized. The same goes for many other genres, particularly those that involve complex narratives. Can deep learning be achieved without extended time commitment? If not, is it time-efficient to use games as educational tools in contexts where time is scarce?

Gardner (1991, 1999) suggests that it is worth taking time to explore a topic in depth because it allows for the best kinds of learning to occur. Instead of only gaining a surface understanding of individual topics, students can achieve deep learning that allows them to apply it to other contexts. Used in this way, students can potentially achieve deep learning that would allow students to explore ideas and possibilities that traditional classrooms do not have time to fully entertain.

It is also possible that deep learning can exist without extended time commitment. Today, many of the most popular games are casual games, which are simple, short, and portable. Mobile games, which are on the rise, do not require the player to spend continuous time within the game,

and can fit better into a restricted schedule. These games are taking gaming to a different level, breaking free from the restricted space of a living room or computer lab, and incorporating geographical markers as part of the social experience (e.g., *Foursquare*). This puts the player in a real world, not only in terms of visual graphics but actual physical space. In some ways, the frequently used real-virtual binary is becoming increasingly problematic, especially when games are beginning to require players to act, move, and respond in the real world.

Implications for Further Research

Although this book looks at only a single genre of videogames among a specific demographic, there are broader implications that needs to be further investigated in future research. Forms of play such as dueling and training are not unique to fighting games. Do other players re-organize themselves and restructure the rules in a similar way? How does meaning-making occur among other players in other situations?

Much effort is presently expended on creating educational games—for schools, for nonprofits, for families, for governments, businesses, and other institutions. These endeavors are important and exciting for the field. However, there is a broader set of topics that videogame research can and should address, which is to understand the nature of learning itself. Lave's (1988) work on everyday cognition suggests that people do better when applying knowledge to real-world settings than they do as schooled-based assessments or laboratory-controlled environments. The practices associated with video gaming suggest that players learn in a very different way than a traditional student is expected to learn (Gee, 2003, 2004). However, while we have a relatively good idea of *whether* players learn, we have a far poorer understanding of *how, what,* and *when* players learn.

It might also be worth exploring two possible entry points for videogames to enter the classroom. Educational researchers have often argued that the advantage of using games is not simply that they are fun and engaging, but that they promote *game-like* problem solving skills that would be useful in the future workplace. Unfortunately, as students advance through the grades, they might become increasingly conditioned to think in *school-like* ways, where knowledge is learned only for testing purposes. In other words, it is possible that the higher the

grade level, the less likely students would benefit from game-based learning. As such, it might be easier and more useful to employ game-based learning in the early grades and ensure that students are able to transfer these skills as they progress through the higher grades. This would mean that research would have to continue to track these students into the higher grades and see whether and how they benefit from game-based learning and are able to transfer them to different contexts.

Videogames are not the only game-based learning that is available. There are a large number of serious games made in the form of board games—*Settlers of Catan, Diplomacy, Modern Art, Lifeboat, Power Grid,* just to name a few, which teach concepts such as history, economics, strategic planning, and decision making. These board games promote the same kind of game-based learning principles that videogames promote, are cheaper to purchase, require little to no additional equipment, and give teachers more control over implementation. They do not require teachers to organize time in computer labs or have computer-ready classrooms, and they do not require technology administrators to worry about firewalls, plug-ins, or privacy issues. These games can be a good way for teachers to understand game-based learning and understand how to teach with them in the classroom. These board games are another area that has not been fully researched by educators and ought to be further explored for their potential. While the trend has been to study videogames, it is a lost opportunity to ignore these other types of serious games as well.

The speed at which technology changes makes it challenging for researchers to keep up. New forms of interaction means having to rethink and redesign traditional methods of research and/or creating new ways of studying behavior. In this book, I have argued that meaningful action occurs both onscreen and off-screen and, as such, both domains need to be studied. This study has been built on a foundation of ethnomethodology, an approach that examines talk-in-interaction through conversation analysis. The epistemological orientation assumes that the process of learning—that is, the process of meaning-making, or the process of making sense through a perceived order—has to be studied as it occurs and not as recalled experience. The goal is to capture the messiness of the situation and describe how players see order out of

the "mess." This form of description can and should be extended to other game genres, players, and environments.

Another possible avenue of research is to study a group that has often been neglected in videogame research: the *non*-players. It is easy to be excited about videogames when we only focus on individuals who are already excited about videogames, but this group is self-selective and can distort the mass appeal of games. This study has shown that non-players are at least as interesting as avid players, if not more so, because non-players reveal different readings of videogames that do not necessarily fit in with conventional interpretations. As much appeal as videogames have, and as well-designed their learning tutorials and instructions can be, you only need to hand a controller to a non-player to see the immediate disorientation they often exhibit. The study of non-players can help unpack what players take for granted and deepen our understanding of how people interact with complex systems.

It is likely that we can learn more about how people interpret games if we also look at moments of *mis*interpretation. The future potential of educational games lies in whether there is enough convincing evidence that demonstrates deep learning. Consequently, educational game research needs to move beyond rhetoric and assertion and aim at accumulating empirical documentation of learning and interaction.

Concluding Thoughts

As a gamer, I am cautiously optimistic about videogames as a medium of communication and education. For me, videogames are able to stir up reactions—pathos, frustration, excitement, dread—that other media cannot. This alone makes me believe that there is still much about videogames and human behavior that we do not fully understand.

For better or worse, videogames are the new mythmakers for many of us. They represent an emerging art form that continues to impress on multiple levels—artistically, visually, musically, narratively, interactively, technologically. Their relative newness makes them frightening to some, promising to others. However, just because they are "new" does not make them trivial, nor does it make them magical. They are neither good nor evil. What they are depends on who we are as users and what we do with them.

Notes

Chapter Two

1. I highly suggest readers, particularly new researchers looking for a topic to study, look through Lemke's list of research questions and consider addressing some of them.

Chapter Three

1. Although CA scholars try to capture much of the details of an interaction, no transcription can ever capture everything. Furthermore, different conversation analysts follow different conventions, particularly when it comes to transcribing non-English conversation. In some cases, the gloss is left out. I opted to keep only the details that are necessary to understand the interchange.

Chapter Four

1. *Mass Effect* allows players to customize only the appearance of the main character.
2. See a review on the real-time strategy game *Dawn of Discovery*, Schiesel, S. (2009). When worlds collide, war need not follow. *The New York Times* Retrieved August 10, 2009, from http://www.nytimes.com/2009/08/03/arts/03discovery.html.
3. There are interesting online discussions and unofficial polls regarding whether players prefer to invert or uninvert their x- or y-axis. In some cases, this preference depends on the game genre.

Chapter Six

1. The guides on the Internet are usually player-created, and can give differing opinions on how to unlock a particular character. A player would have had to keep track of all the actions that were done prior to the new character's

unlocking, and identify all the ones that are relevant to unlock a certain character. For example, in order to unlock Character A, the game might require that players complete goals X, Y, and Z. A player who completes goals W, X, Y, and Z might mistakenly attribute goal W as part of the set of goals needed to unlock Character A. Most of the guides involve collaboration from a group of players. How players decide which actions were part of which character requires further research.

2 In Cantonese, the *me* question marker here casts doubt on the meaning of the entire sentence by making it the sentence into a question.
3 SSBM does allow players to customize some rules, and some of the features mentioned could have been changed if the players had understood how to do so. Nonetheless, how the players decide what parts of the game to change is what we are interested in understanding.
4 For more on SSBM stages, see http://super-smash-bros.wikia.com/wiki/Stage and http://guides.ign.com/guides/16387/page_29.html
5 For more on SSBM items, see http://super-smash-bros.wikia.com/wiki/Item and http://guides.ign.com/guides/16387/page_53.html

Chapter Seven

1 According to marketing researcher, The NPD Group, the best-selling videogames (of all consoles) in the United States, from 2001-2010 are: *Grand Theft Auto III* (2001), *Grand Theft Auto: Vice City* (2002), *Madden NFL 2004* (2003), *Grand Theft Auto: San Andreas* (2004), *Madden NFL 06* (2005), *Madden NFL 07* (2006), *Halo 3* (2007), *Wii Play* (2008), *Call of Duty: Modern Warfare 2* (2009 and *Call of Duty: Black Ops* (2010).

Bibliography

Aarseth, E. (2001). Computer game studies, year one. Retrieved April 3, 2004, from http://www.gamestudies.org/0101/editorial.html
Abt, C. C. (1970). *Serious games*. New York: The Viking Press.
Andrews, G. (2008). Gameplay, gender, and socioeconomic status in two American high schools. *E-Learning and Digital Media, 5*(2), 199-213.
Avedon, E. M., & Sutton-Smith, B. (1971). Games in Education. In E. M. Avedon & B. Sutton-Smith (Eds.), *The Study of Games* (pp. 315-321). New York: J. Wiley.
Bartle, R. A. (1996). Hearts, clubs, diamonds, spades: Players who suit MUDs Retrieved May 15, 2006, from http://www.mud.co.uk/richard/hcds.htm
Bateson, G. (1985). *Steps to an ecology of mind*. New York: Jason Aronson.
Black, R. W. (2008). *Adolescents and online fan fiction*. New York: Peter Lang.
Bogost, I. (2005). Procedural literacy: Problem solving with programming, systems and play. *Telemedium*, Winter/Spring, 32-36.
Bogost, I. (2007). *Persuasive games*. Cambridge, MA: The MIT Press.
Bransford, J., Brown, A. L., & Cocking, R. R. (Eds.). (2000). *How people learn: Brain, mind, experience, and school*. Washington, DC: National Academy Press.
Caillois, R. (1961). *Man, play, and games* (M. Barash, Trans.). Chicago: University of Chicago Press.
Carlson, E. (1971). Games in the Classroom. In E. M. Avedon & B. Sutton-Smith (Eds.), *The Study of Games* (pp. 330-339). New York: J. Wiley.
Cassell, J., & Jenkins, H. (Eds.). (2000). *From Barbie® to Mortal Kombat: Gender and computer games*. Cambridge: The MIT Press.
Charles, C. L., & Stadsklev, R. (1973). *Learning with games: An analysis of social studies educational games and simulations*. Boulder, CO: Social Science Education Consortium.
Coleman, J. (1971). Learning through games. In E. M. Avedon & B. Sutton-Smith (Eds.), *The Study of Games* (pp. 322-325). New York: J. Wiley.
Collins, A., & Halverson, R. (2009). *Rethinking education in the age of technology: The digital revolution and schooling in America*. New York: Teachers College Press.
Crookall, D. (2000). Editorial: Thirty years of interdisciplinarity. *Simulation & Gaming, 31*(1), 5-21.
Diamond, J. (1990). *Guns, germs, and steel*. New York: W. W. Norton and Co.
Dourish, P. (2001). *Where the action is: The foundations of embodied interaction*.

Cambridge, MA: MIT Press.

Duke, R. (1974). *Gaming: The future's language*. New York: Sage Publications.

Duke, R. (2000). A personal perspective on the evolution of gaming. *Simulation & Gaming, 31*(1), 79-85.

Erickson, F. (2004). *Talk and social theory: Ecologies of speaking and listening in everyday life*. Cambridge: Polity Press.

Farias, I., & Bender, T. (2009). *Urban assemblages: How actor-network theory changes urban studies*. New York, NY: Routledge.

Fenwick, T. J., & Edwards, R. (2010). *Actor-network theory in education* (1st ed.). New York: Routledge.

Gardner, H. (1991). *The unschooled mind: How children think and how schools should teach*. New York: Basic Books.

Gardner, H. (1999). *The disciplined mind*. New York: Simon and Schuster.

Garfinkel, H. (1967/2008). *Studies in ethnomethodology* (Reprint ed.). Cambridge: Polity Press.

Garfinkel, H. (2002). *Ethnomethodology's program: Working out Durkheim's aphorism*. Lanham, MD.: Rowman & Littlefield Publishers.

Garfinkel, H. (2008). *Toward a sociological theory of information*. Boulder, CO: Paradigm Publishers.

Garfinkel, H., Lynch, M., & Livingston, E. (1981). The work of a discovering science construe with materials from the optically discovered pulsar. *Philosophy of the Social Sciences, 11*(2), 131-158.

Garfinkel, H., & Rawls, A. W. (2006). *Seeing sociologically: The routine grounds of social action*. Boulder: Paradigm Publishers.

Garfinkel, H., & Sacks, H. (1970). On formal structures of practical actions. In J. C. McKinney & E. A. Tiryakian (Eds.), *Theoretical sociology: Perspectives and developments* (pp. 337-366). New York: Appleton-Century-Crofts.

Gee, J. P. (1996). *Social linguistics and literacies* (2nd ed.). London: Taylor and Francis Group.

Gee, J. P. (1999). *Introduction to discourse analysis: Theory and method*. New York: Routledge.

Gee, J. P. (2003). *What video games have to teach us about learning and literacy*. New York: Palgrave Macmillan.

Gee, J. P. (2004). *Situated language and learning: A critique of traditional schooling*. New York: Routledge.

Gee, J. P. (2007). Pleasure, learning, video games, and life: The projective stance. In C. Lankshear & M. Knobel (Eds.), *A new literacies sampler* (pp. 95-113). New York: Peter Lang.

Gee, J. P., Hull, G., & Lankshear, C. (1996). *The new work order*. Boulder, CO: Westview Press, Inc.

Gibson, J. J. (1979). *The ecological approach to visual perception*. New York: Houghton-Mifflin.

Goffman, E. (1961). *Encounters: Two studies in the sociology of interaction*. Indianapolis: The Bobbs-Merrill Company, Inc.

Goffman, E. (1969). *Strategic interactions*. Philadelphia: University of Pennsylvania Press.
Goffman, E. (1974). *Frame analysis*. Boston: Northeastern University Press.
Goodwin, C. (1981). *Conversational organization: Interaction among speakers and hearers*. New York: Academic Press.
Goodwin, C., & Heritage, J. (1990). Conversation analysis. *Annual Review of Anthropology, 19*, pp. 283-307.
Goodwin, C., & Goodwin, M. H. (1996). Seeing as a situated activity: Formulating planes. In Y. Engestrom & D. Middleton (Eds.), *Cognition and communication at work* (pp. 61-95). Cambridge: Cambridge University Press.
Goodwin, M. H. (2006). *The hidden life of girls: Games of stance, status, and exclusion*. Malden, MA: Blackwell.
Gundaker, G. (2007). Hidden education among African Americans during slavery. *Teachers College Record, 109*(7), 1591-1612.
Halliday, M. A. K. (1978). *Language as social semiotic*. London: Edward Arnold.
Heath, S. B. (1983). *Ways with words: Language, life, and work in communities and classrooms*. Cambridge: Cambridge University Press.
Heritage, J. (1984). *Garfinkel and ethnomethodology*. New York: Polity Press.
Hill, C., & Larsen, E. (2000). *Children and reading tests*. Stamford, CT: Ablex Publishing Corp.
Hillocks, G. (2002). *The testing trap: How state writing assessments control learning*. New York: Teachers College Press.
Huizinga, J. (1955). *Homo ludens*. Boston: Beacon Press.
Hung, A. C. Y. (2010). Participation at the periphery: Boundary-crossing competence in massively-multiplayer online games. *Journal of Virtual Worlds and Education, 1*(2), 111-135.
Hutchby, I., & Wooffitt, R. (1998/2008). *Conversation analysis* (2nd ed.). Cambridge: Polity Press.
Ito, M. (2009). *Engineering play: A cultural history of children's software*. Cambridge, MA: The MIT Press.
Janesick, V. J. (2001). *The assessment debate*. Santa Barbara, CA: ABC-CLIO.
Kafai, Y. B., Heeter, C., Denner, J., & Sun, J. Y. (Eds.). (2008). *Beyond Barbie® and Mortal Kombat: New perspectives on gender and gaming*. Cambridge: The MIT Press.
Kent, S. L. (2001a). Super Mario nation. In M. J. P. Wolf (Ed.), *The medium of the video game* (pp. 35-48). Austin: University of Texas Press.
Kent, S. L. (2001b). *The ultimate history of video games: From Pong to Pokémon and beyond* (1st ed.). Roseville, CA: Prima Pub.
Kifer, E. (2001). *Large-scale assessment: Dimensions, dilemmas and policy*. Thousand Oaks, CA: Corwin Press, Inc.
Kleifgen, J. (2001). Assembling talk: Social alignments in the workplace. *Research on Language and Social Interaction, 34*(3), 279-308.
Kleifgen, J., & Kinzer, C. (2009). Alternative spaces for education with and through technology. In H. Varenne, E. Gordon & L. Lin (Eds.), *Theoretical perspectives on comprehensive education: The way forward*. Lewiston, NY: Mellen Press.

Kline, R. (2003). Resisting consumer technology in rural America: The telephone and electrification. In N. Oudshoorn & T. J. Pinch (Eds.), *How users matter: The co-construction of users and technologies* (pp. 51-66). Cambridge, MA: The MIT Press.

Koschmann, T., Stahl, G., & Zemel, A. (2007). The video analyst's manifesto (or the implications of Garfinkel's policies for studying practice within design-based research). In R. Goldman, S. Barron, S. Derry & R. Pea (Eds.), *Video research in the learning sciences* (pp. 133-143). Mahwah, NJ: LEA.

Kraft, I. (1971). Pedagogical Futility in Fun and Games? In E. M. Avedon & B. Sutton-Smith (Eds.), *The Study of Games* (pp. 326-329). New York: J. Wiley.

Kücklich, J. (2001). *Literary theory and computer games*. Paper presented at the Computational Semiotics for Games and New Media, Amsterdam.

Kücklich, J. (2007). Homo deludens: Cheating as a methodological tool in digital games research. *Convergence, 13*(4), 355-367.

Lankshear, C., & Knobel, M. (2006). *New literacies: Changing knowledge in the classroom* (2nd ed.). New York: Open University Press.

Lakoff, G., & Johnson, M. (1980/2003). *Metaphors we live by*. Chicago: University of Chicago Press.

Latour, B. (1987). *Science in action: How to follow scientists and engineers through society*. Cambridge, MA: Harvard University Press.

Latour, B. (2005). *Reassembling the social: An introduction to actor-network-theory*. Oxford: Oxford University Press.

Latour, B., & Woolgar, S. (1986). *Laboratory life: The construction of scientific facts*. Princeton, NJ: Princeton University Press.

Lave, J., & Wenger, E. (1991). *Situated learning: Legitimate peripheral participation*. Cambridge: Cambridge University Press.

Leander, K. M. (2007). "You won't be needing your laptops today": Wired bodies in the wireless classroom. In C. Lankshear & M. Knobel (Eds.), *A new literacies sampler* (pp. 25-48). New York: Peter Lang.

Lemke, J. L. (2000). Across the scales of time: Artifacts, activities, and meanings in ecosocial systems. *Mind, Culture, and Activity, 7*(4), 273-290.

Lemke, J. L. (2006). Toward critical multimedia literacy: Technology, research, and politics. In M. C. McKenna, L. D. Labbo, R. D. Kieffer & D. Reinking (Eds.), *International Handbook of Literacy and Technology Vol. 2* (pp. 3-14). Mahwah: Lawrence Erlbaum Associates.

Lenhart, A., Kahne, J., Middaugh, E., Macgill, A. R., Evans, C., & Vitak, J. (2008, September 16, 2008). Teens, video games and civics: Teens' gaming experiences are diverse and include significant social interaction and civic engagement. Retrieved November 5th, 2008, from http://www.pewinternet.org/~/media//Files/Reports/2008/PIP_Teens_Games_and_Civics_Report_FINAL.pdf.pdf

Lynch, M. (1993). *Scientific practice and ordinary action: Ethnomethodology and social studies of science*. Cambridge: Cambridge University Press.

Maier, J. R. A., Fadel, G. M., & Battisto, D. G. (2009). An affordance-based approach to architectural theory, design, and practice. *Design Studies, 30*(4).

McCarthy, M. P. (1973). Teaching urban history with Games: A review essay. *The*

History Teacher, 7(1), 62-66.
McDermott, R. P., Gospodinoff, K., & Aron, J. (1978). Criteria for an ethnographically adequate description of concerted activities and their contexts. *Semiotica, 24,* 245-275.
McGrenere, J., & Ho, W. (2000). *Affordances: Clarifying and evolving a concept.* Paper presented at the Proceedings of Graphics Interface 2000, Montreal.
Mehan, H. (1979). *Learning lessons: Social organization in the classroom.* Cambridge: Harvard University Press.
Mol, A. (2002). *The body multiple: Ontology in medical practice.* Durham, NC: Duke University Press.
Myers, D. (2003). *The nature of computer games.* New York: Peter Lang.
New London Group, T. (1996). A pedagogy of multiliteracies: Designing social futures. *Harvard Educational Review, 66*(1), 60-93.
Norman, D. (1988). *The psychology of everyday things.* New York: Basic Books.
Nygren, E., Johnson, M., & Henriksson, P. (1992). Reading the medial record I. Analysis of physicians' ways of reading the medical record. *Computer Methods and Programs in Biomedicine, 39,* 1-12.
Ochs, E., & Schieffelin, B. B. (1984). Language acquisition and socialization. In R. Shweder & R. LeVine (Eds.), *Culture Theory* (pp. 276-320). Cambridge: Cambridge University Press.
Oxford, R., & Crookall, D. (1990a). Linking language learning and simulation/gaming. In R. Oxford & D. Crookall (Eds.), *Simulation, gaming, and language learning* (pp. 3-23). New York: Newbury House Publishers.
Oxford, R., & Crookall, D. (1990b). Making language learning more effective through simulation/gaming. In R. Oxford & D. Crookall (Eds.), *Simulation, gaming, and language learning* (pp. 109-117). New York: Newbury House Publishers.
Parsons, T. (1937). *The structure of social action.* New York: McGraw-Hill.
Parsons, T. (1951). *The social system.* New York: Free Press.
Parsons, T. (1961). An outline of the social system. In T. Parsons, E. Shils, K. D. Naegele & J. R. Pitts (Eds.), *Theories of society: Foundations of modern sociological theory, vol. 1* (pp. 30-79). New York: The Free Press of Glencoe.
Parsons, T. (1971). *The system of modern societies.* Englewood Cliffs, NJ: Prentice-Hill, Inc.
Rancière, J. (1991). *The ignorant schoolmaster: Five lessons in intellectual emancipation* (K. Ross, Trans.). Stanford, CA: Stanford University Press.
Rawls, A. W. (2002). Editor's introduction. In H. Garfinkel & A. W. Rawls (Eds.), *Ethnomethodology's program: Working out Durkeim's aphorism.* Boulder, CO: Rowman and Littlefield.
Rawls, A. W. (2008). Editor's introduction. In H. Garfinkel & A. W. Rawls (Eds.), *Towards a sociological theory of information.* Boulder, CO: Rowman and Littlefield.
Rouse, R. (2005). *Game Design: theory and practice* (2nd ed.). Plano, TX: Wordware Publishing, Inc.
Rose, D., & Blume, S. (2003). Citizens as users of technology: An exploratory study of

vaccines and vaccination. In N. Oudshoorn & T. J. Pinch (Eds.), *How Users Matter: the co-construction of users and technologies* (pp. 103-131). Cambridge, MA: The MIT Press.

Sacks, H. (1980). Button button who's got the button. *Sociological Inquiry, 50*(3-4), 318-327.

Sacks, H., Schegloff, E. A., & Jefferson, G. (1974). A simplest systematics for the organization of turn-taking for conversation. *Language, 50*(4), 696-735.

Schiesel, S. (2009). When worlds collide, war need not follow. *The New York Times* Retrieved August 10, 2009, from http://www.nytimes.com/2009/08/03/arts/03discovery.html

Schegloff, E. A. (1968). Sequencing in conversational openings. *American Anthropologist, 70*, 1075-1095.

Schegloff, E. A. (1996). Issues of relevance for discourse analysis: Contingency in action, interaction and co-participant context. In E. H. Hovy & D. R. Scott (Eds.), *Computational and conversational discourse: Burning issues - An interdisciplinary account* (pp. 4-35). New York: Springer.

Scollon, R., & Scollon, S. B. K. (1981). *Narrative, literacy, and face in interethnic communication*. Norwood, NJ: Ablex Publishing.

Scribner, S., & Cole, M. (1981). *The psychology of literacy*. Cambridge: Harvard University Press.

Seedhouse, P. (2004). *The interactional architecture of the language classroom: A conversation analysis perspective*. Malden, MA: Blackwell Publishing.

Shaffer, D. W. (2007). *How computer games help children learn*. New York: Palgrave Macmillan.

Squire, K. (2004). Replaying history: Learning world history through playing Civilization III. *Instructional Systems Technology*. Retrieved April 3, 2004, from http://website.education.wisc.edu/kdsquire/REPLAYING_HISTORY.doc

Squire, K. (2005). Changing the game: What happens when video games enter the classroom? *Innovation, 1*(6). Retrieved from http://www.innovateonline.info/index.php?view=article&id=82

Squire, K. (2006). From content to context: Videogames as designed experience. *Educational Researcher, 35*(8), 19-29.

Squire, K. (2008). Open-ended video games: A model for developing learning for the interactive age. In K. Salen (Ed.), *The ecology of games* (pp. 167-198). Cambridge, MA: MIT Press.

Steinkuehler, C. (2004). Learning in massively multiplayer online games. In Y. B. Kafai, W. A. Sandoval, N. Enyedy, A. S. Nixon & F. Herrera (Eds.), Proceedings of the Sixth International Conference of the Learning Sciences (pp. 521-528). Mahwah, NJ: Erlbaum.

Steinkuehler, C. (2007). Massively multiplayer online gaming as a constellation of literacy practices. *E-learning and Digital Media, 4*(3), 297-318.

Stevens, R., Satwicz, T., & McCarthy, L. (2008). In-game, in-room, in-world: Reconnecting video game play to the rest of kids' lives. In K. Salen (Ed.), The

ecology of games (pp. 41-66). Cambridge, MA: MIT Press.
Street, B. (1984). *Literacy in theory and practice*. Cambridge: Cambridge University Press.
Street, B. (2003). What's "new" in new literacy studies? Critical approaches to literacy in theory and practice. *Current Issues in Comparative Education, 5*(2), 1-14.
Suchman, L. A. (1987). *Plans and situated actions: The problem of human-machine communication*. Cambridge: Cambridge University Press.
Suchman, L. A. (2002). *Human-machine reconfigurations: Plans and situated actions* (2nd ed.). Cambridge: Cambridge University Press.
Taleb, N. N. (2007). *The black swan*. New York: Random House.
Turnbull, D. (1993). The ad hoc collective work of building gothic cathedrals with templates, string, and geometry. *Science, Technology, and Human Values, 18*, 315-340.
Varenne, H. (2007). Difficult collective deliberations: Anthropological notes toward a theory of education. *Teachers College Record, 109*(7), 1559-1588.
Vorhees, G. A. (2009). I play therefore I am: Sid Meier's Civilization, turn-based strategy games and the cogito. *Games and Culture, 9*, 254-275.
Wenger, E. (1998). *Communities of practice: Learning, meaning, and identity*. Cambridge: Cambridge University Press.
Wheelwright, P. E. (1966). *The presocratics*. New York: Odyssey Press.
Wilkins, J. S. (2009). *Species: A history of the idea*. Berkeley: University of California Press.
Wolf, M. J. P. (2001). Genre and the video game. In M. J. P. Wolf (Ed.), *The medium of the video game* (pp. 113-134). Austin: University of Texas Press.
Woods, S. (2004). Loading the dice: The challenge of serious videogames. *Game Studies, 4*(1). Retrieved from http://www.gamestudies.org/0401/woods/
Wyatt, S. (2003). Non-users also matter: The construction of users and non-users of the Internet. In N. Oudshoorn & T. J. Pinch (Eds.), *How users matter: The co-construction of users and technologies* (pp. 51-66). Cambridge, MA: The MIT Press.

Index

• A •

Abt, Clark C., 6, 12, 15-17, 22
Ace Combat, 81
accountability
 definition of, 38, 39-40
 in conversation analysis, 51
 in games, 56-57, 101, 144, 159
adjacency pairs, 53, 96, 160
affordance, 14, 61-62, 97
 definition of, 72-73
 of fighting games, 73
 of first-person shooters (FPS), 75-76
 of role-playing games (RPG), 74-75
 of simulations, 76
 of strategy games, 74
Age of Empires, 35-36, 65
Age of Mythology, 65
alignment (in videogames), 74
Alpha Centauri, 64
America's Army, 79
assessment,
 in videogames, 149, 155-156, 192-193
 international comparisons of, 3
 see also testing

• B •

Bacon, Francis, 2
Bartle, Richard, 36—37
Bejeweled, 81
bestselling videogames, 208
Blue Dragon, 81
board games, 204

Bogost, Ian, *see* procedural literacy
"bricolage," 42
Burnout, 81

• C •

Call of Duty (series), 67, 75, 80
"capture the flag," 72
cheating, 49-50, 85, 173-174, 185, 194-195, 201
Civilization (series), 28, 35, 36, 64, 74, 76, 77, 78, 80, 81, 202
class (in videogames), 74, 79
classrooms,
 criticism of, 16, 22, 202, 203
 social interaction in, 44-45
 technology in, 3, 27
 videogames in, 27, 198-199, 201-205
cognition, critique of, 45-49
collaboration,
 conventional wisdoms about, 5
 see also cooperation
Command and Conquer (series), 81
communication breakdowns, 39, 44-49, 53
competition, 187-191
Condemned (series), 81
controllers, *see* game controllers
contingency,
 definition of, 41-42
 in games, 56-57
conventional wisdoms regarding videogames, 2-6
conversation analysis (CA),

definition of, 50-56
rules of turn-taking in, 52-53
transcription conventions for, 54
see also accountability; adjacency pairs
cooperation, 176, 187-191
Counter-Strike (series), 81

• D •

Dance Dance Revolution (series), 81
Dawn of Discovery, 35-36, 65, 69
"deathmatch," 72
design, 59, 74, 198
 in *Super Smash Brothers Melee*, 92, 112, 152
 see also Dourish, Paul; game controllers; game design; Suchman, Lucy
designed experiences, 26-28
Devil May Cry (series), 81
Dewey, John, 16, 24
Dourish, Paul, 7, 60, 73, 82-83, 88, 103, 197
 and Button, 38, 58
Dragon Age: Origins, 66
"dueling," 57, 133, 151-176, 177, 179, 184, 191, 194-195, 201, 203
Duke, Richard, 3, 12-15, 17, 22, 27, 199, 202

• E •

educational games, *see* games studies
Elder Scrolls (series), 66, 70, 74
embodied interaction,
 in language, 85-87
 in videogames, 82-85
 see also Dourish, Paul; metaphors; Suchman, Lucy
endogenous games, 27-28
epistemology, 24, 32
epistemic games, 24-25
epistemic arrogance, 25
et cetera provision, 100-101

Eternal Darkness: Sanity's Requiem, 61
ethnomethodology, 56-58, 198
 definition of, 37-39,
 studies using, 43-50
 see also accountability; contingency; conversation analysis; documentary method of interpretation; et cetera provision; indexicality; order
exogenous games, 27-28

• F •

Fable (series), 66, 74
Fallout (series), 66
Far Cry (series), 67
FIFA (series), 81
fighting games, 91-92
 see also affordance; "dueling"; player configuration; genre; procedural literacy; "regular play"; timescale; "training"; turn structure;
Final Fantasy (series), 66, 80, 81,
first person shooters (FPS), *see* affordance; player configuration; genre; procedural literacy; timescale; turn structure
forms of play, *see* "dueling," "regular play," "training"

• G •

Gaia, 81
game controllers, 83-85, 110
 learning how to use, 110, 114
game design, 2, 29, 37, 46, 57-58, 60, 76, 88, 89, 101, 132, 187, 197-200
 conventional wisdoms about, 4
 for education, 16, 18
 relationship to conversation analysis, 56-58
 see also design; genre
games studies, 198-202
 current approaches to, 18-29
 early approaches to, 11-17

future research implications for, 203-205
 see also, serious games
game tutorials, *see* tutorials
Gaming (book), *see* Duke, Richard
Gardner, Howard, 202
 see also multiple intelligences
Garfinkel, Harold, *see* ethnomethodology
Gee, James Paul
 on games, 19-22, 23, 39, 48, 77, 79, 104, 129
 see also, classrooms, criticisms of; learning principles; projective stance
gender, 187-191, 195-196
 see also Goodwin, Marjorie Harness; Separate World Hypothesis
genre
 convention, 59-62
 implications of, 80-82
 popularity among teenagers, 81-82
see also affordance; player configuration; procedural literacy; timescale; turn structure;
Ghost Recon (series), 67
Gibson, James Jerome, *see* affordance
Goffman, Erving, 62, 131
Goodwin, Marjorie Harness, 49-50, 51, 85, 90, 172-174, 185, 188
 and Goodwin, Charles, 43
 see also cheating; gender
Grand Theft Auto (series), 5, 26, 58, 80, 81, 208
Guitar Hero (series), 81

• H •

Habbo Hotel, 81
Halliday, M.A.K., *see* meaning potential
Half-Life (series), 81
Halo (series), 81
Hawthorne effect, 17
Hill, Clifford and Larsen, E., *see* visual orientation
house rules, 132-133

human-machine communication, 45-49, 174-175; *see also* Suchman, Lucy

• I •

Ico, 61
indexicality
 definition of, 40-41, 46
 in conversation analysis, 51
 in games, 57
 in language, 100
initiation-response-evaluation (IRE), 44
 see also classrooms, social interaction in
Ito, Mizuko, 60, 61, 76, 80

• J •

just-in-time learning (JIT), 8
 criticism of, 129-130

• K •

Killer-7, 61
kinderpolitics, 2

• L •

Lakoff, George and Johnson, Mark, *see* metaphors
Latour, Bruno, 43
 and Woolgar, Steve, 43
Lave, Jean, 89, 203
 and Wenger, Etienne, 22, 129-130
Leander, Kevin, 27-28, 201
learning principles, 3, 4, 14, 22, 202-204
learning sciences, 22
Legend of Zelda (series), 81, 91
Lemke, Jay, 30, 207
 see also timescale
Lumines, 81

• M •

Madden, 81
Mario Kart, 81
Mass Effect (series), 66, 79, 207
massively multiplayer online games (MMOG), 16, 29, 71-72, 81-82, 104
meaning potential, 150-151
Mehan, Hugh, see classrooms, social interaction in
metaphors, 22-24, 25, 85-86
 see also embodied interaction; visual orientation
miscommunication, see communication breakdowns
Mortal Kombat (series), 81
multiple intelligences, 22

• N •

Naruto: Clash of Ninjas 2 (NCN2), 64, 84-85, 91, 180-185
Nascar, 81
Neverwinter Nights (series), 28, 66, 72
New Literacy Studies (NLS), 19-24
New London Group, 21-22
Norman, Donald, see affordance

• O •

ontology, 24, 32
order,
 definition of, 38-39
 in classrooms, 44-45
 in conversation, 52-53, 178
 in social action, 32, 43, 50, 188
 in videogames, 56-58, 94-104, 115, 162-163, 174-175, 197-200, 204
 see also ethnomethodology; turning-taking in videogames

• P •

Parsons, Talcott, 34-37
perception, see affordance
Pew Internet and American Life Project, 1, 29, 81-82
player configuration
 definition of, 71
 of fighting games, 71, 115, 174
 of first-person shooters (FPS), 72
 of role-playing games (RPG), 71-72
 of simulations, 72
 of strategy games, 71
procedural literacy
 definition of, 77
 of fighting games, 77
 of first-person shooters (FPS), 79-80
 of role-playing games (RPG), 79
 of simulations, 80
 of strategy games, 77-78
"projective stance," 140

• R •

Rachet and Clank (series), 81
Rainbow Six (series), 67
reality, 32-34
"regular play," 142, 153, 155, 163, 174, 177-187, 192-196, 201
Resident Evil (series), 75, 81
Resistance (series), 67
"ritual insults," 107
role-playing games (RPGs), 6
 see also affordance; player configuration; genre; procedural literacy; timescale; turn structure;
Rollercoaster Tycoon, 81
rules of engagement, 179-187

• S •

Sacks, Harvey, see conversation analysis; schism; speech-exchange systems

Schegloff, Emanuel, *see* conversation analysis; schism; speech-exchange systems
schism, 185-186
Scollon, Ron
 and Scollon, Suzie Wong, 19
Scribner, Sylvia
 and Cole, Michael, 19-20
Second Life, 29, 81
 see also virtual worlds
"Separate World Hypothesis," 188-189
Serious Games (book), *see* Abt, Clark C.
serious games, 10-11
 see also games studies
Shaffer, David, *see* epistemic games
simulations, *see* affordance; player configuration; genre; procedural literacy; timescale; turn structure;
Silent Hill (series), 81
SimCity (series), 11, 13, 36, 68, 72, 76, 80-81
Sims, The (series), 68, 72, 76, 81
skill, 149, 158
 vs. chance, 163-172
 vs. style, 153-163
 see also "projective stance"
situated learning, 8, 22, 48, 89, 104, 129
 see also Lave, Jean; just-in-time learning
Solitaire, 81
social system, *see* Parsons, Talcott
speech-exchange systems, 57
 definition of, 52, 178
 comparison to videogames, 178-187
Squire, Kurt, *see* classrooms, videogames in; designed experiences; endogenous games; exogenous games
StarCraft (series), 81
Star Wars: Knights of the Old Republic, 74, 81
strategy games, *see* affordance; player configuration; genre; procedural literacy; timescale; turn structure;
Street, Brian, 19-20
Street Fighter (series), 60, 64, 73, 80
Suchman, Lucy, 41-42, 45-49, 50, 53, 54, 58, 60, 82-83, 90, 174-175

see also cognition, critique of; communication breakdowns
Super Smash Brothers Brawl (SSBB), 91, 191-195
Super Smash Brothers Melee (SSBM), 91, 94, 103-105, 112, 115, 119, 129, 136-137, 142, 151-152, 163, 167, 180-181, 187, 191, 208

• T •

Taleb, Nassim Nicholas, *see* epistemic arrogance
testing, 16, 18, 86, 203-204
 see also assessment
Tekken, 73, 81
Tetris, 13, 81
timescale
 definition of, 68
 of fighting games, 69
 of first-person shooters (FPS), 70
 of role-playing games (RPG), 70
 of simulations, 70-71
 of strategy games, 69
Tomb Raider (series), 81
Tony Hawk (series), 81
"training," 57, 84, 133-149, 150-151, 168, 174-176, 177, 179, 187, 192, 201, 203
 screenshot of (*Naruto: Clash of Ninjas 2*), 85
turn structure
 definition of, 62-64
 of fighting games, 64
 of first-person shooters (FPS), 67-68
 of role-playing games (RPG), 65-67
 of simulations, 68
 of strategy games, 64-65
turning-taking,
 in videogames, 184-187
 see also conversation analysis
tutorials, 121, 130, 133, 205

• V •

Varenne, Hervé, 89, 115, 129
virtual worlds, 29, 37, 81-82
visual orientation, 85-87

• W •

Wenger, Etienne, *see* Lave, Jean
World of Warcraft, *see* massively multi-player online games (MMOGs)

Colin Lankshear & Michele Knobel
*General Editor*s

New literacies and new knowledges are being invented "in the streets" as people from all walks of life wrestle with new technologies, shifting values, changing institutions, and new structures of personality and temperament emerging in a global informational age. These new literacies and ways of knowing remain absent from classrooms. Many education administrators, teachers, teacher educators, and academics seem largely unaware of them. Others actively oppose them. Yet, they increasingly shape the engagements and worlds of young people in societies like our own. The *New Literacies and Digital Epistemologies* series will explore this terrain with a view to informing educational theory and practice in constructively critical ways.

For further information about the series and submitting manuscripts, please contact:

 Michele Knobel & Colin Lankshear
 Montclair State University
 Dept. of Education and Human Services
 3173 University Hall
 Montclair, NJ 07043
 michele@coatepec.net

To order other books in this series, please contact our Customer Service Department at:

 (800) 770-LANG (within the U.S.)
 (212) 647-7706 (outside the U.S.)
 (212) 647-7707 FAX

Or browse online by series at:

 www.peterlang.com